PAPER: AN ELEGY

IAN SANSOM

PAPER
AN ELEGY

wm

WILLIAM MORROW
An Imprint of HarperCollins*Publishers*

Text permission acknowledgments and picture credits appear on page 231.

PAPER. Copyright © 2012 by Ian Sansom. All rights reserved. Printed in the
United States of America. No part of this book may be used or reproduced in
any manner whatsoever without written permission except in the case of brief
quotations embodied in critical articles and reviews. For information address
HarperCollins Publishers, 10 East 53rd Street, New York, NY 10022.

HarperCollins books may be purchased for educational, business, or sales
promotional use. For information please write: Special Markets Department,
HarperCollins Publishers, 10 East 53rd Street, New York, NY 10022.

First published in Great Britain in 2012 by Fourth Estate,
an imprint of HarperCollins Publishers, London.

FIRST U.S. EDITION

Library of Congress Cataloging-in-Publication Data has been applied for.

ISBN 978-0-06-224143-6

13 14 15 16 17 DIX/RRD 10 9 8 7 6 5 4 3 2 1

For Nicholas and George,
with thanks for Christmas lunch

CONTENTS

The old book collector's pulse was almost visible, throbbing in his wrist and temples. His voice became deeper as he held the book up to his eyes so he could read more clearly. His expression was radiant.

"A magnificent book," confirmed Corso, dragging on his cigarette.

"It's more than that. Feel the paper."

ARTURO PÉREZ-REVERTE, *The Club Dumas* (1993)

RESPECTING PAPER
An Introduction

First of all, respect your paper!

J.M.W. TURNER's advice to Mary Lloyd, recollected by her in 1880,
quoted in *Turner Studies*, vol. 4, no. 1 (1984)

Welcome to the Paper Museum. The museum is dedicated to the preservation and study of paper and paper products, including not only—and obviously—books, letters and diaries, but also account ledgers and ballot papers, bandboxes and banderoles, bandages and dressings, bank checks and ledgers, banners and bunting, beer mats, birth certificates, death certificates, baptism and bastardy papers, board games, bookmarks, business cards, cartons and packaging, menus, cash register receipts, charts (nautical, medical, educational and otherwise), cigarette papers, clothes (including suits, hats, shirts, overcoats, kimonos, overalls and coveralls), coffins, coloring books, confetti, coupons, construction and tracing paper, emery boards, envelopes, filters and gauzes (medical, industrial and culinary), fireworks, flypaper and official forms of all kinds, funeralia, greeting cards, postcards, kites, carpets, lanterns and lampshades, library cards, identity cards and passports, magazines, catalogues, newspapers, maps and globes, paper bags, paper cups, paper dolls, paper flowers, paper money, paper pipes, panoramas, photographs, playing cards, postage stamps, Post-it notes, posters, prescriptions, puzzles, report cards and registers, sandpaper, shoe boxes, stationery, stickers, streamers, tags, labels and tickets, tea bags, telephone directories, wallpaper, wrapping paper, etc., etc., etc.

We live in a paper world. Without paper our lives would be unimaginable. Or almost unimaginable. We can, of course, imagine it, as we can imagine anything, for the great writers and artists and musicians have taught us to imagine, in their books, and their paintings, and through their music. We have been trained by them, educated by them *on* paper, and *through* paper, and *by* paper, to imagine. So it's easy to imagine a world without paper. Like being dead, or never having been born.

We arise, wash, and go to the restroom—though without toilet paper. We enjoy a bowl of cereal, unpackaged, naturally. Tea: no bags. Coffee: no filter. We do not buy a newspaper on our way to the train station: there are no newspapers to buy. And besides, we have no money. Well, coins maybe. Bags of coins. Or cowrie shells. But we buy no lottery ticket. And no chewing gum: no wrapper. No ticket for the train—which, anyway, has no train schedule. (We'll assume, just for fun, that there is a train, and a train station, and a house, and an office or workplace to go to—although without plans and schedules and surveys and backs-of-envelopes and blueprints and patents and maps and graphs, all of this is of course highly unlikely; not impossible, but about as likely as you being able to read these words without ever having read or written anything on a piece of paper.) We certainly shall not gaze at advertisements on the train, or at billboards. Nor buy a cup of takeout coffee, in a takeout coffee cup, protected by a takeout coffee-cup sleeve, and our nonexistent loyalty card can remain forever lost, forgotten and unstamped. Nor do we post our mail: there is no post office. So no Amazon packages. Nor do we spend our days printing out emails, filing papers in folders, filling in forms, surrounded by familiar wallpaper and family photos, sticking up Post-it notes, or writing

"documents" on screen and "filing" them in "folders." Nor do we read a magazine or a paperback at lunchtime, while eating a sandwich neither wrapped nor carried in paper, our greasy hands untouched by a paper napkin. At no point in the afternoon do we file our nails with an emery board, fix our makeup, or blow our nose with a tissue. No cupcake tin liners, no cake boxes. No business cards. No bills. No banks. No building societies. No insurance companies. A little industry, perhaps, a little government. Maybe some law and order. But certainly we smoke no cigarettes, wipe no bottoms with a wet wipe, wrap no presents, nor mark, correct or assist with any homework, read no menus, send no Christmas cards, pull no crackers, light no fireworks . . .

Imagine for a moment that paper were to disappear. Would anything be lost? Everything would be lost.

We have been using paper for around two thousand years. What began in China as a rare and precious material and commodity eventually spread and spread, like alarm and disease, and dreams and despondency, until the nineteenth century, when papermaking machines replaced hand production. Then things really took off, and the truly phantasmagoric age of paper began. The average office employee in the West now uses over ten thousand sheets of paper per year. If you live in America you consume, all told, about 750 lbs. of paper per year—which is about the weight of seven bags of cement, or 150 bags of sugar—maybe more. If paper did not exist, then someone would have to invent it—Gutenberg, probably, because what use would his movable type have been without it? Paper is the ultimate man-made material. It's cheap, light, durable, and can be folded and cut and bent and twisted and lacquered and woven and waterproofed so that it can be used

in almost any way and for anything. What, boats? Yes. Clothes? Yes. Furniture? Yes. Houses? Yes. Weapons? Yes. Games, puzzles and toys? Yes. The wheels on high-speed trains? Yes. And we shall come to them all later.

But these are only paper's more prosaic uses. In Japan, cut as streamers, paper consecrates sacred places. In India, during religious festivals, cut paper, *sanjih*, is placed on the floor to produce *rangoli*, the beautiful decorative shapes and patterns that welcome the Hindu deities. In Switzerland, elaborate paper cuts are used to ratify legal documents. In China, at a Taoist or Buddhist funeral, sacred papers are burned to ease the passage of the dead through to the other world. And in the stories of Sherlock Holmes, criminals are caught with the simple application of brain to paper. "'I have some papers here,' said my friend Sherlock Holmes as we sat one winter's night on either side of the fire, 'which I really think, Watson, that it would be worth your while to glance over'" ("The *Gloria Scott*"). At a glance, and just for fun, here is Holmes on paper: in "A Scandal in Bohemia" he establishes, with the aid of his *Continental Gazetteer*, that a crucial piece of paper was produced in Bohemia; in *The Sign of Four* he even more quickly deduces, without assistance, that a piece of paper is "of native Indian manufacture"; his monographs on technical subjects include not only the celebrated "Practical Handbook of Bee Culture," "Upon the Distinction Between the Ashes of the Various Tobaccos" and contributions to the study of tattooing, ears, the form of the hand, the tracing of footsteps and the polyphonic motets of Lassus, but also a "trifling" monograph upon the subject of secret writings, and one upon the dating of documents; and in "The Stockbroker's Clerk" he is able to tell Watson's state of health from a scrap of paper:

"Your slippers are new," he said. "You could not have had them more than a few weeks. The soles which you are at this moment presenting to me are slightly scorched. For a moment I thought they might have got wet and been burned in the drying. But near the instep there is a small circular wafer of paper with the shopman's hieroglyphics upon it. Damp would of course have removed this. You had, then, been sitting with your feet outstretched to the fire, which a man would hardly do even in so wet a June as this if he were in his full health."

Just so.

And as such paper logic relentlessly proceeds, so paper itself might be revealed to be the unlikely foundation of the world. In origami, we learn first to make a base, the bird base, or the frog base, and from this base we can build any number of shapes and models, constructing worlds from simple folds and creases. In the same way, paper has been the base, the foundation, of all the curious folds and creases of our history: our economy, our art, our wars and our attempts to make peace have all been conducted by means of paper. Elementary.

Yet, as we are forever being reminded, we are now entering a world beyond paper, or certain forms of paper. Everywhere we look, paper is disappearing. We can book and check in on a flight without any paper changing hands (though we may still need a passport, and a visa, and a list to remind us to pack our passport and our visa, and onboard we may be glad of a paperback, and the sick bag, and the laminated emergency instructions, and the prethumbed in-flight magazine, and the wake-up paper face wipes). We have ticketless parking, and e-books and iPads. And yet at the same time, paper is also proliferating: more and more books are being published; more

barista-proffered paper cups dispensed; more and more homes equipped with their very own HP desktop printer. "Is This the End of the Book?," the newspaper headlines endlessly ask. Will there be a continuing role for paper?

Short answer: yes.

This book will attempt to show, at much greater length, that reports of the death of paper have been greatly exaggerated. As the richly paper-fed French philosopher Jacques Derrida remarked, "To say farewell to paper today would be rather like deciding one fine day to stop speaking because you had learned to write." Derrida returns again and again in his work to the question—the questions, rather—of paper. "Seeing all these questions emerging on paper, I have the impression . . . that I have never had any other *subject*: basically, paper, paper, paper."

Paper, paper, paper. Anyone old enough to remember floppy disks will remember that paperlessness was once a universal goal among get-ahead office managers. But as Abigail J. Sellen and Richard H. R. Harper explain in their book *The Myth of the Paperless Office* (2001), it soon became apparent that technological development—and in particular the introduction of email, and network computing—increased rather than decreased office paper consumption. According to Sellen and Harper, technological change has not replaced paper use but rather has shifted "the point at which paper is used": we distribute, then print, rather than print and distribute. And anyway, the ultimate goal of all technological development seems to be a paperlike device on which information can not only be accessed, sent and read, but also marked up in a paperlike way. Paper remains the ghost in our machines. We are, simply, paper fanatics and paper fundamentalists: even when it's not there,

when it has been shown to be unnecessary or not to exist, we continue to imagine it, to honor it, and to wish it into being.

The word-processing document I am currently typing onto and into, for example, has—for no good reason at all—the appearance of a sheet of white paper. In the corner of the screen sits an image of a wastepaper basket. There are margins. Paragraphs. The little page counter at the bottom of the "page" tells me that this is "page" 4—though how can it be, unless I imagine some vast Platonic paper mill somewhere behind the screen? My "wallpaper" shows a misty mountaintop, like a mural or giant photo pinned to an imaginary wall. The great irony of the end of the age of paper is that the image of paper is everywhere increasing, and continues to determine the shape and scene of our writing and reading. This may be because paper is so useful as a metaphor for language itself—as Saussure notes in his *Course in General Linguistics*, "Language can also be compared with a sheet of paper: thought is the front side and sound the back; one cannot cut the front without cutting the back at the same time; likewise in language, one can neither divide sound from thought nor thought from sound; the division could be accomplished only abstractedly, and the result would be either pure psychology or pure phonology." We can't seem to abstract or extract paper from our thinking, or our thinking from paper. We change. Words change. But the paper remains the same. It can absorb everything, and be absorbed into everything. Even the most advanced and cherished technologies of our age resemble the page: the iPad is like a jotter; the Kindle like a book; the mobile phone a pocket diary. And the page continues to determine the rhythm of our reading—on my Kindle, page 2 still follows page 1, as sure as night follows day, and the long shadow of

paper continues to determine the very *color* of my reading. Why black marks on white, on screen, if not because of paper?

It is perhaps because paper is forever disappearing and reappearing in this way—burned, lost, discarded, disowned, rediscovered, restored, reified—that it remains ancillary to most academic study, so insignificant and inessential as barely to merit discussion outside specialist books, journals and publications. (In Japanese there's a phrase, *yokogami yaburi*, which means to tear paper sideways against its grain—idiomatically, it means "perversity" or "pigheadedness." By ignoring paper, we are perverse; we go against the grain.) Because of its everyday usefulness, paper is an artifact without a popular history. *Paper: An Elegy* is an attempt to trace and recover some of this history in its many forms.

What this book is not, strictly speaking, is a history of paper. It is, rather, a kind of personally curated Paper Museum, a boutique museum, perhaps, or a *musée imaginaire*, an imaginary museum, a term borrowed from André Malraux, novelist, art historian and also, somehow, in that extraordinary French way, French minister of cultural affairs from 1959 to 1969. Malraux realized that many of the objects that people now think of as art were not originally regarded as art at all: they were totems or amulets, emanations or images of the gods. "In the seventeenth century," writes Malraux in *The Imaginary Museum of World Sculpture* (3 volumes, 1952–54), "a Sung painting would not have been compared with a work by Poussin: that would have meant comparing a 'strange-looking' landscape with a noble work of art." The imaginary museum, according to Malraux, was a "song of metamorphosis," a "re-creation of the universe, confronting the Creation"; it was a celebration of all that might be called art, rather than everything that had been art. So, in the Paper

Museum, a Dickens manuscript might sit alongside blue sugar paper and brown paper packages tied up with string, forming a kind of vast paper mirror in which we might view ourselves and our world—colossal, dreadful and amazing.

Any history of paper, it should further be said, for the purpose of clarification—and in particular this history of paper, which is not a history of paper—is not the same thing as a history of the book, nor indeed the same thing as a history of writing. There are plenty of such histories already. There was of course writing before paper, on birch bark, clay tablets, ivory, wood and bone, papyrus, palm leaves and silk. And there is writing after paper. There were also books before paper, on papyrus and parchment; and there are books after paper. *Paper: An Elegy* is not really about books, though books are undoubtedly one of the most ubiquitous of paper products. Nor is it a book about papermaking, in itself a vast and fascinating subject. *Paper: An Elegy* is, rather, an attempt to show how and why humans became attached to paper and became engrafted and sutured onto and into it, so that our very being might be described as *papery*.

Because everything that matters to us happens on paper. Without paper, we are nothing. We are born, and issued with a birth certificate. We collect more of these certificates at school, and yet another when we marry, and another when we divorce, and buy a house, and when we die. We are born human, but are forever becoming paper, as paper becomes us, our artificial skin. Everything we are is paper: it is the ground of activity, the partner to all our enterprises, the key to our understanding of the past. How do we know the past? Only through paper and all it records—and through architecture, of course, though architecture, as we shall see, rather depends on paper. So. Paper wraps stone.

Paper: An Elegy will address and acknowledge the great pathos of paper, and our nostalgia for its past: the thickness and weight of old writing paper; the tattered posters of our idealistic youth; the increasing vulnerability and scarcity of all those scraps of paper that represent our personal and collective history. But above all it will be concerned with the paradoxes of paper, the ironies of its uses, its multiple meanings, its values, and its extraordinary scope and scale. The fact that a piece of paper may be a priceless artifact—a painting or a manuscript—or a piece of litter. The simple fact that it may bring glad tidings, or spread bad news: a love letter, and a suicide note. That it is both adequate to communication and inadequate to thought: antecedent to thought, and *a posteriori*. A form of external memory, and the means by which we forget. Lacking in substance, yet full of value. Material and simulacrum. Vulnerable and durable. (Tales of lost manuscripts are legion: Carlyle's famous manuscript of the first volume of his *The French Revolution*, used by a maid to light the fire; Thomas De Quincey losing his notes for *Confessions of an English Opium-Eater* when "The spark of a candle [fell] unobserved amongst a very large pile of papers in a bedroom"; Tennyson losing the manuscript of his *Poems, Chiefly Lyrical* from his gaping greatcoat pocket.) Delicate yet sharp, and capable of inflicting cuts. Ephemeral yet everlasting. (Byron in *Don Juan*: "To what straits old Time reduces/Frail man, when paper, even a rag like this,/Survives himself, his tomb, and all that's his.") Everything and nothing: the ultimate MacGuffin. An object that somehow magically grants us access to ourselves, that leads us from the surface into imaginary worlds, and deep within, a threshold to what Henri Bergson called "the uninterrupted humming of life's depths."

And the greatest irony of all? Paper's most powerful magic? Simply this. That paper allows us to be present—or to appear to be present—when we are in fact absent. It both breaks and bridges time and distance. I am talking to you now, for example, on paper. You cannot see me, and you cannot hear me. I may, for all you know, already be dead. But by the mysterious application of pen to paper, and by your patient reading, we have between us conjured the illusion of communication: a voice on the page, and my disappearance into that voice on the page. Paper provides for my self-invention, my self-disclosure and my self-erasure. Total visibility. Perfect camouflage. In William Golding's novel *Free Fall* (1959) the narrator addresses the reader: "I tick. I exist. I am poised eighteen inches over the black rivets you are reading, I am in your place, I am shut in a bone box and trying to fasten myself on the white paper. The rivets join us together and yet for all the passion we share nothing but our sense of division." Here I am. There I go.

Paper: An Elegy is intended in part as a technological and material history, but more importantly as a symbolic history, or a history of symbols, of how paper becomes sacred, and sacralized and fetishized, how it promises and provides us with freedoms, and imposes upon us clear boundaries. There is, alas, much paper that will be missing from the book: no decoupage; no exam papers; no musical scores. Online, such limits do not apply: we can just click through. (And let me mention here some words, phrases and ideas that might send you scurrying to Google—papier poudré, papillotes, papeterie, paper ministers, paper skulls, paperage, papercrete and papercreters, the infinite history of litter.) There are so many types and kinds of paper that I have had to leave unfingered and untouched. Among

Japanese papers alone, there are, or were, hundreds of unexplored treasures: *hiki awase*, once used as the inner lining of a warrior's breastplate; *hosokawa-shi*, used for government land records; *shibugami*, the persimmon-juice-impregnated paper used for the sacks in which grains and cereals were stored; the rickshaw driver's padded paper coats; the paper used to wrap medicines; the paper used to wrap a kimono. The sounds of different papers. The smells of different papers; the smell of ammonia used in large office print machines. The collection is not complete. But it has begun.

We have lived in a world of paper, and we are paper people. In Salvador Plascencia's novel *The People of Paper* (2005)—a masterpiece of paper, on paper—a monk named Antonio becomes "the first origami surgeon." His skills are extraordinary, but he is, inevitably, excommunicated, outcast and unemployed, until one day he retreats, alone, to a factory with a wheelbarrow filled with cardboard and napkins and books:

> Antonio split the spines of books, spilling leaves of Austen and Cervantes, sheets from Leviticus and Judges, all mixing with the pages of *The Book of Incandescent Light*. Then Antonio unrolled the wrapping paper and construction paper and began to cut at the cardboard and then fold.
>
> She was the first to be created: cardboard legs, cellophane appendix, and paper breasts. Created not from the rib of a man but from paper scraps.

This magnificent creature rises from Antonio's cutting table, steps over her exhausted, dying creator, and strides out into the world.

Let us take her hand now and enter the Paper Museum.

A Note on the Paper Used in
the Writing of This Book

All my books have really been counterproofs, or offsets, re-marques, like cartoons, those drawings made to the same scale as the grand painting or fresco but which are in fact only preparatory, and which are applied to the wall, and pricked through or indented: a mere outline or image of some greater design.

This book I like to think of not as a cartoon but as like John F. Peto's *Old Scraps* (1894), a miniature *trompe l'oeil*. Or a *trompe l'esprit*.

"I am typing this book on yellow paper," announces the narrator of Stevie Smith's *Novel on Yellow Paper* (1936). "It is very yellow paper, and it is this very yellow paper because often sometimes I am typing it in my room at my office, and the paper I use for Sir Phoebus's letters is blue paper with his name across the corner." The yellow paper helps distinguish the novel from the work.

Alas, I have adopted no such sensible system.

I have typed on a laptop, and on a desktop. I have read many books: paper books, Kindle books, Google books. I have read articles online, in print journals, and in magazines. I have made copies; I have pressed "Print." I have written notes in margins, and I have written notes, by hand, in notebooks, and on A4 narrow-feint paper. I have organized my notes into folders. I have disorganized my notes in the folders. I have typed sentences, then paragraphs, then chapters. I have printed out these

chapters, marked up revisions and corrections in pencil, and then incorporated these changes, and printed out the chapters again. And again. And again. And again. And then finally, I sent the "document" by email to my editor, who suggested further changes. Some of which I ignored. Most of which I ignored. But some of which I incorporated. And all of which required yet more printing, and marking up and correcting, before sending it all off again. And then again. Proofs. More corrections. More proofs. Interminable? Inexplicable.

In total, this book is made from twenty reams of plain white 80 gsm copier paper, fifteen A4 lined, narrow-feint pads, four Moleskine pocket notebooks, six packs of A5 lined index cards, fifty manila folders (green), and three wrist-thick blocks of Post-it notes (assorted colors). I'm sure there are easier ways of writing books.

The finished product is printed on Glatfelter's Offset 70 lb. B18 Antique from a mill in Spring Grove, Pennsylvania—virgin paper with no added optical brighteners, made by a chlorine-free process and using pulp from woodlands that comply with guidelines set by the Sustainable Forestry Initiative.

Too much? Too much. Not enough.

1

A MIRACLE OF INSCRUTABLE INTRICACY

Looking at that blank paper continually dropping, dropping, dropping, my mind ran on in wonderings of those strange uses to which those thousand sheets eventually would be put. All sorts of writings would be writ on those now vacant things—sermons, lawyers' briefs, physicians' prescriptions, love-letters, marriage certificates, bills of divorce, registers of births, death-warrants, and so on, without end . . . "Yours is a most wonderful factory. Your great machine is a miracle of inscrutable intricacy."

HERMAN MELVILLE, "The Paradise of Bachelors and the Tartarus of Maids" (1855)

Japanese tissue paper with fine swirls of fiber

Making Japanese paper:
1. Stripping the bark
2. Soaking the bark in water
3. Beating the fibers to a pulp
4. Placing the paper mold into the vat of pulp
5. Drying and polishing the resulting sheet of paper

You are living, let us say, in Japan, two thousand years ago. You and your family have planted some trees—mulberry trees. The trees grow. You remove some of the branches of the trees and steam them in order to loosen the inner bark. You peel and dry and soak and scrape and rinse the bark. You find this pleasing: it turns the bark whiter and lighter. The fibers of the bark begin to separate. You boil the bark to soften it further, and then you bleach it in the sun. And then you beat it, and you beat it, and you beat it with a wooden beater and then you throw lumps of this bleached bark pulp into a vat filled with water. And then you mix it and beat it again. And again. You now have a vat of gray mush. You take a wooden frame with a sievelike screen, dip it into the mush, scoop up the frame, tossing off the excess water, and rock it back and forth until you have a nice, smooth, consistent sheet of mush on your sieve. You allow all the water to drain off. Now you have a sort of damp mat of macerated fiber stuck to your sieve. You remove this mat from the sieve, and place it on a wooden board to dry. It dries, and you smooth it and polish it, maybe with some animal fat or maybe just with a stone, anything you can get your hands on to make it shiny and smooth. And then you trim the edges and admire your handiwork. Congratulations. You have produced a sheet of paper.

Basically, paper has continued to be made by this method

throughout the world to this very day, and seems likely to continue to be made by the same method tomorrow. Compare the ancient Japanese technique to John Evelyn's description of hand papermaking in seventeenth-century England, for example, from his diary, dated August 24, 1678:

> I went to see my Lord of St. Alban's house, at Byfleet, an old large building. Thence, to the paper-mills, where I found them making a coarse white paper. They cull the rags which are linen for white paper, woollen for brown; then they stamp them in troughs to a pap, with pestles, or hammers, like the powder-mills, then put it into a vessel of water, in which they dip a frame closely wired with wire as small as a hair and as close as a weaver's reed; on this they take up the pap, the superfluous water draining through the wire; this they, dexterously turning, shake out like a pancake on a smooth board between two pieces of flannel, then press it between a great press, the flannel sucking out the moisture; then, taking it out, they ply and dry it on strings, as they dry linen in the laundry; then dip it in alum-water, lastly, polish and make it up in quires. They put some gum in the water in which they macerate the rags. The mark we find on the sheets is formed in the wire.

The details may differ, but the processes remain essentially the same (as indeed did Evelyn's famous note-taking habit, established at the age of just eleven, and which sustained him over seventy years, through Oxford, a grand tour, the English Civil War, Cromwell's Protectorate, the Restoration, and work on dozens of books and treatises).

Industrial methods have now largely replaced hand beating and dipping and drying, with mechanical agitators to beat pulp, and high-pressure jets and conveyor belts to spray it and

Papermaking: the same yesterday, today and tomorrow

spread it, and vacuums and cylinders and presses to dry it, and rollers to polish it, but there are still really only three stages in the whole paper-production process: the preparing of the pulp; the forming of the paper on a mold or a mesh; and the drying and finishing. In a modern paper plant, these stages translate into a process that goes something like this. Bales of wood pulp are fed into a hydrapulper, in which the pulp is diluted with water and mixed—think of a hydrapulper as a giant Moulinex, and the pulp as paper gruel. The porridgelike substance produced—the "stock" or "stuff"—can then be further diluted and undergo further beating, or fibrillation, to cut and break up the fibers of the pulp, and screened to remove impurities,

A diagram of a papermaking machine

and blended with various additives. Then, and only then, is the stuff ready for the papermaking machine proper. A typical modern machine is mind-bogglingly huge: hundreds of meters long, costing millions, running twenty-four hours a day and capable of producing hundreds of thousands of tons of paper every year. The slurry, or stock—which looks like milk at this stage, or at least a kind of thin white water—passes through a "flow box" or "head box," where it is sprayed onto a mesh conveyor belt. As the stock is sprayed, the water drains through the mesh, leaving behind a fibrous mat, just as in the early Japanese hand molds, only on a massive scale, and at astonishing speed. The stuff then passes through heavy rollers, with more moisture being squeezed and sucked out, and beneath a dandy roll, and through steam-heated drying cylinders and a size press, where sizing is added—the starch that reduces absorbency—and then over the calender, the big iron rollers that polish and glaze the surface of the paper, and finally it passes onto large reels, ready to be cut into sheets or split into smaller reels and

packed for dispatch to paper merchants and converters who will produce and package the paper ready for you to print out your essential emails and flight boarding details.

It is an amazing sight to see a modern paper machine in full flow, even now in the twenty-first century: in the nineteenth century it was nothing less than astonishing. Herman Melville, that great nineteenth-century chronicler of astonishment, describes a paper mill in his story "The Paradise of Bachelors and the Tartarus of Maids" (1855), in which the narrator visits a mill that is oddly but reassuringly very like a whale, a "large whitewashed factory," "like an arrested avalanche." This vast white beast, which swallows up rags and water and people, is located "not far from Woedolor Mountain in New England . . . By the country people . . . called the Devil's Dungeon." The narrator of the story is a businessman, "Having embarked on a large scale in the seedsman's business," who is seeking a cheap wholesale source for seed packets. Inside the factory he stands, amazed:

> Something of awe now stole over me, as I gazed upon this inflexible iron animal. Always, more or less, machinery of this ponderous, elaborate sort strikes, in some moods, strange dread into the human heart, as some living, panting Behemoth might. But what made the thing I saw so specially terrible to me was the metallic necessity, the unbudging fatality which governed it. Though, here and there, I could not follow the thin, gauzy veil of pulp in the course of its more mysterious or entirely invisible advance, yet it was indubitable that, at those points where it eluded me, it still marched on in unvarying docility to the autocratic cunning of the machine. A fascination fastened on me. I stood spellbound and wandering in my soul. Before my eyes—there, passing in slow procession along the wheeling cylinders, I seemed

to see, glued to the pallid incipience of the pulp, the yet more pallid faces of all the pallid girls I had eyed that heavy day. Slowly, mournfully, beseechingly, yet unresistingly, they gleamed along, their agony dimly outlined on the imperfect paper, like the print of the tormented face on the handkerchief of Saint Veronica.

Who could possibly have conceived of such a monster, such a panting Behemoth? A man called Louis-Nicolas Robert could. Like Melville, Robert too saw the pallid faces of the workers in the pallid incipience of the pulp, though where Melville saw agony and torment, Robert saw freedom and liberation. In its very incarnation, by its very originators, the papermaking machine was seen as a metallic necessity, a triumph of technology over man.

Louis-Nicolas Robert, born in Paris in 1761 and nicknamed "the Philosopher" at school, became a soldier in the French army, in the First Battalion of the Grenoble Artillery. Restless and dissatisfied, and with no prospect of promotion, he eventually found himself back in Paris in the very midst of the French Revolution, working as "an inspector of personnel," a classic *petit cadre*, in a paper mill at Essonnes, to the south of Paris, where he was appalled by the behavior of the workers, who had become infected with the ideas of the times. Encouraged by his employer, François Didot, Robert began experimenting with plans for a machine that could replace the troublesome papermakers. After much trial and error just such a machine was devised, and on January 18, 1799, Robert was granted a patent for a papermaking machine to make "sheets of an extraordinary length without the help of any worker." Ironically, Robert and Didot then began wrangling between themselves, arguing about money and the patent, but since neither man could afford to

make a success of the enterprise alone, Didot called upon his brother-in-law John Gamble, an Englishman, who took drawings and samples of the machine-made paper to London in 1801, hoping to find investors. Gamble got lucky: he managed to persuade a famous, wealthy family of London stationers, the Fourdriniers, to back him, and together they were soon granted an English patent for an "Invention for Making Paper" ("in single sheets, without seam or joining, from one to twelve feet and upwards wide and from one to forty feet and upwards in length"). The industrial history of papermaking had begun.

Robert's machine was brought from France in 1802, and the Fourdriniers employed a young man called Bryan Donkin to modify and improve it. Like Robert a genius in the pay of the boss class, Donkin became a kind of consultant inventor who worked out of a factory set up for him by the Fourdriniers in Bermondsey, where he established the first British cannery, was responsible for developing split steel nibs for pens, designed and improved metalworking tools such as lathes and drills, and ended up advising Marc Isambard Brunel in his work on the Thames Tunnel. But the paper machine was his first big break. He set about making a series of improvements to Robert's prototype, removing the vat from below the wire and eventually replacing the hand-operated crankshaft with a mechanical drive. The first improved Fourdrinier machine was set up at Frogmore Mill in Hertfordshire in 1803, and remains the effective template for all modern paper machines: a moving belt made of wire mesh has stock poured onto it, water drains through the mesh, leaving a fibrous sheet, which is cut into sections and hung out to dry, as indeed were the Fourdriniers, who had poured money into the enterprise and found them-

selves bankrupt by 1810, having made a net loss on the machine of over £50,000 (approximately $81,240), though years later Parliament granted them some small compensation for "being reduced to comparative poverty in the evening of a long life spent in the execution of a great national object."

The great national object did not meet, however, with universal acclaim. As it was for the mighty Fourdriniers, so it was for the lowly workers, only more so: the machines stole not their capital but their livelihoods. More and better machines meant that fewer and less-skilled people needed to be employed. The machine became an enemy. During the Swing riots that spread throughout England in 1830 a number of paper mills were attacked—in Norfolk, Wiltshire, Worcestershire and Buckinghamshire. Most of those involved seem to have been members of the Original Society of Papermakers, who were furious and fearful for their futures. But, alas, the riots solved nothing. Several paper manufacturers went out of business, and those workers who were tried and found guilty were transported to Tasmania. The march of the machines continued.

Progress was relentless. The cylinder machine—using a revolving brass cylinder that was part submerged in the pulp vat—had been patented by another Englishman, John Dickinson, in 1809, and on November 29, 1814, *The Times* became the first newspaper printed on such a machine. In 1820 Thomas Bonsor Crompton was granted a patent for drying cylinders, which meant paper no longer had to be hung to dry. In 1824 John Dickinson was granted another patent—he was, with Bryan Donkin, one of the great paper pioneers—this time for a machine that pasted paper together to form a kind of cardboard. In 1825 the first "dandy roll" was developed, so called because on seeing

it in action workers at the mills apparently exclaimed, "What a dandy!" It was used to press watermarks into machine-made paper. A Fourdrinier machine—built by Donkin in England—was set up in America in 1827. In 1830 bleach was introduced into the process of turning rags into paper. In 1840 Friedrich Gottlob Keller, a weaver and reed binder in Saxony, patented a wood-grinding machine, making mass paper production possible. Christmas cards, photographs, adhesive postage stamps and paper bags all began to be produced during the 1840s and 1850s, and by 1900 there were machine-made cigarette papers, tracing papers, cups, plates, collars, cuffs, napkins, tissues and almost every other imaginable paper product. With the first commercial production of corrugated cardboard boxes around the

Watermarks: the equivalent of an artisan's trademark

turn of the century—making it possible for paper safely to send itself to itself by itself—the Age of Paper had reached its zenith.

It all began in China, of course, many years ago, and it continues in China still, where the political, economic and cultural significance of paper can't be overestimated: traditional prayers are still written on paper and burned; traditional paper kites are still flown; and traditional cut paper is still used to decorate shrines. More importantly, the Chinese paper industry is now booming and grinding in the same way it boomed in Europe and America in the nineteenth century, with a consolidation of production into large-scale mills and a move away from the use of recycled material toward the use of wood pulp (largely imported from Russia) to feed the country's burgeoning appetite for brand spanking new Western-style packaged consumer goods, mail-order catalogues, newspapers, magazines and paper money. It's possible, as some scholars have suggested, that paper was not originally a Chinese invention, and that the Khanzadas people, from Tizara in the Alwar district of Rajasthan in India, first made it from cellulose fibers sometime in the third century BC. Or maybe the Aztecs. Or the Mayans. It's also possible that the Chinese did not invent printing, gunpowder and the compass. But even if they didn't invent them, they may as well have: they did invent banknotes, and cannonballs, and manned flight with kites, and numerous astronomical instruments; whether or not they got there first with the four great inventions, they were certainly early adopters. In August 2006 at Dunhuang, in the Gansu province of northwestern China, an important town on the ancient Silk Road and the site of numerous archaeological discoveries over the past hundred years, flax paper was discovered that dates back to the Western Han Dynasty (202 BC–

AD 220), meaning that paper may have been in use at least two hundred years before the oft-cited date of AD 105, when T'sai Lun, the *Shang Fang Si*, the officer in charge of the Emperor's weapons and instruments, is said to have first reported its invention.

From Dunhuang it is possible to chart the vast westward drift of paper, like a slow-moving landslide. Plotted by significant sites of paper production, and going from right to left, the paper trail flows majestically over about a five-hundred-year period, first from China to Samarkand, and then to north Africa (Baghdad, Damascus, Cairo, Fes), before moving on to Europe between the tenth and twelfth centuries (Xativa, Fabriano, Troyes, Nuremberg, Krakow, Moscow). By the fifteenth century pulp tech had even washed up in England: John Tate established the first paper mill in Britain, in Hertfordshire, in 1495. Legend has it—a legend derived from an old Arabic manuscript, *Roots of Trades and Kingdoms*—that papermaking began its long journey to the west at a battle in AD 751 at the River Talas (Tharaz/ Taraz), about five hundred miles east of Samarkand, at which Arab armies, victorious over the Chinese, seized some papermakers as prisoners, who promised to reveal the secrets of papermaking in exchange for their freedom.

True or not, by the end of the eighth century the Sogdian Arabs had certainly taken to papermaking, and paper had taken to them: they had become, like us, paper people. The first paper factory opened in Baghdad in 793–94, and under the Abbasid caliphate, the great Islamic Golden Age, the city became a center of learning with its own unique paper market, consisting of shops and stalls, fueling and fulfilling the great demand for paper by the city's artists, philosophers and scientists. By the ninth century paper was being produced in

Damascus, in Hama, and in Tripoli, and by the end of the
tenth century the skills and knowledge of papermaking, car-
ried by Muslim scribes and texts, had spread through Tunisia,
Mauritania and Morocco, arriving in Spain around AD 950.
The production and manufacture of paper, if not its actual in-
vention, might therefore be said to be one of Islam's many gifts
to the West (the word "ream," as the great scholar of Islamic
papermaking, Jonathan Bloom, points out, derives from the
Arabic word for "bundle"). Though it was not a gift that was
always warmly received, even by the most foresighted and dis-
cerning: in 1221 the Holy Roman Emperor Frederick II, bald
and brilliant, known as the *stupor mundi*, the wonder of the
world, issued a decree declaring that all documents written on
paper were invalid; they would not last; they were ephemeral.
Some scholars have speculated that the *stupor mundi* may have
been under pressure from sheep and cattle breeders who were
fearful of losing the market for parchment. Or maybe Frederick
was just not so *stupor* after all. Either way, the decree came too
late: paper was the future. Parchment was yesterday's news.

So from China to the Arab world, and through the Byzantine
Empire into Christian Europe, paper made its slow procession—
and slow precisely because hand papermaking was a slow pro-
cess. It was also cold, hard work: for the vatman, who dipped the
mold into the vat, and lifted it out, allowing the water to drain;
for the coucher, who removed the wet sheet from the mold and
laid it on felt; and for the layman, who stacked and pressed the
sheets and hung them to dry, sheet after sheet after endless weary
sheet. And this is not to mention all the other equally back-
breaking and even less glamorous tasks: before the invention by
the Dutch of the so-called Hollander beater in the early eigh-

teenth century there was the shredding and beating of the rags for the pulp; and the dipping of the finished sheets in sizing; and the polishing of the pages by hand, or calendering them between rollers; the eternal smoothing out of ridges and wrinkles. Dard Hunter, who knew papermaking from the inside out, and the outside in—as both a scholar and a practitioner of the craft, and as the founder of his own paper mill, and a paper museum, and the author of one-man books, *The Etching of Figures* (1916) and *The Etching of Contemporary Life* (1917), for which he made the paper, and designed and cut and cast the typeface, and etched the pictures and wrote the words—believed that papermakers needed unusually robust constitutions because "the constant stooping posture, combined with the heat of the paper stock in the vat, caused them to grow old prematurely . . . at fifty many of these hard-working craftsmen appeared to have reached the allotted threescore years and ten."

And yet despite all these hardships, traditions of hand papermaking still survive. Gandhi famously demonstrated papermaking at the 1938 Haripura Congress, and ancient methods of Indian papermaking are still maintained in a town called Sanganer, near Jaipur, where all the paper is chemical-free, sun-dried, unbleached and naturally colored. In Nepal, handmade *lotka* paper is still made from the bark of daphne trees. And in Japan there will always be *washi*. "Why is *washi* so wholesome?" asks Soetsu Yanagi, cofounder of the Japan Folk Art Society. "When we try to figure it out, we cannot help but think it is because nature is paper's mother and tradition paper's father." And England? In England, the Exotic Paper Company of Chilcompton, Somerset, makes a paper using elephant dung from Woburn Safari Park.

Meanwhile, in the giant paper mills, the machines grind on, the wood chips stewing in their alkali solutions, and the top-secret pulp recipes crying out like addicts at a meth clinic for their chemical additives. A recent *Handbook of Toxicology and Ecotoxicology for the Pulp and Paper Industry* (2001) lists more than thirty common compounds that are used to make paper: acrylamide monomer; alkenyl succinic anhydride; alkyl ketene dimer wax dispersant; aluminum sulfate; aniline green dye; anionic polyurethane; azo dye anionic; azo dye cationic; bentonite; bronopol-type biocide; calcium polyacrylamide; cationic starch; chlorine; colloidal silica sol; defoamer; fluorescent whitening agents; hydrochloric acid; hydrogen peroxide; N-methylisothiazolinone-type biocide; polyaluminum hydroxide chloride; polyamide amine epichlorohydrin resin; polyamine; polyethylenimine; rosin size dispersant; sodium chlorate; sodium dithionite; sodium hydroxide; sodium silicate; stearic acid; and styrene/acrylate copolymer. These are the chemicals and dyes that give paper the strength and the whiteness we so admire and desire. They are applied in two ways: either blended with the stock, to fill and load the space between the wood-pulp cellulose fibers, laid down like fatty-tissue deposits or little Botox boosts; or sprayed and applied as coatings, like permatan, or varnish. When you pick up a book—when you hold a piece of paper—what you have in your hand is no natural product, no emanation of mind. It is the product of two thousand years of continual beating, dipping and drying. It is a testament to human industry and ingenuity—a miracle of inscrutable intricacy.

2

IN THE WOOD

"Wood" is an old name for forest. In the wood there are paths, mostly overgrown, that come to an abrupt stop where the wood is untrodden. They are called *Holzwege*. Each goes its separate way, though within the same forest. It often appears as if one is identical to another. But it only appears so. Woodcutters and forest keepers know these paths. They know what it means to be on a *Holzweg*.

MARTIN HEIDEGGER, *Off the Beaten Track* (1950)

Handmade fibrous paper incorporating leaves

L ike that of poor blind Oedipus, my fate was sealed long ago, but I have only now solved the riddle, have only now found the path. In the late 1970s and early 1980s even the most nonselective and nonacademic of secondary schools in England began offering a kind of rudimentary careers advice to pupils. At the end of the fifth year we were invited to meet with a teacher—let's call him Tiresias—who had been entrusted with running the newfangled punched-card careers guidance system. We had to answer various questions, and the cards on which our answers had been entered were fed into the school's computer—an Oracle?—which eventually delivered its verdict on a till-type printout. And so we children of Essex were taught to aim for careers as secretaries, receptionists, cabbies and mechanics. I was lucky. My destiny, apparently, was to work in forestry. Youth Training Schemes were available.

Thirty years later, and having barely set foot in a forest since, except for the occasional hike and adventure in Epping Forest, and in the fictional woods and groves of Greek myth and Arthurian romance, as well as in the Hundred Acre Wood, and *Where the Wild Things Are* and *The Gruffalo*, I realize that I am in fact up to my neck in the leafy depths, drowning in the loam. Not a forester, but certainly a child of the forest, a denizen of the dusky dells and ferny floors. Wood is my fuel: this morning alone I came home with two reams of copier paper, two Silvine

reporter's notebooks, some gummed envelopes, five HB pencils, a *Belfast Telegraph*, a *Daily Telegraph*, a *Guardian*, *The Times*, a *Daily Mail*, *The World of Interiors* and *Boxing Monthly*. And I'd only gone into the shop for some stamps. I consume more paper, pound for pound, than any other product, food included. I am a paper omnivore. I devour it: any kind, from anywhere. (Or almost anywhere: in London recently I wandered absent-mindedly into Smythson, the high-class stationers on Bond Street, one of those shops where the staff are even better-looking than the customers, who are anyway better-looking than anyone you've ever met, and where there are security guards on the door, and where a nice brown leather writing desk will set you back £1,500 (approximately $2,440), and where the notebooks can be gold-embossed with lettering of your choice, and where, realistically, I couldn't even afford a pack of cedar pencils.)

And of course, when I scribble and print on my piles and piles of virgin white paper with my Faber-Castell pencils and my decidedly non-state-of-the-art Hewlett Packard scanner-copier-printer, what I'm really doing is taking a big double-headed felling ax and laying it unto the root. *Now I am become Death, the destroyer of . . . woods*. If a ream of paper is roughly equivalent to 5 percent of a tree—though such figures are notoriously difficult to calculate and verify—then at approximately twenty reams' worth of notes, or eight thousand sheets, the book you are currently holding in your hands is the product of at least one *entire* tree, though that's not including all the paper books that were read and consumed in its production, nor the paper used for its own printing and publication: the gross product cost far exceeds the one tree, and is probably at least a small copse. The world's great forests are not in Can-

ada, Russia or the Amazon basin: they are in bookshops, book-
shelves and Amazon warehouses all over the world.

As soon as one begins to investigate and explore how and
why we have made trees into paper one finds oneself in deeply
troubling Oedipus territory—ignorant, blind, doomed as a de-
spoiler—or perhaps more like Dante at the beginning of the
Inferno, "*Nel mezzo del cammin di nostra vita/mi ritrovai per una
selva oscura/che la diritta via era smarrita*" ("In the middle of
the journey of our life/I found myself in a dark forest,/where
the straight way was lost"). The poet Ciaran Carson translates
Dante's famous "*selva oscura*" as "gloomy wood": in tracing the
history of modern paper manufacturing, the gloom at times
seems overwhelming and all-encompassing, like the sudden
approach of night, or like Malcolm's army advancing toward
Dunsinane at the end of *Macbeth*, creeping up unsuspected,
camouflaged by boughs cut from the Great Birnam wood (a
scene brilliantly, darkly depicted in Kurosawa's 1957 film ad-
aptation of the play, *Throne of Blood*: see YouTube). Light turns
first to shadow and then to inescapable dark.

During the eighteenth and nineteenth centuries, paper manu-
facturers began to search for new papermaking materials. There
were simply not enough rags to go around: in 1800, Britain im-
ported £200,000 (approximately $325,000) worth of foreign rags
for papermaking, and prices were rocketing. In the words of Dard
Hunter, author of the unsurpassable *Papermaking: The History and
Technique of an Ancient Craft* (1943), what was required was "a
vegetable fibre in compact form, easily gathered and handled and
furnishing the highest average yield per acre of growth." Wood
was the obvious answer, and a man named Matthias Koops—
mapmaker, bankrupt and inventor—came up with a quick solu-

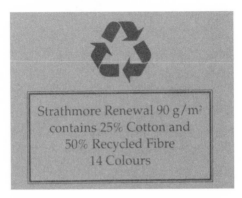

An example from G. F. Smith & Sons Ltd., paper and envelope makers, of the fiber content of their business envelopes

tion. In 1800 Koops published the magnificently titled *Historical Account of the Substances Which have been Used to Convey Ideas from the Earliest Date to the Invention of Paper*, in which he claimed that some of the pages of the book were of "Paper made from wood alone, the product of this country, without any intermixture of rags, waste paper, bark, straw or any other vegetable substance, from which paper might be, or has hitherto been manufactured; and of this the most ample testimony can be given."

Testimony was indeed forthcoming, for during 1800 and 1801 Koops was granted a number of patents for paper manufacturing, including one "for manufacturing paper from straw, hay, thistles, waste and refuse of hemp and flax, and different kinds of wood and bark." Attracting investors to his alternative paper-manufacturing project, Koops built a vast paper mill in London, at Westminster—the grim sight of which the William Blake scholar Keri Davies believes may have influenced Blake's apocalyptic vision of industrialization in his prophetic book, *The Four Zoas*—but within a year Koops's creditors had closed

in on him again, and by 1804 the mill had been sold off, and it was left to others to profit from paper made from wood. These others included Friedrich Gottlob Keller, the German weaver who was granted the patent for a wood-grinding machine in 1840, a machine that was then developed by Heinrich Voelter and imported to America by Albrecht Pagenstecher, founder of the first groundwood pulp mill in the United States. Chemical wood-pulping processes, which stew wood rather than grind it—using either alkali, in the soda process, or acid, in the sulfite process—were developed during the same period, and by the mid-nineteenth century the West's potential paper crisis had been averted: raw-material costs had fallen, production had increased, demand worldwide exploded. The Age of Paper had truly begun. Wood had saved paper.

And paper, in turn, has destroyed wood. Today, almost half of all industrially felled wood is pulped for paper, and according to green campaigners our uncontrollable appetite for the white stuff has become a threat to the entire blue planet. In medieval Britain special courts and inquisitions were held to hear the "pleas of the forest," with tenants and foresters being summoned for breaches of the forest laws, including damage to timber and the poaching of venison. In a contemporary reversal of these forest eyres, activists and campaigners now call upon multinational paper companies to account for their forest-management crimes.

One of the angriest and most eloquent among the modern-day forest pleaders is the writer and activist Mandy Haggith, who argues that "We need to unlearn our perception of a blank page as clean, safe and natural and see it for what it really is: chemically bleached tree-mash." According to Haggith

and many others—groups such as ForestEthics, the Dogwood Alliance and the Natural Resources Defense Council—modern papermaking has had devastating human and environmental consequences: in short and in summary, as well as causing soil erosion, flooding, and the widespread extinction of habitats and species, it has also caused poverty, social conflict, and is leading us on a long and inexorable paper trail to world apocalypse, via self-destruction. The few giant global companies that dominate the paper industry—International Paper, Georgia-Pacific, Weyerhaeuser, Kimberly-Clark—are accused of razing ancient forests, replacing them with monoculture plantations that are dependent upon chemical-based fertilizers, and polluting rivers and lakes with their industrial by-products.

The charge sheet is long and complicated, but even if the paper companies could acquit themselves entirely, and wood resources were inexhaustible, and all forests forever sustainably managed, paper manufacturing would still pose a threat to the world's future, because the mass industrial production processes use so many other finite resources, including water, minerals, metals and fuels. "Making a single sheet of A4 paper," according to Haggith, "not only causes as much greenhouse gas emissions as burning a lightbulb for an hour, it also uses a mugful of water." (Industry figures suggest that it takes about forty thousand liters of water to make a ton of paper, though much of that water is recycled.) With our delicious, decadent daily diet of newspapers, magazines, Post-it notes, toilet and kitchen rolls, we are guzzling down gallons of water and eating up electricity: we have grown fat and become obese on paper. In the UK, average annual paper consumption per person is around two hundred kg. (approximately 441 lbs.); in America it's closer to three

hundred kg. (approximately 661 lbs.); and in Finland—whose paper industry accounts for 15 percent of the world's total production—it's even more. Consumption in China is currently a mere fifty kg. (approximately 110 lbs.) per person, but gaining fast. World paper consumption is now approaching a million tons per day—and most of this, after its short useful life, ends up in landfill. One way or another, and indisputably according to Haggith, "We treat paper with utter contempt."

Which is odd, because we absolutely love trees. In fact, we worship them—not dendrologists, but *dendrolators*. In *The Golden Bough* (1890), that massive, mad compendium of myths and rituals, James Frazer has a whole chapter on the worship of trees, listing rituals for just about every human and nonhuman experience, from birth to marriage to death and rebirth, ad infinitum. *The Golden Bough* is of course itself named after the story from the *Aeneid*, in which Aeneas and the Sibyl are required to present a golden bough to Charon, in order to cross the river Styx and thus gain access, through Limbo and Tartarus, to the Elysian Fields, where Aeneas is reunited with his father, Anchises. Trees grant us access to underworlds and other worlds also in Norse mythology, with Yggdrasil, the World Tree, a giant ash that connects all the worlds, and from which Odin is sacrificed by being hanged, before being resurrected and granted the gift of divine sight. Stories of special, sacred and cosmic trees abound in religion, in history and in legend: Augustine is converted under a fig tree; Newton is inspired under an apple tree; the Buddha under the Bo tree; Wordsworth "under this dark sycamore," composing "Tintern Abbey"; and in the eighteenth century a large elm tree in Boston, the so-called Liberty Tree, became the symbol of resistance to British rule over the American colonies.

If the tree is a site of personal enlightenment and a symbol of emancipation, then woods and forests are places of enchantment that can and often do represent entire peoples, nations, and indeed the world as a whole. In Andrew Marvell's "Upon Appleton House, to my Lord Fairfax" (1651), for example, often read as an allegory on the English Civil War, the narrator takes "sanctuary in the wood," where "The arching boughs unite between/The columns of temple green"—the wood as a place of safety where one can take stock, rethink and reimagine. Similarly, in Italo Calvino's fabulous novel *The Baron in the Trees* (1957), set in Liguria in the eighteenth century, the young Baron Cosimo Piovasco di Rondò climbs up into a tree in order to escape his tormenting family and to gain perspective on the world: he likes it so much up there that he decides to stay.

A yearning for arboreal existence is no mere fairy tale—although it is also, often, a fairy tale (the tales of the Brothers Grimm, for example, feature a veritable forest of forests, so much so that they might be said to grow not from German folktales but direct from German soil). An extraordinary number of recent books celebrate trees and woodlands in near mystical fashion. Colin Tudge, in *The Secret Life of Trees: How They Live and Why They Matter* (2005), argues that "without trees our species would not have come into being at all." Richard Mabey, in *Beechcombings: The Narratives of Trees* (2007), sees trees as witnesses to human history, "dense with time." And Roger Deakin, in *Wildwood: A Journey Through Trees* (2007), provides a personal account of how trees teach us about ourselves and each other, the forest not as a mirror to nature, but the mirror of nature. "I went to the woods because I wished to live deliber-

ately," proclaimed Thoreau, long ago, in *Walden, Or, Life in the Woods* (1854), "to front only the essential facts of life, and see if I could not learn what it had to teach, and not, when I came to die, discover that I had not lived."

And here perhaps lies the source of our contemporary guilt and confusion about turning trees into paper; here is the heart of the sylvan darkness. It's not that we can't see the wood for the trees: we can't even see the trees. When we gaze into the forest mirror we see ourselves. The anthropologist Maurice Bloch, in an article, "Why Trees, Too, are Good to Think With: Towards an Anthropology of the Meaning of Life" (1998), argues that "the symbolic power of trees comes from the fact that they are good substitutes for humans." Are we human? Or are we dryad? In the growth and maturation of a tree we are reminded of the growth and maturation of a person. In tree parts, for better and for worse, we see body parts: branches, limbs; leaves, hair; bark, skin; trunk, torso; sap, blood. Lavinia, in Shakespeare's *Titus Andronicus*, has her hands, "her two branches," "lopp'd" and "hew'd"; in his poem "Tree at My Window," Robert Frost has Fate put man and tree together, "Your head so much concerned with outer/ Mine with inner, weather." Living trees clearly symbolize the regeneration and continuation of human life: the transformation of wood into paper is therefore a kind of self-annihilation, a diabolical transformation, the reverse of the transformation of the wine into the blood of Christ during Mass. Black Mass = white sheet. In one of the most extraordinary passages about tree worship in the whole of *The Golden Bough*, Frazer writes:

> How serious the worship was in former times may be gathered from the ferocious penalty appointed by the old German laws for such as dared to peel the bark of a standing tree.

The culprit's navel was to be cut out and nailed to a part of the tree which he had peeled and he was to be driven round and round the tree until all his guts were wound around its trunk. The intention of the punishment clearly was to replace the dead bark by a living substitute; it was a life for a life, the life of a man for the life of a tree.

Such narratives and fantasies of punishment and self-punishment characterize much contemporary Western nature writing, which often reads like an experiment in narcissism, in that true sense of Narcissus being unable to distinguish between himself and his reflection. The theoretical branch of nature writing is a form of literary criticism called ecopoetics (from the Greek *"oikos,"* home or dwelling place, and *"poiesis,"* making), which wrestles with difficult issues of selfhood and self-sufficiency. According to Jonathan Bate, one of the most brilliant proponents of ecopoetics, "our inner ecology cannot be sustained without the health of ecosystems." In his book *The Song of the Earth* (2000), a *tour de force*, or at least a *tour de chant*, Bate argues that "The dream of deep ecology will never be realized upon the earth, but our survival as a species may be dependent on our capacity to dream it in the work of our imagination." The means by which we might do this, according to Bate, borrowing his terms from the American poet Gary Snyder and the philosopher Paul Ricoeur, is to understand works of art as "imaginary states of nature, imaginary ideal ecosystems, and by reading them, by inhabiting them, we can start to imagine what it might be like to live differently upon the earth." In a riddling conclusion to his book, Bate writes that "If mortals dwell in that they save the earth and if poetry is the original admission of dwelling, then poetry is the place where we save the earth."

Book plate of Erich Saffert, Doctor of Agriculture and Forestry Surveying, Austria, early twentieth century

Bad news: poetry is probably not the place where we will save the earth. And there is probably little evidence either for Bate's contention that "mortals dwell in that they save the earth." Mortals dwell, rather—or certainly have dwelt—in that they use the earth, from the Romans and the Saxons clearing British woodland for developing iron-smelting works, to the development of *Forstwissenschaft* (forest science) in Germany, where algebra and geometry combined to produce a kind of mathematics of the forest, by which foresters could calculate volumes of wood and timber and therefore plan for felling and replanting. Ecopoetics yearns for oneness with the natural world, but all of our experience suggests that separation from nature—domination, despoliation—is the norm.

So how to continue in this difficult relationship? How to find our way through the gloom? How to dwell with forests

and with paper? Might we perhaps restrict ourselves solely to *rotefallen*, or *wyndfallen* wood, so-called *cablish* (from the Latin "*cableicium*," or "*cablicium*"), in order to provide ourselves with fuel and with fiber for our books? Should we all become little Thoreaus, building cabins from small white pines? Perhaps we should further investigate alternatives to wood pulp in paper production—alternatives that include sustainable crops such as hemp, straw, flax and kenaf? At the very least we should respect our paper—if nothing else, as a sign of respect for ourselves.

.

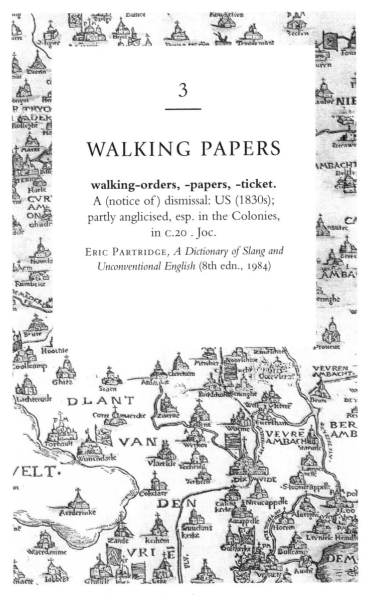

3

WALKING PAPERS

walking-orders, -papers, -ticket.
A (notice of) dismissal: US (1830s);
partly anglicised, esp. in the Colonies,
in c.20 . Joc.

ERIC PARTRIDGE, *A Dictionary of Slang and
Unconventional English* (8th edn., 1984)

Woodcut map printed on paper, sixteenth century

Redrawn from Capability Brown's plan for Burghley House

Maps are drawn by men and not turned out automatically by machines, wrote the geographer J. K. Wright in his classic essay "Map Makers are Human" in 1942. Times have changed: these days, maps are turned out automatically by machines, or at least by humans using machines known as Geographic Information Systems (GIS), the computer hardware and software that's used to capture, store and display geographical and topographical data and which, according to one standard introduction to GIS, "is changing the world and almost everything in it." Computer mapping systems were first developed by the Canadian government and then at Harvard University during the 1960s, and by now we're all accustomed to maps that we can simply download, pinch, zoom and click rather than scribble on, fold and leave to rot at the bottom of a rucksack: atlases at our fingertips, giant globes in our pockets. Logically, the paper map should already be consigned to the glove compartment of history. But it isn't.

This may be due to the fact that people simply like the look and feel of paper maps—with some people of course liking the look and feel of them much more than others. In 2006, a man called Edward Forbes Smiley III was jailed for stealing more than a hundred maps, worth $3 million, from collections at Yale, Harvard and the British Library. Smiley sliced the maps out of books using a razor blade, in much the same fashion as

another famous map thief, Gilbert Bland, an antiques dealer from Florida, apparently as unassuming as his name, who was in fact, according to his biographer, the "Al Capone of cartography"—though without the violence, bootlegging, bribery and late-stage neurosyphilis. Bland, like Smiley, was really just a petty thief with a taste for antique paper.

So why do people steal maps? For the same reason they steal money and books, of course: because they're paper marked with symbols that make them valuable. But perhaps more especially, people steal maps because a map is a symbol of conquest, so the theft of a map somehow represents the ultimate conquest: the possession of the means of possession, as it were. At least, that's my theory. No gangster mapper, I have to admit that the temptation to snaffle old paper maps has occasionally been all but overwhelming: the seventeenth-century, gold-enriched, hand-colored, multitinted maps issued by Willem Janszoon Blaeu and sons, for example, on display in the Dutch Maritime Museum in Amsterdam, are so extraordinary and so exquisite that only the most dimly pixel-fixated could fail to feel the stirrings of desire (Blaeu had to design and build his own printing presses in order to produce work of such quality). Or the maps produced by Christopher Saxton under the authority of Queen Elizabeth in the sixteenth century, the first ever maps of the English counties, beautiful, simple, restrained, lovingly handcrafted by engravers and artists imported from the map-pioneering Low Countries, and popularly reproduced on playing cards. Or John Seller's seventeenth-century sea charts: full-fathom masterpieces. Or the maps of the great Sanson family of France—no relation—whose work, in the words of one authority, was "always dignified and attractive, with an ornamental cartouche." If only.

Even my own modest collection of Half-Inch Bartholomew maps, with their tweedy Edinburgh elegance, have a kind of satisfying thickness to them, a fullness, like a wooden jigsaw puzzle, or an old Bakelite radio, a reminder that things were somehow heavier and thicker, more substantial, in the old days. The past always seems to weigh more—because often it did. My Bartholomew maps, some of them over a hundred years old and of printed paper mounted on linen, barely show their age except for a little fraying at the edges, and still sit sturdily in the hand on long hikes, like Arthur Wainwright's ubiquitous pipe, or a greaseproof wrap of sandwiches. It just seems natural to find one's way using a printed map—presumably because for centuries people have indeed navigated their way with paper, so we have become accustomed to them guiding us toward our destination: map reading another of our many ingrained paper habits. In an article in the *Journal of Environmental Psychology* in 2008, "Wayfinding with a GPS-Based Mobile Navigation System: A Comparison with Maps and Direct Experience," Dr. Toru Ishikawa, a cognitive-behavioral geographer at the University of Tokyo, found that pedestrians using GPS devices made more errors than those using paper maps (but that people using paper maps made more errors than those who were shown the route in person). Dr. Ishikawa has also studied how people view art in museums using both audiovisual aids and traditional guidebooks and floor plans: those using the new technology tend to forget what they've seen more quickly than those using the traditional guides. Good old paper, man's best friend, trotting along beside us like a faithful retriever.

It can even be relied upon in virtual realms. In the Super Mario series of video games, for example—which includes

the excellent *Paper Mario, Super Paper Mario, Paper Mario: The Thousand-Year Door*, and the spin-off Mario and Luigi series—part of the appeal and attraction is not only that Mario can fold up into a paper plane, and a paper boat, feats that are of course excellent and impressive in themselves, but also that he often navigates the bewildering virtual world with a trusty map in his white-gloved hand: an intrepid mustachioed explorer, Mario is also our guide. For homemade Mario-style mapping, an Italian self-styled "jedi architect and media master" called Iacopo Boccalari has created a simple method for turning dull on-screen Google Maps into paper-looking on-screen Google maps (see www.iacopoboccalari.com), while MapsOnPaper.com, run by a Swedish design agency, will transform a screen-friendly map into a printer-friendly format. Paper remains the ghost in the machine. Metaphorically.

Literally. Recently, the increased availability of open-source data and mapping tools has allowed people to make their own maps: in the now customary Web 2.0 fashion, map consumers have become map producers. This new kind of mapmaking is sometimes called neocartography, and in 2004 a man called Steve Coast became one of the first digital neocartographers when he created something called OpenStreetMap (OSM), the Wikipedia of maps. Using a cheap handheld GPS device, Coast set out to create a map that could be made freely available, without copyright restrictions, and that could be added to and edited by others. In the words of its mission statement, OpenStreetMap is "dedicated to encouraging the growth, development and distribution of free geospatial data and to providing geospatial data for anybody to use and share." What's amazing is that the using and sharing of geospatial data via OSM still re-

Map illustrating a historical event

quires paper in order to work effectively. Not everyone has the cutting-edge digital tools or cartographic instincts or training to be able to add meaningful details to digital maps, so various methods of contributing to OSM maps have quickly evolved, including the so-called Walking Papers method, which allows people to print OSM maps on paper, add details to them with a pen, and then scan them back onto the map using the OSM web-based software. It's easy: we're all neocartographers now. And, crucially, it isn't just a hobby for wannabe geographers.

Kibera is a massive slum in Nairobi, Kenya: estimates of its population range from 200,000 to more than a million. In 2008 the independent Map Kibera Project, organized by an

Italian academic, Stefano Marras, began mapping Kibera using the Walking Papers method, with the aim of producing reliable, up-to-date maps for use by the inhabitants of this ever-changing city. Local children are trained in basic GPS technology, in order to be able to capture the geographical data of an area using handheld devices, and organizers and volunteers then print out A1-size maps using this data so that others can then use tracing paper and sets of colored markers to add important details such as the location of markets, sewers, pathways and streams. This marked-up paper map is then photographed and copied to a computer, the original map is updated, and large numbers of the maps are printed for distribution: a dynamic digital-paper-digital-paper flow.

This collaborative, hybrid form of digital/paper mapping has also been used successfully in disaster zones: in 2010 in the Pakistan floods, after the Christchurch earthquake in 2011, and currently in Haiti. Arguably there has been no enterprise quite like it since the English Society for the Diffusion of Useful Knowledge (SDUK) produced its cheap maps for working people—sold for a shilling—in the early to mid-1800s, and even then there was of course no sense in which the readers of the SDUK maps were also the producers. The hierarchical model of geographical data collection and distribution may have changed, but paper still has a role to play in the digital era: machines may make maps, but machines still run on paper.

Between the first maps being drawn in the sand and the new Golden Age of Google and OSM neocartography there have been centuries of men and women making maps not only on paper but on just about any kind of material, including stone, wood, and in the famous case of Charlemagne, plates of solid

silver. Everyone knows that the first printed map in the Western world appeared in a 1472 edition of the dictionary of St. Isidore of Seville, and everyone knows it was the Flemish cartographer Gerardus Mercator who in the late sixteenth century began making maps using a projection based on latitude and longitude (the considerable advantage of which is that it makes navigation easier, the considerable disadvantage of which is that it makes Greenland look bigger than China, and Europe bigger than South America). But not everyone knows the story of Mercator's contemporary, Abraham Ortels, of Antwerp—printer, bookseller, print dealer and *"afsetter van carten,"* decorator of maps—who was one of the first great entrepreneurial mapmakers, and who pipped Mercator to the post by creating the first modern paper atlas.

The story goes that sometime in the mid-1500s a rich Antwerp merchant was complaining to a friend about the state of contemporary maps: the big ones were too large and unwieldy, the small ones could hardly be read at all. How big were the big ones? They were enormous. Martin Waldseemüller's *Universalis Cosmographiae Descriptio in Plano*, for example, published to accompany his *Cosmographiae Introductio* (1507)—which was, incidentally, the first map to bear the word "America"—was printed on multiple sheets that, pasted together, would make a map of about thirty-six square feet. These days, algorithms are used in the design and folding of large maps, and these methods have in turn been used to develop three-dimensional objects that can be folded from flat sheets, with both flat-pack furniture and production-line car parts evolving from the mathematical rules for folding paper. But in sixteenth-century Antwerp there was no flat-pack furniture and there were no handy

algorithms, so the merchant's friend mentioned his complaint to a gifted young map illuminator, Abraham Ortels—known as Ortelius—to see if he could assist. Ortelius made up a volume of about thirty maps for the merchant, sensible and uniform in size, and being young and ambitious, he realized that there was more in this than just a one-off commission: this was his big opportunity. He began collecting and editing more maps, and engraving plates of his own, and had them printed and bound, and after a mere ten years of hard work, on May 20, 1570, the first edition of the first modern atlas was published. Its title: *Theatrum Orbis Terrarum* (Theater of the World); seventy maps on fifty-three copper-plate printed sheets, thirty-five pages of text, price 6fl 10st. The *Theatrum* was really an amazing piece of art—Ortelius was friends with Peter Brueghel the Elder and was an early collector of the work of Dürer—but it was also profoundly practical. Portable, readable, reliable, affordable. A second edition was produced within three months, a Dutch edition in 1571, with other editions and supplements soon to follow: scholars have estimated total sales of around 7,750 copies of the full atlas in its first few years of publication. The first edition of Mercator's combined atlas—incorporating all his maps—wasn't published until 1602, and although it soon eclipsed the *Theatrum* in popularity, Ortelius had got there first: the *Theatrum* is organized entirely as a modern atlas might be organized, beginning with a map of the world and continuing with maps of the continents, and then of various countries.

What followed this sixteenth-century revolution in mapping and map technology, in the words of Lloyd A. Brown, in *The Story of Maps* (1950), was "the greatest real estate venture of all time." During the sixteenth, seventeenth, eighteenth, nineteenth

and twentieth centuries, paper maps allowed groups and individuals not only to navigate, but also, crucially, to make plans for navigations and adventures, both great and small. What's true for countries is true also for country estates. Lancelot "Capability" Brown, for example, was so called because he could see the capabilities in a landscape; he could read it like a document, or a map. Explaining his method of garden design, Hannah More famously recounted how Brown would point a finger and announce, "'I make a comma and there,' pointing to another spot, 'where a more decided turn is proper, I make a colon; at another part, where an interruption is desirable to break the view, a parenthesis; now a full stop, and then I begin another subject.'" Using maps and surveys, estates could be managed, trees planted, and grand visions and ideas put into practice.

Over the past five hundred years, paper has helped to create and define landscapes, peoples and nations. Maps have assisted and determined the colonial and military explorations of the Dutch and the French, the commercial activities of the British East India Company, and countless other enterprises. (And as with space, so time was also colonized using paper, in the form of timelines, timetables, astronomical charts, genealogies and succession lists—among the most famous and elaborate of which is the massive triumphal arch, the *Ehrenpforte*, designed on paper by Dürer for Maximilian I around 1516, which consists of forty-five giant folded plates.) At home as well as abroad, maps defined and legitimated places: rulers who could literally see and grasp their territories could define and defend them. The work of the Ordnance Survey, for example, begun in 1791, was a survey for the British Board of Ordnance, undertaken following the successful use of maps in the

Scottish Highlands after the crushing of the Jacobite rebellion at Culloden in 1746. But it's not all bad news. It's not all about subjugation. If a map is a visual statement and argument about the world and our place in it—announcing both "I am here" and "You are there"—it can be used for good as well as for ill.

In the nineteenth century, Charles Booth famously used maps to illustrate his campaigning work on behalf of the London poor, with his street maps with their seven-color system, from black, "inhabited principally by occasional labourers, loafers, and semi-criminals," to yellow, inhabited by wealthy families who kept "three or more servants." (My own family, I note, are from the black streets.) In the 1970s, Stuart McArthur's upside-down "Universal Corrective Map of the World," which shows Australia on top, became a form of national self-assertion, and the famous Peters projection, which shows all countries and continents with their relative sizes maintained, unlike Mercator's projection, became a challenge not just to cartographers but to the international community: now that you can see the size of Africa, what are you going to do about it? In J. H. Andrews's pithy summation, in *Maps in Those Days: Cartographic Methods Before 1850* (2009), "Maps express beliefs about the surface of the earth"—and, one would want to add, its inhabitants. When HMS *Beagle* set out from England on December 27, 1831, with a young naturalist named Charles Robert Darwin along for the ride, it was on a cartographic mission, its aim to chart South American coastlines: it returned five years later with the beginnings of a new map of human civilization.

The map historian R. A. Skelton summarizes the power and role of maps thus: "In the political field, maps served for the demarcation of frontiers; in the economic, for property assess-

ment and taxation, and (eventually) as an inventory of national resources; in administration, for communications in military affairs, for both strategic and military planning, offensive and defensive." Maps are an integral part of that vast substrata of paper that underpins and still underlies the modern world, a system, in the words of the radical geographer Denis Wood, that includes "codes, laws, ledgers, contracts, treaties, indices, covenants, deals, agreements." Modernity was created by, sustained by, and remains saturated in paper.

Smothered by it also. One of the traditional challenges of mapping is how to represent that which is basically a sphere on a flat surface, an example of the perennial and troubling problem of the relationship between any object and its representation. In 1931 the philosopher Alfred Korzybski delivered a paper, "A Non-Aristotelian System and Its Necessity for Rigor in Mathematics and Physics," at a meeting of the American Association for the Advancement of Science, in which he remarked that "a map is not the territory." But what if it were? What if a map were so accurate that it was the territory? What if the representation were perfect? In a short story by Jorge Luis Borges, "On Exactitude in Science" (1946), a cartography-obsessed empire produces a 1:1 map, but then, over time, "Less attentive to the Study of Cartography, succeeding Generations came to judge a map of such Magnitude cumbersome." The giant map is left to rot, though fragments of it are to be found sheltering "an occasional Beast or beggar." We are Borges's beasts and beggars still, for all the advances in digital technology, still wrapping ourselves in paper and its representations, still struggling to distinguish between maps and the territory, still hoping against hope that our paper guide has strong folding properties, is water

repellent, abrasion resistant, and will sit sturdily in the hand on a long journey. Or perhaps that's only me.

The Iron Curtain

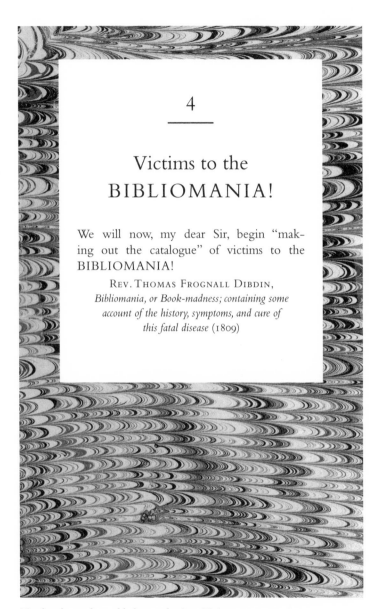

4

Victims to the
BIBLIOMANIA!

We will now, my dear Sir, begin "making out the catalogue" of victims to the BIBLIOMANIA!

REV. THOMAS FROGNALL DIBDIN,
Bibliomania, or Book-madness; containing some account of the history, symptoms, and cure of this fatal disease (1809)

Handmade comb-marbled paper by Ann Muir

gentes : incipientibus ab iherosolima.
Uos aut testes estis horu. Et ego mit=
tam pmissum patris mei i uos : uos
aut sedete in ciuitate quoadusq; indu=
amini uirtute ex alto. Eduxit aut eos
foras in bethaniam : z eleuatis mani=
bus suis benedixit eis. Et sactu est du
benediceret illis recessit ab eis : z fereba=
tur in celum. Et ipsi adorantes regres=
si sunt in iherusalem cum gaudio ma=
gno : et erant semper in templo lau=
dantes et benedicentes deum amen.
Expliciunt euangeliu sccdm lucam Incip
plogus i euangeliu sccdm iohanne.

Hic est iohannes euange=
lista un⁹ ex discipulis dni :
qui uirgo a deo electus e :
que de nuptijs uolentem
nubere uocauit deus. Cui uirginitatis
in hoc duplex testimoniu datur in eu=
angelio : cp et pre ceteris dilectus a deo
dicit : et huic matrem sua de cruce com=
mendauit dns : ut uirgine uirgo serua=
ret. Deniq; manifestans in euangelio
cp erat ipse incorruptibilis uerbi opus
inchoans solus uerbu carne factum
esse nec lumen a tenebris copreheensu
fuisse testatur : primu signu ponens qd
in nuptijs fecit dns ostendens cp ipse
erat : ut legentibz demonstraret cp ubi
dns inuitatus sit deficere nuptiaz ui=
num debeat : et ueteribus immutatis
noua omnia quae a cristo instituunt
appareat. Hoc aut euangeliu scripsit in
asia postea cp i pathmos insula apo=
calipsim scripserat : ut cui i principio ca=
nonis scorruptibile principiu pnotat
in genesi : ei etia incorruptibilis finis
p uirgine i apocalipsi redderet dicere
cristo ego sum alpha et o. Et hic e io=
hannes : qui sciens superuenisse diem re=
cessus sui. Conuocatis discipulis suis

in ephesopermulta signoz experimen=
ta pueniens cristu descendens i defossu
sepulcre sue locu facta oratione posi=
tus est ad patres suos : tam extrane⁹
a dolore mortis cp a corruptione car=
nis inuenitur alienus. Tamen post o=
mnes euangeliu scripsit : z hoc uirgini
debebat. Quoz tame uel scripto2 tepo=
ris dispositio uel libro2 ordinatio ideo
a nobis per singula non exponitur :
ut sciendi desiderio collato et queren=
tibus fructus laboris : z deo magiste=
rij doctrina seruetur. Explicit plog⁹
Incipit euangeliu sccdm iohanne.

In principio erat uerbu : z uerbu erat
apud deu : et de⁹ erat uerbu. Hoc erat
in principio apud deu. Omnia p ipm
facta sunt : z sine ipo factum est nichil.
Quod factu est in ipo uita erat : z uita
erat lux hominu : et lux in tenebris lu=
cet : z tenebre eam no comphenderut. Fu=
it homo missus a deo : cui nome erat io=
hanes. Hic uenit i testimoniu ut testi=
moniu phiberet de lumine : ut omnes
crederent p illu. No erat ille lux : sed ut
testimoniu phiberet de lumine. Erat
lux uera : que illuminat omne homi=
nem uenientem in hunc mundu. In mu=
do erat : z mudus p ipm factus est : et
mudus eu non cognouit. In ppria ue=
nit : z sui eu no receperut. Quotq; aut
receperut eu : dedit eis potestatem filios
dei fieri : hijs qui credut in nomine ei⁹.
Qui no ex sanguinibus neq; ex uolun=
tate carnis neq; ex uolutate uiri : sed
ex deo nati sunt. Et uerbu caro factum
est : et habitauit in nobis. Et uidimus
gloria ei⁹ gloriam quasi unigeniti a
patre plenu gratie z ueritatis. Iohan=
nes testimonium phibet de ipo : z cla=
mat dicens. Hic erat que dixi : q post
me uenturus est ante me factus est :

A page from Gutenberg's forty-two-line Bible

At the beginning of his famous novel *The Naked Lunch* (1959), William Burroughs includes what he calls a "deposition: a testimony concerning a sickness" (my copy of the book, a nice tight hardback, with original dust jacket, published by John Calder, was bought secondhand from an old junk shop in Chelmsford that I used to visit with school friends on weekends in search of cheap paperback Beats, and Jean-Paul Sartre, and Albert Camus, and the Picador Richard Brautigan, and Borges, and Philip K. Dick). Burroughs is writing about his fifteen-year addiction to "junk"—opium and all of its derivatives, including morphine, heroin, Eukodol, Pantopon, Demerol, Palfium and a whole load of other stuff that he had variously smoked, eaten, sniffed, injected and inserted. "Junk," Burroughs writes, "is the ideal product . . . the ultimate merchandise. No sales talk necessary. The client will crawl through a sewer and beg to buy . . . The junk merchant does not sell his product to the consumer, he sells the consumer to his product . . . The addict . . . needs more and more junk to maintain a human form . . . [to] buy off the Monkey."

The chances are, if you are reading this book, you are no better or worse than William S. Burroughs. The chances are, you have a serious problem: you're an addict. You have been sold to a product. You have a monkey on your back. And that monkey is made of paper.

(But it's OK. You are not alone. Here's where I'm at: I am wearing a pair of dirty, brown, broken slip-on boots that my sister bought for me about ten years ago; in both boots the sole is split right across the middle, and I have attempted to fix them with Super Glue. I have two other pairs of shoes, but they too are broken, too broken in fact for me to be able to patch up, and they have therefore required professional attention and are currently awaiting collection from the excellent boot and shoe repair shop—motto, "Shoes Good Enough to Wear Are Good Enough to Mend"—just off Botanic Avenue in Belfast. I am wearing one of the shirts that the father of a friend of mine kindly sent me a few years ago, when he'd retired and was throwing out all his old work clothes and buying leisurewear. All of the shirts are made of a drip-dry nylon—Alagon—of a kind now unavailable for reasons not at all clear to me; you get used to the rashes after a while, and the benefit of not having to iron the shirts surely outweighs any slight skin complaint the material may cause. My trousers are one of the two wearable pairs that I'm currently running, and they're in pretty good condition, although they are covered in green paint from a couple of summers ago when I was painting the shed where I work in the garden. My jacket is circa 1990. And I am standing in the War on Want bookshop, down at the other end of Botanic Avenue, ostensibly on my way home from work, and I have half a dozen books in my arms, and I know that if I blow all of my spending money on these books I won't be able to get my shoes back from the cobbler, and I'll have to leave them there another week. They've already been in for a month, and the proprietor of the shop has started leaving messages for me on my answering machine. I have a decision to make. I buy the books. For the foreseeable future I shall continue

to be dressing like a vaudeville comedian, or a character in a play by Samuel Beckett.)

The first documented use of the word "bibliomania," according to my *OED*—the twenty-volume second edition, bought as a present to myself when I received the advance on my first novel, and which cost me the advance on my first novel, which meant effectively that I wrote a book to buy a book—was in 1734, in the *Diary of Thomas Hearne*, bibliognost, antiquarian and assistant keeper of books at the Bodleian. "I should have been tempted," writes Hearne, "to have laid out a pretty deal of money without thinking my self at all touched with Bibliomania." Then in 1750 Lord Chesterfield writes, warning his son, "Beware of the Bibliomanie." But the word doesn't appear to come into popular usage until 1809, when the Reverend Thomas Frognall Dibdin publishes his book *Bibliomania, or Book-madness; containing some account of the history, symptoms, and cure of this fatal disease*. The disease, in Dibdin's wild, medico-rhapsodico account, manifests itself in a desire for first editions, uncut copies, illustrated copies, and a "general desire for Black Letter." Book madness, in Dibdin's diagnosis, is a paper-borne disease.

Yes, of course there were books before paper. As every schoolboy knows, for the first few thousand years or so of its existence, a "book" might have been a clay tablet or a roll of papyrus, and it wasn't until the coming together of three key components—ink, type and paper—in the giant technological leap forward that was the invention of the movable type printing press by Johannes Gutenberg in about 1450, that the book as we know it took off and took over. Nicole Howard describes the role of paper in the Gutenberg printing process in *The Book: The Life Story of a Technology* (2005):

When ready for a new job, the printer would order the requisite amount of paper from a warehouse. It would arrive in stacks, or tokens, of 250 sheets. The night before printing began, the approximate number of sheets needed for the job were wet down and then stacked upon each other. The weight of the stack squeezed out much of the water, resulting in slightly damp sheets the next day. The moistness allowed the fibers of the paper to receive the ink in a way they would not, were they completely dry.

Taken individually from the stacks, the sheets were placed in the tympan. The frisket was then swung into place to cover the paper's margins, and then the whole unit slid beneath the platen. With a pressman's turn of the screw, the type—which had been inked with special leather pads—transferred the image to the paper. With the impression complete, the paper was removed from the press and hung to dry in the rafters of the shop.

And—hey presto!—welcome to the modern world. Books produced by this sort of method have been accorded responsibility by historians for everything from the scientific revolution to the Protestant Reformation, to the collapse of the *ancien régime* in France, to the rise of capitalism and the fall of communism, and just about anything and everything in between. Books, as we know, transmit ideas, foment and ferment strong feelings, prop up and bring down governments, offer escape and enlightenment, and encourage variously greed, hate, love, self-love and self-help: basically, books make history, and are made by history. And books, lest we forget, are made from paper.

In fact, from Gutenberg on, we have come to identify books so closely with paper that it's nigh on impossible for us to divorce our idea of the book from its long-standing relationship

with paper: they're a couple; it's the perfect marriage. Even now, after a brief, fun flirtation with the dynamics of hyper-textuality back in the late 1980s and 1990s, e-books and their associated reading devices have come increasingly to resemble paper books in almost every regard: in their shape, size, feel and functionality. Prophets and opponents of the new technologies continually insist that e-books are amazingly, shockingly, mind-alteringly, paradigmatically different from p-books, when in fact the truth is that they are drearily similar. All we need is an e-book reader that actually *smells* like paper—the I Can't Believe It's Not Paper Reader™—and the impersonation of old books by new books will be complete. Paper books, a mere mechanism for conveying information, have become so closely identified with the information they convey that we have difficulty in believing that anything else really *is* a book. A young novelist recently told me that she was dissatisfied with the e-book deal her agent had secured for her because "It isn't the same as a real book deal" (not the same, that is, except for the pitiful advance, the risible royalties, the virtually non-existent marketing and distribution and the handsome 15 per-cent paid to the agent; no wonder so many aspiring authors are flocking to Kindle direct publishing).

Since paper books seem so clearly to embody knowledge it's hardly surprising that we have come to believe that the possess-ing of books is in itself sufficient to possess knowledge. In one of his great little intellectual *jeux d'esprit* Flann O'Brien imagines the range of services that might be provided by a professional book handler: "De Luxe Handling—Each volume to be mauled savagely, the spines of the smaller volumes to be damaged in a manner that will give the impression that they have been carried

around in pockets, a passage in every volume to be underlined in red pencil with an exclamation point or interrogation mark inserted in the margin opposite, an old Gate Theatre programme to be inserted in each volume as a forgotten bookmark." This is funny because it's true. Nowhere is the disease of vanity more evident than in books and our possession of books. Nowhere is the paper disease more virulent. Nowhere has paper asserted its power and prestige more clearly and aggressively than in books. Like ancient people we have come to believe in the magic power of a talismanic object: books are our little household gods. The literary historian James Carey, going against the critical grain, has suggested that "the book was the culminating event in medieval culture," and "an agent of the continuity of medieval culture rather than its rupture." If so, we are living in the Middle Ages still.

Of course, I may be exaggerating. Writers, after all, are perhaps more in thrall to paper than others; like Bob Hope and Bing Crosby, we are endlessly and hopelessly Morocco-bound. From a young age, writers become connoisseurs of the many fine and distinguishing features of books, from all those inviting covers to all those suggestively folded corners; so much so that many of us come to identify strongly and physically with books, perhaps more so than with humans:

> My bones are made of leather and cardboard, my parchment-skinned flesh smells of glue and mushrooms . . . Hands take me down, open me, spread me flat on the table, smooth me, and sometimes make me creak . . . No one can forget or ignore me: I am a great fetish, tractable and terrible.
>
> JEAN-PAUL SARTRE, *The Words* (1963),
> trans. Bernard Frechtman, 1964

Sartre of course had a significant head start in that he already looked like an actual fetish, but many if not most other writers have willingly assumed roles as high priests and totems in the great cult of the codex.

Take, for example, William Morris. The fifty-three books produced by Morris in his "little typographical adventure," the Kelmscott Press, were all printed on exactly the same paper, produced by the family firm of Batchelor and Sons, of Little Chart, near Ashford in Kent. On his first trip to meet Mr. Batchelor and his sons, on October 22, 1890, Morris took with him a fifteenth-century Italian book (*Speechio di coscienja* by Antonius Florentinus) to show them the kind of paper he was looking for: in paper, as in all things, Morris knew exactly what he wanted. "It was a matter of course that I should consider it necessary that the paper should be hand-made, both for the sake of durability and appearance. It would be a very false economy to stint in the quality of the paper as to price: so I had only to think about the kind of hand-made paper" ("A Note on the Founding of the Kelmscott Press"). False economies were Morris's bugbear: "It is a waste of time," he announced in a lecture to a group of working men in London in 1884, "to try to express in words due contempt of the productions of the much-praised cheapness of our epoch. It must be enough to say that this cheapness is necessary to the system of exploiting on which modern manufacture rests." Scholars have estimated that the paper produced by Mr. Batchelor and his sons cost Morris five or six times as much as machine-made paper of similar quality, a cost that when passed down to his own customers rather precluded the poor working men from actually buying Morris's books. But that wasn't the point. The books weren't merely printed on paper: they were *made* of paper.

As books have become precious objects and storehouses of knowledge, with an associated monetary and moral value, so too have we become increasingly obliged to protect, store and preserve them. In his brilliantly unlikely book *The Book on the Bookshelf* (1999), Henry Petroski, a professor of civil engineering who specializes in brilliantly unlikely books, chronicles the long history of the storage of books—from horizontal stacking to vertical, from the chained book to the unchained, from spines shelved inward to spines shelved outward—and demonstrates exactly how inventive and versatile humans have been in devising storage systems for what are, essentially, huge piles of paper. And no human more inventive and versatile than William Ewart Gladstone.

Four times British prime minister, and a man who might very properly be described as a bibliomaniac—he was said to have arrived once at a bookstore and bought the entire stock— Gladstone wrote an article in 1890, "On Books and the Housing of Them," in which he claimed to have solved the book collector's perennial problem. Gladstone set about the book question with the same gusto and enthusiasm with which he dealt with the Irish Question and the rescue of fallen women. "Let us suppose," he writes, "a room 28 feet by 10, and a little over 9 feet high. Divide this longitudinally for a passage 4 feet wide. Let the passage project 12 to 18 inches at each end beyond the line of the wall. Let the passage ends be entirely given to either window or glass door. Twenty-four pairs of trams run across the room. On them are placed 56 bookcases, divided by the passage, reaching to the ceiling, each 3 feet broad, 12 inches deep, and separated from its neighbours by an interval of 2 inches, and set on small wheels, pulleys, or rollers, to

work along the trams." According to Gladstone, the adoption of this system in a room of the dimensions outlined—about the size of a large front sitting room—would enable the amateur book collector to accommodate about twenty-five thousand volumes. Unfortunately, there would be no room for your sofa, your coffee table, your lamps, your wide-screen TV, your knickknacks, or indeed for you. (For everyday practical purposes, Petroski usefully notes in *The Book on the Bookshelf*, the home shelf builder need only remember to keep shelves either short or deep, in order to prevent what engineers call "deflection" and what us laypeople know more familiarly as sag.)

The next step up from personal book-storage solutions is the institutional book-storage solutions—those great museums and mausoleums of folded documents, rolls or codices that we have come to know as libraries. Wealthy rulers, noblemen, churches, governments and various other institutions and organizations—from the Assyrians and the Pharaohs to the early Church fathers, Muslim scholars and billionaire philanthropists—have been engaged for millennia in building these veritable palaces in which to store books. (The gods arguably got in on the act even earlier: Brahma's library was the Vedas; Odin had his jars of knowledge; and according to Jewish tradition, God keeps a Book of Life, a kind of library in one volume, which he opens on Rosh Hashanah and records the names of those who are destined for heaven.) Once having stored these precious documents, these same individuals and institutions have developed complex taxonomies in order to classify and study them, and technologies to protect them, so that this ever-growing physical record of collective memory can be saved for the next generation.

This extraordinary, never-ending process of producing,

collecting and curating printed paper has become, one might argue, almost a form of madness, or a mania, like *die Lesewut*, the reading craze that swept through Germany in the eighteenth century. It has certainly often been undertaken in a spirit of religious and moral fervor. The Carnegie libraries, with which many of us will have been familiar from our earliest youth, funded by the philanthropic American steel magnate Andrew Carnegie, were designed as temples of knowledge, with their noble, basilicalike designs and holy trinity of adult library, reading room and children's library, attended by priestly librarians with privileged access to codes and catalogues. Massive changes may have occurred in libraries in recent years, with new digital resources and services supplementing the old traditional resources and services, the dog-eared card catalogues ripped up and destroyed, workstations suddenly everywhere, but one essential aspect of "libraryness" has not changed: libraries remain places dedicated to storage. Books continue to be published in greater and greater numbers—so great in fact that there are no accurate figures as to exactly how many are published: some say one every thirty seconds, others four thousand per day, others a million per year—and somehow, whether through the off-site storage of the physical books themselves, or microfilm copying, or digital scanning, we remain obliged to keep up with or afloat in this vast deluge of paper. Even the new, high-tech rebranded libraries opened to great fanfare in the London Borough of Tower Hamlets in the 1990s could not get away from this essential fact of paper hoarding: they were called "Ideas Stores."

But there is of course another obvious solution to the book-storage problem. The problem of proliferating paper. The problem of where and how to store ideas. We could just

get rid of it all. Sweep it away. Books are easy to destroy—and writers, interestingly, are among the keenest of the destroyers. (Writers who have burned or destroyed, or instructed others to destroy, their works include Gerard Manley Hopkins, Kafka, Freud and Elias Canetti's fictional hero Peter Kien, in his 1935 novel *Auto da Fé*.) The habit or custom of book burning goes back to pagan antiquity—the legend goes that Protagoras's work was publicly burned sometime in the fifth century BC—but undoubtedly the world's most famous book burning took place within living memory, on May 10, 1933, a warm-up by the architects of the Final Solution.

The Nazi book burnings were organized not by the Nazi hierarchy, but by ordinary German student bodies, assisted, as it happens, by librarians—not that they had much choice. Lists of books suitable for burning had been published in newspapers in the preceding weeks. Announcements of collection points had been advertised. Goebbels had agreed to give a speech in Berlin. And then, on the fateful night, the bonfires were lit, from Frankfurt to Munich, to Bonn, to Cologne, to Dresden, Hamburg, Hanover and Heidelberg. Songs were sung, speeches were made, and the heavens opened (like a church fête, the ceremony in Freiburg was canceled due to inclement weather). Books burned included works by Freud, Kafka, Marx, Heine, Lenin, Thomas Mann and Stefan Zweig—a list so impressive, in fact, that you wouldn't have wanted your books not to be among those burned. Bertolt Brecht—in exile—wrote a poem, "Die Bücherverbrennung," in which he expressed his wish for his work to join the inferno: "*Verbrennt mich!*," Burn me!

And this, of course, is the problem. Books are so closely associated with their authors—paper so close to skin—that it's

only a short step from burning books to burning people. In Heinrich Heine's play *Almansor* (1820–22), set in Spain in the 1500s, one of the characters expresses disgust at the public burning of the Koran: *"Das war ein Vorspiel nur, dort, wo man Bücher Verbrennt, verbrennt man auch am Ende Menschen"* ("That was only a prelude. Where they burn books, they will, in the end, burn human beings too"). Heine was correct, both before and after. Confucius's *Analects* was burned *c.* 200 BC, and hundreds of his disciples buried alive. Martin Luther was burned in effigy, along with his books. And Salman Rushdie had a lucky escape. In Ray Bradbury's dystopian novel *Fahrenheit 451* (1953) it's the job of the firefighter Guy Montag to burn books, in the hope that if books are put to death, the ideas they contain will also be put to death. (In *The Tempest*, when Caliban is plotting the overthrow of Prospero he counsels his coconspirators, "Remember/First to possess his books; for without them/ He's but a sot, as I am, nor hath not/One spirit to command: they all do hate him/As rootedly as I. Burn but his books.") Of course, it has the opposite effect: the burning of books fans the flames of ideas. Ironically, it is only by the burning of books that we are reminded that books themselves are unimportant.

Books aren't worth the paper they're printed on. They're worth more.

5

ORNAMENTING THE FAÇADE OF HELL

A descriptive analysis of bank notes is needed. The unlimited satirical force of such a book would be equalled only by its objectivity. For nowhere more naively than in these documents does capitalism display itself in solemn earnest. The innocent cupids frolicking about numbers, the goddesses holding tablets of the law, the stalwart heroes sheathing their swords before monetary units, are a world of their own: ornamenting the façade of hell.

WALTER BENJAMIN, "One-Way Street" (1928)

Adhesive postage stamp perforation

The machine was operated by two women—one to load, one to unload. Powered by a small motor, it consisted of a tank about three feet wide, four feet deep, nine feet long, and was divided into two compartments. The first compartment was filled with laundry soap and bleach, the second with water for rinsing. Both were fitted with brass rollers, and between the rollers ran a mechanized belt, which then passed over a gas-heated iron roller. Designed and constructed during 1911, this ingenious piece of equipment was first installed in the Office of the Treasurer of the United States in 1912. It was—literally—a money-laundering machine.

The trouble with money, apart from the obvious fact that it's often literally as well as metaphorically dirty, "filthy lucre," is that demand always tends to outstrip supply, which means that if you can't produce and distribute enough of it, and quickly enough, sometimes you just have to give it a rinse and make do. Money can take many forms: shells, tobacco, nails, gold and silver coins, wampum. The trouble with all these forms of commodity money is that they are relatively scarce, and if you're a government, say, and you want to pay for a war, or an economic boom, you can't just magic up wampum from nowhere: you have to go and collect your shells from the beach and string them into beads, before exchanging them for rifles, or economic boom boxes (the little-known Cardboard Box Index is used by

investors to gauge levels of production and consumption of consumer goods). But you can print more paper, quickly and inexpensively, or at least give it a quick wash and go. Paper can be created by fiat. And so, in summary and in very, very short—see Joseph Schumpeter's gold-standard *History of Economic Analysis* (1954), J. K. Galbraith's silvery *Money: Whence It Came, Where It Went* (1975) and Niall Ferguson's cash-registering *The Ascent of Money* (2008) for every red cent and penny-pinching detail— modern economies and modern economics are basically built on paper. Postmodern economies are also built on paper, or at least on electronic money, which is basically paper money without the paper. In the words of Ben Bernanke, the Princeton economics professor who went on to become chairman of the United States Federal Reserve under both George W. Bush

Nineteenth-century shares and certificates

and Barack Obama, "The U.S. government has a technology, called a printing press (or, today, its electronic equivalent), that allows it to produce as many U.S. dollars as it wishes at essentially no cost . . . We conclude that under a paper-money system, a determined government can always generate higher spending and hence positive inflation." So, it's all good. Until the printing press breaks down, that is, or goes into overdrive. Cheap to produce, easy to store, carry and exchange, replaceable, reproducible, and easy to fold into origami animals: paper money, as it turns out, is its own worst enemy.

The Chinese were the first to use paper currency, as long ago as the ninth century, during the reign of Emperor Hien Tsung, when, as usual, necessity became the mother of invention. There was a copper shortage. Chinese coins were made of copper. And so, lo, came there paper currency. The Chinese eventually abandoned paper money in the fifteenth century, however, having discovered that the more of it you print, the less it tends to be worth, but by then the damage had been done. Word had got out about the extraordinary power of paper money: the cash was out of the bag. Marco Polo, in his famous thirteenth-century book of travels, described the process of turning paper into money under the reign of Kublai Khan:

> When ready for use, he has it cut into pieces of money of different sizes, nearly square, but somewhat longer than they are wide. Of these, the smallest pass for a half tournois . . . the next size for a Venetian silver groat; others for two, five, and ten groats; others for one, two, three, and as far as ten bezants of gold. The coinage of this paper money is authenticated with as much form and ceremony as if it were actually of pure gold or silver; for to each note a number of officers, specially ap-

pointed, not only subscribe their names, but affix their seals also. When this has been regularly done by the whole of them, the principal officer, appointed by his Majesty, having dipped into vermillion the royal seal committed to his custody, stamps with it the piece of paper, so that the form of the seal tinged with vermillion remains impressed upon it. In this way it receives full authenticity as current money . . .

Our ceremonial complications are obviously now more advanced and highly mechanized—with watermarks and metal threads, and reflective foils and coatings—but in essence, Kublai Khan's paper money is exactly the same as our own. Coleridge's famous poem "Kubla Khan," which was inspired by a book quoting Marco Polo, ends with a warning:

And all should cry, Beware! Beware!
His flashing eyes, his floating hair!
Weave a circle round him thrice,
And close your eyes with holy dread,
For he on honey-dew hath fed
And drunk the milk of Paradise.

That bankers might read more poems.

The earliest European paper money was produced in Sweden in the seventeenth century, but it was a Scotsman, John Law, a gambler, murderer and mathematical genius, whose ideas and experiments with paper money influenced, for better and for worse, the future of Western finance. "I have discovered the secret of the philosopher's stone," Law claimed: "it is to make gold out of paper." (Making gold out of paper is traditionally what writers do, of course, or try to do—the old Johnsonian "No man but a blockhead ever wrote, except for money"—and nothing wrong with that. The problem usually arises when

writers try to make paper out of gold. The history of literature is full of examples of writers styling themselves as gurus, but some alas also set themselves up as financial advisers, perhaps most famously the poet and anti-Semite Ezra Pound. According to one biographer, Pound only "maintained an interest in such figures as Homer, Dante and Shakespeare . . . by convincing himself that they were really poet-economists." Pound was particularly interested in what are called "scrip" currencies, the term used to describe any form of nonlegal tender used as money, such as, say, meal vouchers, or babysitting co-op coupons, and although most of his ideas about economics, and most other things, are entirely discredited, scrip remains rather intriguing; it has certainly intrigued Nobel Prize–winning economist Paul Krugman, who often uses scrip as an example to illustrate his ideas about economic depressions and government intervention. Literary history itself, one might add, is really just a vast system of scrip, of IOUs, gift certificates and locally valid currencies. Anyway.)

In his *Money and Trade Consider'd with a Proposal for Supplying the Nation with Money* (1705), Law argued that nations should establish central banks with the power to issue and supply paper money, which is "more qualified for the use of money, than silver," being, among other things, "easier of delivery" and "easier kept," so that, in his words, "the People may be employed, the Country improved, Manufacture advanced, Trade Domestic and Foreign be carried on, and Wealth and Power attained." Law was eventually able to put his theories into practice in France, where, after years of hard work and hustling, he was appointed Controller General of Finances (preceding by some years the paper-cutting Étienne de Silhouette). Law established first the

private Banque Générale in 1716, and then when the Banque Générale became the Banque Royale in 1718—in effect, the first French central bank—he pursued an aggressive policy of monetary expansion, printing banknotes and share certificates as if there were no tomorrow. There's always a tomorrow. The Banque Royale rapidly boomed and then inevitably collapsed in 1720. According to the historian Niall Ferguson, "John Law was not only responsible for the first true boom and bust in asset prices. He also may be said to have caused, indirectly, the French Revolution by comprehensively blowing the best chance the *ancien régime* monarchy had to reform its finances."

The consequences of the paper money revolution, and the revolutions it caused, remain with us today, so much so that all our recent history might be said to be financial history: the true written record of our times lies not in books but in cash, shares, stocks, certificates, promissory notes and bills of exchange. Joseph Schumpeter argues that it was during the eighteenth century that capitalism was effectively discovered, or at least became "analytically conscious of itself," and this awakening to consciousness came through paper. Trade, wage labor, capital accumulation: paper first enabled and then sustained all of the essential aspects of capitalism. And capitalism, in return, has enabled and sustained nations. Richard Doty, curator of the National Numismatic Collection at the Smithsonian Institution, in his book *America's Money—America's Story* (1998), claims that paper money is the very fuel and foundation of America's superpower status: "Had there been no paper, we would now be speaking of the numismatic history of a much smaller, and a much lesser country." Smaller and lesser countries that also converted to paper money during

the seventeenth and eighteenth centuries included Great Britain, of course, with the Bank of England founded in 1694 with the purpose of managing and financing government debt by issuing promissory notes to depositors. And where Britain and America first trod, other nations soon followed. By the 1930s, with the final abandonment of the gold standard—which had meant that the amount of paper money in circulation had to be tied to the value of gold—paper money had triumphed. It was free.

And everywhere has us in chains. Given its obvious usefulness, and almost universal adoption, it's remarkable how many writers, thinkers and commentators have spoken out and continue to speak out against the very idea of paper money. Thomas Jefferson, for example, was famously the principal author of the Declaration of Independence, but he was also the sole author of a learned paper, "Notes on Coinage" (1784), in which he proposed a system of currency based on the dollar unit, with decimal fractions, which was adopted by Congress and is of course the currency system still in use in America today. Jefferson believed that paper money, unlike coins and good hard metal, created economic instability: English banknotes, he wrote, were nothing but "the ghost of money, and not money itself." He opposed the establishing of a national bank in America—the First Bank of the United States, which was founded in 1791—and was delighted when its charter expired in 1811. Following a banking crisis in 1814 he wrote, "Providence seems, indeed, by a special dispensation, to have put down for us, without a struggle, that very paper enemy which the interest of our citizens long since required ourselves to put down, at whatever risk. The work is done." The work

was not done: after the war with England, the fledgling nation was in significant debt, and so the Second Bank of the United States was established in 1817. Again, Jefferson remained unimpressed. After another banking crisis in 1819 he exulted, "the paper bubble is . . . burst." The paper bubble wasn't burst. It never bursts. It always bubbles again.

Paper-driven bubbles and bursts have characterized financial history ever since the early Chinese revenue-raising experiments. The process goes roughly like this: governments and rulers find that they need more money, and so press the button on the literal or metaphorical printing press and increase the money supply, inflation ensues, crisis occurs, and writers and philosophers line up to complain about it. Alexander Pope, in his *Epistle to Bathurst* (1733), lambasts "paper-credit," "That lends Corruption lighter wings to fly." David Hume, in his *Political Discourses* (1752), describes paper money as "counterfeit money," "which foreigners will not accept of in any payment, and which any great disorder in the state will reduce to nothing." Thomas Carlyle, in *The French Revolution: A History* (1837), despairs of "the Age of Paper" in eighteenth-century France, full of "Bank-paper, wherewith you can still buy when there is no gold left" and "Book-paper, splendent with Theories, Philosophies, Sensibilities . . . not only revealing Thought, but also . . . hiding from the want of Thought!" And then there is Karl Marx. In one of those typically dizzying passages in his early economic and philosophical manuscripts—in which he is busy frantically working out all his ideas about alienation and labor and suchlike, and all on paper, necessarily—Marx writes of money as "the universal confusion and transposition of all things, the inverted world, the confusion and trans-

position of all natural and human qualities." Money, according to Marx, "transforms real human and natural faculties into mere abstract representations, i.e. imperfections and tormenting chimeras."

It is, above all, the chimerical aspect of paper money that seems most to worry its critics. Compared to, say, gold and silver—"Exemplary metal," in the words of Geoffrey Hill in his poem sequence *Mercian Hymns* (1971)—paper money is light, flighty and insubstantial, like a spook or a sprite (Pope: "A single leaf shall waft an Army o'er,/Or ship off Senates to a distant Shore;/A leaf, like Sibyl's, scatter to and fro/Our fates and fortunes, as the winds shall blow:/Pregnant with thousands flits the Scrap unseen,/And silent sells a King, or buys a Queen"). The word "credit" is itself of course derived from the Latin *credere*, to believe, and you don't have to be a poet, or a philosopher, or, say, an anthropologist, to be able to work out that money requires the exercise of belief in order to function properly, though the anthropologist Mary Douglas does indeed helpfully identify money as a kind of belief system, and indeed "an extreme and specialised form of ritual" in her book *Purity and Danger* (1966). (In fitting tribute to Douglas, the novelist Will Self has suggested a new paper currency called "The Douglas," which confers upon the bearer "the right to a ritual of some unspecified kind.") If faith in the ritual of paper money disappears, then it simply doesn't work. In order to fulfill its ritualistic role, paper money therefore resorts to all sorts of mystical garb and mumbo jumbo: serial numbers, authenticating signatures, scrolls, seals and images; those cupids and goddesses that Walter Benjamin describes as ornamenting the façade of hell. And there is no more splendid

an example of ornamentation than the American dollar bill, with its vast array of symbols and images, including not only signatures, seals and serial numbers, but also a framed portrait of George Washington, a pyramid with an eye perched on top, a bald eagle, a cluster of stars, olive branches, and multiple announcements of its value (not only "1," x 8, but also "ONE," x 6, and furthermore, "ONE DOLLAR," x 2). As if these images and symbols were not enough, the US dollar bill is also garlanded with words and phrases in English ("THIS NOTE IS LEGAL TENDER FOR ALL DEBTS, PUBLIC AND PRIVATE," "IN GOD WE TRUST," "THE UNITED STATES OF AMERICA") and in Latin ("E PLURIBUS UNUM," "ANNUIT COEPTIS," "NOVUS ORDO SECLORUM"). One can understand why people find it so alluring and so fascinating: it is designed to allure and to fascinate. "'If you don't mind my asking, Robert, how did you get involved with the Illuminati?'" asks Vittoria Vetra in Dan Brown's *Angels and Demons* (2000). "'Actually,'" replies the Harvard University supersymbologist Robert Langdon, "'it was money.' . . . He reached in his pants pocket and pulled out some money. He found a one-dollar bill. 'I became fascinated with the cult when I first learned that U.S. currency is covered with Illuminati symbology.'"

Because of its strenuous and largely successful efforts to convince us of itself, it sometimes takes a grand gesture to remind us of the fact of paper money's profound fictitiousness. When Bill Drummond and Jimmy Cauty—two former pop stars turned art provocateurs who called themselves the K Foundation, and who in 1991 had a memorable, profitable worldwide hit with the single "Justified & Ancient (Stand by The JAMs)," featuring country singer Tammy Wynette singing

about 99 Flakes—burned a million pounds (approximately $1,625,000), in bundles of fresh-minted £50 notes, in a boathouse on the isle of Jura in 1994, the most common reaction, recorded in the book *K Foundation Burn a Million Quid* (1997), was not shock but disbelief: "You've really blown your credibility with this"; "It's like burning people's dreams in front of them." Drummond and Cauty seem to have been seeking to account and atone for their past enterprises and endeavors: paper as the nightmare from which they were trying to awake.

If for writers, philosophers and former pop stars paper money presents a disturbing and destabilizing challenge, for others it presents an obvious opportunity. In early 1861, for example, two opportunistic English con artists, William Burnett—aka Harold Tremayne, aka Bill Day, aka Bill Jackson—and his mistress, Ellen Mills—aka Ruby Tremayne, aka Ellen Day, aka Mary Day, aka Mary Williams, aka Emma Davey, aka "Flash Emma"—found themselves recently released from jail and staying at an inn, The Plough, in Whitchurch in Hampshire. Whitchurch, as it happened, was the home of many of the workers from a famous paper mill, Portal's, in nearby Laverstoke. And Portal's, by good fortune, was the supplier of paper to the Bank of England. As luck would have it, one evening Burnett and Mills met a man named Harry Brown, who was the assistant carpenter at the mill. Brown and Mills soon became lovers, and in April 1861, at Mills's request, Brown risked his job by stealing some plain, unglazed banknote paper. At which point, the poor man's fate was sealed: he had fallen into the trap; he was the mark, the patsy, the stooge, the sucker, the gull, the pawn, the pigeon and the chump. Burnett, through Mills, had him in his grasp, and he duly began to squeeze. He

blackmailed Brown into stealing more sheets; the paper supply began to flow. Even when Brown was discovered by another worker at the mill, an assistant mold maker named Richard Brewer, Burnett was able to turn this to his advantage: he bought Brewer's silence, and so acquired two inside men. All he needed now was some help in turning the precious paper into money.

By the summer of 1862, after trawling the pubs and taverns of the land, Burnett had found his gang of accomplices: Robert Cummings, aged ex-con, and an electroplater and gilder, met at The Feathers on Smith Street in Westminster; James Griffiths, an engraver and copper-plate printer, met at The Bull's Head in Birmingham; Henry Williams, another engraver, of St. Paul's Road, Kennington Park; and George Buncher, who ran a butcher's shop in Westminster, but who also acted as a receiver and fence for counterfeit money. Between them, Burnett's posse of paper thieves managed to smuggle out hundreds of sheets, and produced thousands of notes of varying denominations. But their enterprise was short-lived: the theft of paper from the mill was soon discovered, and by the end of 1862 the police had rounded up the gang. The trial was held at the Old Bailey in January 1863—"Regina *v.* Griffiths and Others." Ellen Mills had already been discharged at the committal hearing—it had been decided that she had been acting "under the influence of her husband or the man with whom she was co-habiting." The forger, Griffiths—who may in fact have been the instigator and leader of the whole plot, the Keyser Söze—was sentenced to life imprisonment. The fence, Buncher, was sentenced to twenty-five years. Burnett received twenty years. Williams, the engraver, got off lightly with four

years. Cummings was merely cautioned, and Harry Brown had turned Queen's evidence and therefore escaped prosecution. Richard Brewer was acquitted. A leader article about the case of "the precious paper of Laverstoke" in *The Times* on January 13, 1863, concluded, "the truth is . . . the paper is the thing . . . the product was as much a piece of secret art as the paste of Sevres or Dresden. It has never been successfully imitated and, until now, has never been purloined."

Paper money is the embodiment of capitalism, so it's perhaps hardly surprising that the purloining of paper money is or has been a capital offense. In England, the death penalty for banknote forgers was introduced in 1725, and between 1797 and 1829 more than six hundred people were hanged for forging or for circulating forged notes. The death sentence was repealed in 1832—saving Griffiths, Burnett and co. from almost certain death—but severe penalties continue to apply to purloiners, fakers, fabricators and knockoff merchants. In many countries it's illegal merely to handle, never mind to produce, paper that's similar to that used in currency production. (De La Rue, the company that prints banknotes for the UK and many other countries, uses specially manufactured paper, and complex intaglio print processes, and microprints, and watermarks, and ultraviolet features, and foil patches, and holographs, and any number of other security features to guarantee its products, but of course this doesn't deter determined counterfeiters: in 2009, according to Bank of England figures, over half a million counterfeit notes were in circulation in Britain.) If governments wish to take up counterfeiting, however, it's a different matter.

Banknote forgery has always been a part, and continues to be a part, of economic warfare: in the eighteenth century Brit-

ain was producing forgeries of the currencies of several of the American colonies; Napoleon printed Austrian notes during his occupation of Vienna in 1806; and during World War II, in the famous Operation Bernhard, Nazi Germany managed to flood the UK with an estimated nine million counterfeit notes. During the recent Gulf wars, the ongoing so-called "war on terror" and the Arab spring, rumours and reports of counterfeit dollars, dinars and afghanis circulated like counterfeit dollars, dinars and afghanis. Pakistan floods India with forged notes. North Korea apparently specializes in bogus $100 bills. Governments have the advantage here over amateurs and crooks, because forgery is not as easy as it looks: photocopying doesn't really work with money, and the traditional schoolboy method of soaking paper in tea, putting it in the oven and rubbing dirt into it is not a convincing aging process. (Though in his highly reliable history of forgery, *Forging History: The Detection of Fake Letters and Documents* (1994), Kenneth W. Rendell—one of the experts who helped unmask the Hitler diaries hoax—points out that many forged documents of all kinds are in fact of poor quality and stand up to little scrutiny. A forgery of an autographed note by John F. Kennedy, for example, of his famous remark, "Ask not what your country can do for you, but what you can do for your country"—part of his inauguration address in 1961—was written on genuine White House stationery, watermarked 1981.)

Paper money, real or fake, is actually only one facet or component of the relationship between paper and money: there is also the complicated matter of account books, ledgers, and all the other ways that banks, building societies, insurance companies, small and large businesses, governments and individ-

uals have of recording debts and credits and trade on paper. One of the first people ever to take his account books seriously was the great one-legged potter, inventor, industrialist—and the grandfather of Charles Darwin—Josiah Wedgwood. Having founded his own pottery in 1759, Wedgwood's business went from strength to strength, until the early 1770s, when demand slumped and production costs increased. Wedgwood immediately undertook a kind of primitive cost accounting analysis, examining his books and ledgers, and discovered not only inefficiencies but also evidence of embezzlement; his prompt action preserved the business for generations to come. Paperwork had saved the day.

In an unexpectedly thrilling article about paper-based accounting and business systems in the British Association of Paper Historians' indispensable journal, *The Quarterly* (no. 61, January 2007), the appropriately named Andrew Gold trawls through vast treatises on accounting and company archives, and stationers' catalogues of loose-leaf ledgers, to show exactly how "the account book is a good example of the versatility of paper." Versatile, true, but slowly dying. Lamenting the demise of the great paper-based accounting systems, including the products of Twinlock, one of the giant stationery and office-supply manufacturers, Gold notes that "The site of Twinlock's head office and factory is now the car park for a Tesco supermarket."

Big fat ledgers and double-entry accounting books may have been replaced by software systems, and most of our transactions at Tesco may now be paperless and processed electronically, but still all around us, and beneath us, and behind us, from recent memories of the credit-fueled Irish construction boom, to the vast Greek trade deficits threatening to topple the

eurozone, and the debt crises in Spain and Portugal, there still flows paper money, greasing palms, feathering nests and keeping heads—just—above water. In *Dombey and Son* (1848), poor Paul Dombey is taught a difficult lesson by his father: money can do anything, except save us. "Mr Dombey . . . expounded to him how that money, though a very potent spirit, never to be disparaged on any account whatever, could not keep people alive whose time was come to die; and how that we must all die, unfortunately, even in the City, though we were never so rich." Never to be disparaged, but not to be relied upon: paper money is only ever a postponement.

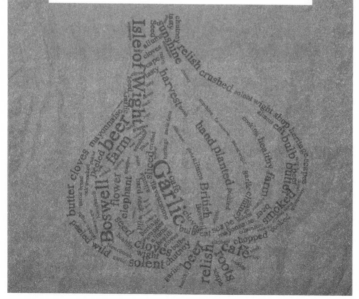

6

THE SOUL OF ADVERTISEMENT

Promise, large promise, is the soul
of advertisement.

SAMUEL JOHNSON, *The Idler*, 1759

A paper bag

Kindly place this label on the END of the package

P. & O.S.N. Co.

BAGGAGE
ROOM

Not to be placed on "CABIN" Baggage.

Name _____

"VICEROY OF INDIA"

Paper can wrap, contain, protect and preserve all sorts of goods and products, from peanuts to pineapples, and from paint pots to packets of pins. It allows us to transport goods, to handle them safely, to store them, and to draw up ever more complex stock and inventory control systems— and I know, I used to work in Foyle's bookshop, on the Charing Cross Road in London, where the antiquated system of collecting a voucher for one's books at one counter, and then paying for them at another, before returning with a carbon copy and a receipt to collect them from the first counter, was absolutely guaranteed to enrage and baffle customers. Paper also allows us to decorate and advertise goods and products, like this book, to make them seem prettier and more desirable than they actually are, and so to sell them to others for more money, an example of paper making paper.

One of the simplest forms of advertisement is the label: abundant, versatile and essential, the label is perhaps the most ubiquitous and yet often the most opulent of all paper forms, existing somewhere between a guarantee, a sign and a promise. So let us begin an investigation of the relationship between paper and advertising by looking at labels. But which labels to look at? The Campbell's soup labels, immortalized by Andy Warhol? (Which of course represent a nice little trick, a sleight of hand, the making of high art from a low-end high-street paper product, even

if Picasso got there first, with his *Landscape with Posters* (1912), which features depictions of KUB bouillon packaging and Pernod labels, and his *Au Bon Marché* (1913), made up of a collage of ads.) Or the grand luggage labels of the 1920s and 1930s, by which and through which we might trace the rise and fall of the golden age of Continental travel? Or cigar box labels, with their lingering whiff of luxury? Date box labels? *Eat me.* Beer, brandy or rum labels? Fruit labels? Parkinsons' sugar-coated Blood & Stomach Pills labels? The choice is fantastic, bewildering. The great label historian Robert Opie—great, it should be said, not only because he is perhaps the one-and-only label historian, but because he is the historian also of tins and sweets and toys, the true ephemerist's ephemerist—traces the history of the paper label back to the sixteenth century and forward into infinity and beyond. "During the history of the label," he writes, "countless millions of designs have been used." It might be best to start with a label, then. And a labeler.

Tissue wrapper used to package citrus fruit

London, 1824. A young boy—maybe eleven, twelve—has been forced, through desperate family circumstances, to leave school and find employment. He is recommended to the owners of Warren's Blacking warehouse, near Hungerford Stairs, just off the Strand, and in return for a week's work is paid six or seven shillings, enough to buy himself an old stale pastry for breakfast, a dry sausage and a penny loaf for lunch, and an occasional copy of the *Portfolio* or some other cheap periodical for amusement. On his way home at night to his dreary lodgings in Camden Town he sometimes visits Covent Garden Market, to stare at the pineapples, or stops off at a sideshow to marvel at the human and animal curiosities: the Fat Pig, the Wild Indian, the Little Lady. And in the warehouse? He spends his days pasting labels onto earthenware pots. One of the labels, designed by no less than George Cruikshank, the "modern Hogarth," shows a cat, a scruffy tabby, shocked by its reflection in a shiny boot:

> Twelve pairs of new Boots, most transcendently grac'd
> By WARREN'S fam'd *Jet*, in a room had been plac'd,
> Where twenty-four Cats were accustom'd to meet,
> And viewing the Boots they a united squalling
> Commenc'd, than the yelling of imps more appalling,
> All inmates that forc'd from the house to retreat,
> Its shade in the *Jet* every Cat fiercely fighting—
> The row when explain'd, all the hearers delighting
> With cheers who proclaim'd it, and ONE CHEER MORE
> backing
> The Mart, 30, Strand, and its reflecting *Blacking*.

Our poor little label paster is of course Charles Dickens. Recalling his time in the blacking warehouse many years later—"even now, famous and caressed and happy, I often forget in my dreams

that I have a dear wife and children; even that I am a man; and wander desolately back to that time in my life"—he describes in detail the exact nature of his employment:

> My work was to cover the pots of paste-blacking: first with a piece of oil-paper, and then with a piece of blue paper, to tie them round with a string; and then to clip the paper close and neat all round, until it looked as smart as a pot of ointment from an apothecary's shop. When a certain number of grosses of pots had attained this pitch of perfection, I was to paste on each a printed label; and then go on again with more pots.

Dickens's working life begins and ends with paper. On the evening of June 8, 1870, almost fifty years after his stint in the warehouse, having spent the day working on Chapter 23 of his fifteenth novel, *The Mystery of Edwin Drood*, in the two-story prefabricated Swiss chalet that served as his studio—his own fancy, miniature warehouse?—in the garden of Gad's Hill Place, he collapsed, suffering from a stroke, and died twenty-four hours later. The closing words of Chapter 23, written some time that afternoon in bright blue ink, are "and he fell to with an appetite."

Some writers have peculiar appetites for paper: Rudyard Kipling, for example, who used writing blocks made especially for him, "to an unchanged pattern of large, off-white, blue sheets." And the high-minded German critic and cultural theorist Walter Benjamin, who was a stationery-obsessive. In a letter in 1927, Benjamin wrote with delight to his friend Alfred Cohn, thanking him for a gift of a blue notebook: "I carry the blue book with me everywhere and speak of nothing else . . . I have discovered that it has the same colours as a certain pretty Chinese porcelain." "Avoid haphazard writing materials," Benjamin advises in "One Way Street" (1928), though this is not

an admonition he himself seems to have heeded, having used a bewildering range of notebooks and index cards in tandem and in parallel. (Benjamin also collected postcards, photographs, miniature Russian children's toys and quotations.)

In comparison, Dickens was by no means slapdash—certainly not when compared to the truly haphazard Byron, for example, who wrote *Don Juan* on the backs of playbills, or the pipe-smokingly self-forgetful Tolkien, who wrote *The Lord of the Rings* on the backs of undergraduates' exam papers—but his real appetite was for words rather than for stationery. Indeed, he even had trouble spelling the word: it was, for him, tellingly, always "stationary"; something that was holding him back. Dickens's furious handwriting, strenuous and aggressive, snarling almost, suggests that he might have written on anything, anywhere, and for anyone: give him the pot, and he'd paste on the label. For his novels he tended to use rough blue paper, not unlike the blue paper used on the Warren's Blacking pots, which he'd tear in half, writing quickly and firmly on one side only, sometimes using the reverse for corrections and additions. Dickens speaks in a letter of "writing and planning and making notes over an immense number of little bits of paper." These bits and sheets he called his "slips," almost as though they were merely receipts or dockets, loading bays for his vast cargo of characters. (Other famous slip-making novelists include Arno Schmidt and Vladimir Nabokov—authors who pieced together their books from boxloads of index cards.)

In this sense, Dickens was the first capitalist writer: his work exists somewhere between an act of labeling, of bookkeeping, and of advertising. Some scholars indeed argue that Dickens's first published work was some advertising copy, a poem for

Warren's Blacking, not to adorn the pot labels, but for a news-paper advertisement, and there have always been those who have felt that even the novels are just so much puff and blather, like clouds, or Pears soap bubbles. George Orwell, in a famous essay, complained that Dickens's characters were insubstantial, paper-thin, that you couldn't have a proper conversation with them, that they had no "mental life": "Tolstoy's characters can cross a frontier. Dickens's can be portrayed on a cigarette-card." (Orwell is presumably thinking here of the Player's cigarette cards of his youth, depicting Dickens's characters, which were first issued in 1912.) There is something "unreal" about Dickens, according to Orwell; and in this also, Dickens was a writer of his time.

Modern consumer capitalism was born and came to life on paper in the nineteenth century, with public space suddenly colonized as a realm for advertising goods and services. As the cultural critic Raymond Williams was one of the first to note, the true history of advertising begins not with the scraps of papyrus used to announce rewards for the capture and return of runaway slaves in Thebes, or with the handmade paper used to wrap acupuncture needles in China, or even with the illustrated hand-bills advertising plays, circuses and menageries in the eighteenth century, but with the "institutionalized system of commercial information and persuasion" inaugurated in England by the abolition first of the Advertisement Tax in 1853, and of Stamp Duty in 1855, and by the invention of lithographic printing, with all its lurid possibilities, in 1851. Williams, in his essay "Advertising: The Magic System" (1980), describes what he calls "a highly organized and professional system of magical inducements and satisfactions," operated by writers and artists and published in

newspapers and magazines and displayed on posters and bill-boards, which produced what he calls "the culture of a confused society." In the nineteenth century, in the form of advertising, paper came, saw and conquered.

Paper smothered London. In *Sketches by "Boz," Illustrative of Every-day Life and Every-day People* (1836), Dickens describes London as "a circus of poster and trade bill, a receptacle for the writings of Pears and Warren's until we can barely see ourselves underneath. Read this! Read that!" According to the paper historian Dard Hunter, between 1805 and 1835 the annual production of machine-made paper in England rose from 550 tons to almost twenty-five thousand tons: the mills were spewing paper into the atmosphere, and out onto the streets, as the factories were billowing out smoke. The effect was both suffocating and intoxicating. In a popular engraving from 1862, "The Bill Poster's Dream," the bill poster sits slumped like a drunk against a lamppost, exhausted, glue pot by his side, examples of his handiwork illuminating the night sky. In an article on "Bill-Sticking" in *Household Words* (March 1851), Dickens described an old warehouse "which rotting paste and rotting paper had brought down to the condition of an old cheese":

> The forlorn dregs of old posters so encumbered this wreck, that there was no hold for new posters, and the stickers had abandoned the place in despair . . . Here and there, some of the thick rind of the house had peeled off in strips, and fluttered heavily down, littering the street; but, still, below these rents and gashes, layers of decomposing posters showed themselves, as if they were interminable.

Dickens—"The Inimitable"—returns to images of the interminable again in *Our Mutual Friend* (1865), his last complete novel:

> That mysterious paper currency which circulates in London when the wind blows, gyrated here and there and everywhere. Whence can it come, whither can it go? It hangs on every bush, flutters in every tree, is caught flying by the electric wires, haunts every enclosure, drinks at every pump, cowers at every grating, shudders on every plot of grass, seeks rest in vain behind the legions of iron rails.

Paper here is omnipresent, and no paper more omnipresent than Dickens's own, of course. "I am become incapable of rest," he wrote to his friend and official biographer John Forster in 1857—as incapable of rest as wind-blown wastepaper. In addition to the novels there were the acres of journalism, and nonfiction, and poetry, and plays, and letters—fourteen thousand of them, no less, in the twelve-volume Pilgrim edition. And this is not even to begin to add up all the paper devoted to actually advertising Dickens, by Dickens and by others: his publishers Bradbury and Evans produced four thousand posters and three hundred thousand handbills to advertise the first number of *Little Dorrit* alone.

If paper plagued you and followed you everywhere in the nineteenth century, it also pushed and prodded and guided you. This was the age not only of the omnipresent advertisement, of the proliferating periodical, and of vast triple-decker novels, but also of mass-produced ready reckoners, calendars, ledgers and account books. It was, above all, according to *The Times* in 1874, the "age of timetables." Route maps and distance charts allowed the ever-expanding population of city dwellers to make sense of their ever-expanding cities. *Fielding's Hackney Coach Rates*, first published in 1786, was only the first of a long line—a cab stand—of hackney-coach companions

THE TIMES

For 7th NOVEMBER. 1805

BATTLE OF

TRAFALGAR

CAPTURE OF

FRENCH AND

SPANISH FLEETS

DEATH OF NELSON

List of Killed and Wounded

and travelers' maps, including the magnificently titled *The Arbitrator, or Metropolitan Distance Map* (1830), *The Hackney Carriage Pocket Directory* (1832), and William Mogg's *Ten Thousand Cab Fares* (1851), designed to guide the traveler safely, and at a fair price, through the metropolis. In Robert Surtees's 1853 novel *Mr. Sponge's Sporting Tour*, the eponymous hero travels everywhere with his Mogg in his pocket, just as Phileas Fogg sets out from Charing Cross with a red-bound copy of *Bradshaw's Continental Rail and Steam Transport and General Guide* in *Around the World in 80 Days* (1873). And even if you weren't traveling with a pocketful of paper, it accompanied you anyway. The German nobleman Prince Hermann Ludwig Heinrich

von Pückler-Muskau, in his *Tour of a German Prince* (1831–32), described England's famous walking advertisements: "Formerly people were content to paste them up; now they are ambulant. One man had a pasteboard hat, three times as high as other hats, on which is written in great letters, 'Boots at twelve shillings a pair—warranted.'"

Unwarranted, actually, and alarming. Posters, handbills, billboards, sandwich boards: advertisements were taking over, all over, uninvited and unasked for. In the United States, bill-

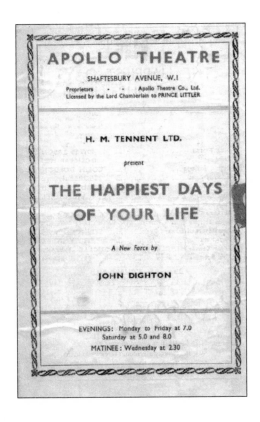

boards lined the streets of the nation, like it or not. During the 1860s, the site for the new New York City Post Office was leased to advertisers, with a fence specially erected for bill posters. An article in *Collier's* magazine in 1909 complained that "There is no hour of waking life in which we are not besought, incited, or commanded to buy something of somebody. Our morning paper is full of it; our walk to the nearest car bristles with it; the transfer which we take blazons it." Even in France, where the poster was venerated as a work of art, there were suspicions that this new popular form sought to persuade and influence the masses to act in ways contrary to the laws of nature, and of God. With his brightly colored images of pretty dancing girls, the artist Jules Chéret may have made the poster a thing of beauty and an object of desire—and inspired the work of Toulouse-Lautrec, among others—but the journalist Maurice Talmeyr, in an article entitled "The Age of the Poster" (1896), lamented that such posters exhorted viewers not to "Pray, obey, sacrifice yourself, adore God, fear the master, respect the king," but rather to "Amuse yourself, preen yourself, feed yourself, go to the theatre, to the ball, to the concert, read novels, drink good beer, buy good bouillon, smoke good cigars, eat good chocolate, go to your carnival, keep yourself fresh, handsome, strong, cheerful, please women, take care of yourself, comb yourself, purge yourself, look after your underwear, your clothes, your teeth, your hands, and take lozenges if you catch cold!"

Paper had caught a cold: it was sick, a sign and a symptom of degeneration. The fear and horror of a world created by paper and made of paper is best summed up in an extraordinary article by John Hollingshead, "The City of Unlimited Paper," in

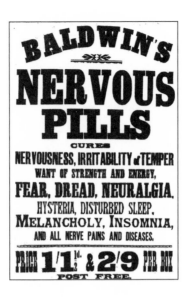

a December 1857 issue of Dickens's *Household Words*, in which Hollingshead imagines London as "New Babylonia":

> Within a certain circle, of which the Royal Exchange is the centre, lie the ruins of a great paper city. Its rulers—solid and substantial as they appear to the eye—are made of paper. They ride in paper carriages; they marry paper wives, and unto them are born paper children; their food is paper, their thoughts are paper, and all they touch is transformed into paper . . . the stately-looking palaces in which they live and trade are built of paper . . . which fall with a single breath. That breath has overtaken them, and they live in the dust.

Echoes here, clearly, of Genesis 2:7, "And the LORD God formed man of the dust of the ground, and breathed into his nostrils the breath of life; and man became a living soul." And so, one wonders, could the process of decay and decline de-

scribed by Hollingshead perhaps be reversed? Could a paper city be reborn and redeemed, re-formed from dust?

It could. It was. And it is, in the Dublin of James Joyce's *Ulysses* (1922). Every degrading paper thing to be found in Dickens—the posters, pamphlets, public papers, private papers, brochures, advertisements, sandwich-board men, and even an advertisement for boot blacking, called "Veribest"—is to be found also in Joyce; but the proliferation of paper in *Ulysses* is not a threat but the very stuff of life. *Ulysses* itself might indeed be read as a kind of giant self-advertisement, of the kind described by Joyce's Leopold Bloom as causing "passers to stop in wonder": "vertically of maximum visibility . . . horizontally of maximum legibility, and of magnetizing efficacy to arrest involuntary attention, to interest, to convince, to decide." Bloom

A bottle label: author's private collection

Advertisement for the forerunner of today's delicatessen, showing the use of glass and tin to increase the storage life of perishable foods

himself is of course an advertising canvasser, soliciting ads for the Dublin paper *The Freeman*, and the novel is literally composed from scraps: "I make notes on the backs of advertisements," Joyce told a friend in 1917; he also made much use of waistcoat-pocket-sized pieces of paper, large enough to make multiple memos-to-self about Epps's cocoa, Bushmills whiskey, Guinness, ginger ale, Pears soap and Plumtree's potted meat, all of which feature largely and exuberantly throughout the novel: "What is home without Plumtree's Potted Meat?— Incomplete. With it an abode of bliss." In one extraordinary passage, Bloom imagines an innovative traveling stationery advertisement: "a transparent show cart with two smart girls sitting inside writing letters, copybooks, envelopes, blotting paper. I bet that would have caught on." Two smart girls and reams of paper: the Irish writer's fantasy.

Advertising, then, may be the true curse of paper, its original sin, forever seeking redemption and renewal; the watermark the mark of Cain. As Elizabeth Eisenstein explains in her classic study *The Printing Press as an Agent of Change* (1979), it was printers who first used advertisements as we understand them today, in increasingly desperate attempts to outdo their rivals: "The art of puffery, the writing of blurbs and other familiar promotional devices were also exploited by early printers who worked aggressively to obtain public recognition for the authors and artists whose products they hoped to sell." The history of paper is bound up in and emblazoned upon the goods and products and services that it packages and promotes. And just like those goods and products and services—unless saved for posterity in a real or an imaginary museum—it is destined, ultimately, for oblivion. In *Posters: A Critical Study of the Devel-*

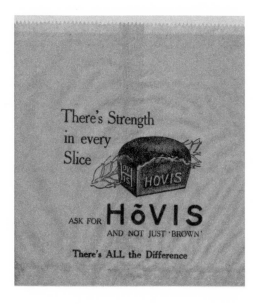

opment of Poster Design in Continental Europe, England and Amer-ica (1913), Charles Matlack Price warns that "When a poster fails, its failure is utter and irretrievable, and its inevitable destiny is its consignment to the limbo of waste paper." At best, perhaps, we can hope to act like King Chulalongkorn of Siam, who collected matchbox labels, and who during a famous visit to London in 1897 would scoop up matchboxes from the gutter, to add to his collection. King Chulalongkorn was what is called a phillumenist. We might prefer to label ourselves cartophilists (collectors of cigarette cards), deltiologists (collectors of postcards), notaphilists (collectors of banknotes), labologists (collectors of beer labels), or even tryroemiophilists (collectors of Camembert cheese labels), but in all cases it is worth bearing in mind this simple piece of advice: "The best way of removing labels from bottles or boxes is to soak them in warm water and wait for them to float off. Some assistance in peeling off the label may be necessary" (Robert Opie, *The Art of the Label*, 1987). Paper sticks.

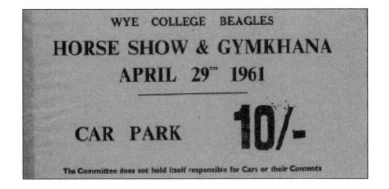

7

CONSTRUCTIVE THINKING

Paper is usually pasted; instead of pasting it we try to tie it, to pin it, to sew it, to rivet it. In other words, we fasten it in a multitude of different ways ... Our aim is not so much to work differently as to work without copying or repeating others. We try to experiment, to train ourselves in "constructive thinking."

JOSEF ALBERS, quoted in
Herbert Bayer, *Bauhaus Weimar*
1919–1925 (1975)

Craft paper, as its name suggests, is tensile and strong

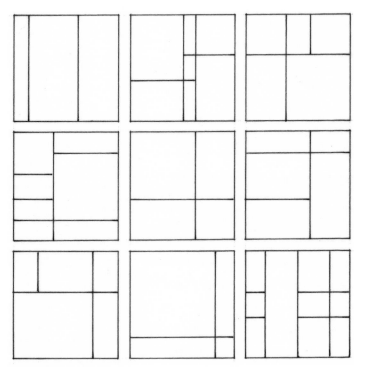

Homage to the Square

We join Josef Albers (1888–1976), artist, poet, philosopher, photographer, typographer, former elementary-school teacher, polymath, progressive educator and explorer of the possibilities of color and of the square, at the Staatliches Bauhaus, in Dessau, Germany. It is sometime in the late 1920s. Founded by Walter Gropius in 1919, the Bauhaus seeks to combine the teaching of fine arts with applied arts, and in Gropius's words, "to create a new guild of craftsmen, without the class distinctions which raise an arrogant barrier between craftsman and artist." Albers is the perfect example of Gropius's new breed. Himself educated at the Bauhaus, he is now teaching the school's preliminary course, the *Vorkurs*. Classes take place four mornings a week, on the second floor in one of the new buildings of glass and steel designed by Gropius on the outskirts of the city (after 1932, the same buildings are used as a training school for members of the National Socialist Party, before being bombed, restored, repaired and declared a World Heritage Site, with tours and tour guides available).

Albers walks into the room with a bundle of newspapers under his arm. He is wearing a dark suit, white shirt, tie, tie-pin, hair cut close with a high fringe—that characteristic modern take on the Ciceronian crop, accentuating both forehead and mad stare, favored also by Gropius and many of the other

Bauhauslers, and which makes them in group photographs look scarily like the Addams family. Albers is thirtysomething years old. He is wearing steel-rimmed spectacles. He looks absolutely the part: he looks, in fact, like a Bauhaus architect, though he is not an architect and has never built a house. He is not even a "paper architect," the pejorative term sometimes applied to architects whose work is never built, and adopted as a badge of honor by a group of Russian architects in the 1980s, who refused to produce the bland, gray, standardized Soviet buildings that were the degraded, degenerate offspring of the Bauhaus style. Albers is no paper architect: he is an architect of paper.

He introduces himself to the class and explains his ideas about the meaning of form and beauty and how "the complexity of the form is dependent upon the form with which we are working." So far, so good. But now for the grand gesture. (Albers often compared teaching to acting, and would sometimes ask students lining up for classes if they had brought with them their tickets for the "show.") He gives each of the students one of the newspapers he has brought with him. "I would now like you to take the newspaper you have just been given and make something out of it that is more than it is now. I would also like you to respect the material, to employ it in a meaningful way and thereby consider its characteristic qualities. If you can do so without the aid of knives, scissors or glue, so much the better. Good luck!"

Good luck, indeed. (Albers's teaching methods tended to divide opinion: Robert Rauschenberg, a student who went on to become a great experimenter in paper and cardboard, described him as "a beautiful teacher and an impossible person." Others thought the opposite.)

Hours later, Albers would return to find—as Tom Wolfe takes

up the story in *From Bauhaus to Our House* (1981)—"Gothic castles made of newspaper, yachts made of newspaper, airplanes, busts, birds, train terminals, amazing things. But there would always be some student, a photographer or glassblower, who would simply have taken a piece of newspaper and folded it once and propped it up like a tent and let it go at that." And that, the simple fold of the paper into a tent—not the birds, not the trains—was what Albers adored, and what Wolfe abhors. The whole point of Albers's preliminary course was to teach the students about the integrity of materials. Wood, he thought, should not be ashamed to be wood, nor glass to be glass, nor concrete . . . well, to be concrete. As for paper, his favorite teaching material and medium:

> paper, in handicraft and industry, is generally used lying flat; the edge is rarely utilized. For this reason we try paper standing upright, or even as a building material; we reinforce it by complicated folding; we use both sides; we emphasize the edge. Paper is usually pasted; instead of pasting it we try to tie it, to pin it, to sew it, to rivet it. In other words, we fasten it in a multitude of different ways. At the same time we learn by experience its properties of flexibility and rigidity, and its potentialities in tension and compression. Then, finally, after having tried all other methods of fastening we may, of course, paste it. Our aim is not so much to work differently as to work without copying or repeating others. We try to experiment, to train ourselves in "constructive thinking."

Albers went on to teach at the experimental Black Mountain College in North Carolina, at Harvard and at Yale, and is now remembered, if at all, for his work on color theory and for his quaint series of paintings, Homage to the Square—the title

indicates precisely the content—which occupied him for over twenty years. But it is for his pioneering work as a pedagogue, and in particular on the role of paper in teaching constructive thinking, or in constructing thinking, that he most deserves to be remembered.

If the product of architecture often resembles paper—and today, almost a hundred years after their first construction, the Bauhaus buildings still look like something you might have made yesterday with a glue stick, some cellophane, cereal boxes and a printing set—so too is paper essential to the architectural process. Traditionally, buildings are made on paper, and they look like paper. Take a sheet of A4 paper, for example, and go and stand in front of a house. Now step back and step back until you can hold up the sheet of paper so that it covers the surface area of the house: the house fits the paper. Now step back a little farther. The windows are like sheets of paper, stuck on the sheet of paper. Hold the paper upright and you have the front door, and for the roof, just fold your piece of paper in half lengthways. Why should this be so?

Perhaps because planning and thinking and drawing are often inseparable, and take place on paper, with rulers and T-squares. "The plan is the generator," according to Le Corbusier, who attempted to break away from old ways of thinking and who devised a new system of measurement and design, which he called the "modulor," based on the dimensions of the human body. But even this system required the amassing and comparing of hundreds of detailed diagrams and sketches, a process that seems to have given him little pleasure. In *Toward an Architecture* (1923) he writes that "A plan is not a pretty thing to be drawn, like a Madonna face; it is an austere abstrac-

tion, it is nothing more than an algebrization and dry-looking thing." If Le Corbusier found paper a constraint, Alfred Loos—another architect who wrote more than he built—viewed it as a form of tyranny: "Through architects the art of architecture has sunk to the level of a graphic art. It is not those who can build best that receive the most commissions but those whose work looks best on paper."

Like it or not, architecture has been, for most of its history, a paper profession. When imagining a house, architects have traditionally done so on paper. When imagining a palace, they have traditionally done so on paper. And when imagining an entire city—they have done so on slightly larger sheets of paper. Robert Fludd's seventeenth-century fortified city; Joseph Smith's plan for an ideal Mormon city; pioneering socialist Robert Owen's "A view and plan of the agricultural and man-ufacturing village of Unity and Mutual Co-operation"; eccen-tric self-taught stenographer Ebenezer Howard's vision of the "garden city," which he promoted throughout the late nine-teenth and early twentieth centuries with pamphlets, maps and diagrams, and by touring the country giving lectures illustrated with lantern slides; and of course Le Corbusier's grand plans for a *ville contemporaine*, a contemporary city, presented in a hundred-square-meter diorama at the Paris Salon d'Automne in 1922, and which was eventually made real at least in part in his work on the Indian city of Chandigarh: all these places exist first and foremost on paper. As do the plans to erase and destroy whatever people or buildings existed there before. In Romania, in the early 1990s, I met an architect who told me a story about Nicolae Ceaușescu's plans and designs for his pal-ace, the House of the Republic, in the center of Bucharest: the

self-styled "Genius of the Carpathians" apparently commissioned a vast cardboard architectural model of the existing city to be built in a gymnasium, with the strict requirement that none of it should be glued down. He then peremptorily swept away approximately a fifth of what had been made in model form, and set seven hundred architects to work on designing a vast building to fill the gap. In another strange and sinister republic, Plato's *Republic*, Socrates says that artists "will not start work on a city nor on an individual (nor will they draw up laws) unless they are given a clean canvas, or have cleaned it themselves." Clean canvas. New start. A nice fresh sheet of paper.

Early architects may have provided some scale drawings on papyrus or parchment or vellum, but most of the actual design of buildings seems to have taken place on site, being sketched onto a skim of plaster, or carved onto stone, with master masons acting as draftsmen. But as paper evolved, so too did the profession of architecture: paperwork became the foundation for building work, and drawing became an essential skill. Alberti, in *On the Art of Building in Ten Books* (1452), the first major treatise on architecture of the Renaissance, claimed that ideas formed in the mind could only be perfected through drawing, echoing Vitruvius's instructions in the *Ten Books on Architecture* that an architect must be "educated, skilful with the pencil, instructed in geometry, know much history, have followed the philosophers with attention, understand music, have some knowledge of medicine, know the opinions of the jurists, and be acquainted with astronomy and the theory of the heavens." From being just one attribute among many, pencil skills became a defining characteristic of the profession.

One biographer of Christopher Wren goes so far as to suggest that he became an architect merely because he had "a taste for drawing and a preference for visible results." And until recently, most architects have shared Wren's taste.

From initial sketches, to more detailed plans and designs, to even more complex project plans and site plans—the work of an architect has taken place in a blizzard of blueprints, whiteprints, tracing paper and photocopies. Indeed, one of the closest things to an actual paper shrine is perhaps the Alvar Aalto Foundation, at no. 20 Tiilimäki, Munkkiniemi, Helsinki, where architecture students are welcome to come and see where the great Finnish architect worked, with his trusty 6B pencils, from 1955 to his death in 1976. The building looks from the outside like a white-card architectural model. Inside is the same. According to Aalto, "The Creator created paper to draw architecture on. Everything else is, at least as far as I see it, a misuse of paper." (The Japanese architect Shigeru Ban—whose paper log houses and emergency paper shelters have been used in numerous disaster relief projects—began his work using discarded industrial paper tubes as a building material when designing an Alvar Aalto exhibition at Tokyo's Axis Gallery in 1986.) Aalto would often work on napkins at a local restaurant, and would also sketch ideas on the back of the packets of his favorite cigarettes, Turkish Klubi 77 Klubb. Every morning his secretary would lay out on his desk sheets of thin, Finnish sketch paper—*tervakoski luonnospaperi*—cut to lengths of exactly 30 cm., and he would line up his pencils in order of length and begin work. Between them, Aalto and his staff would make up to five thousand sketches for any particular project: they were literally growing buildings from paper.

What's true of a great Aalto is true also of the humblest abode. The export of portable, prefabricated buildings, for example—barns, cottages, customs houses, churches and cast-iron arcades—during the nineteenth century relied not only on the manufacture of standardized parts, but on the production of clear, cheap plans, catalogues and detailed assembly instructions. One of the most successful producers and exporters of prefabricated iron parts and buildings during the nineteenth century was Walter MacFarlane & Co., "Architectural iron-founders and sanitary engineers" of Glasgow. Their beautiful illustrated catalogues, which run to almost two thousand pages, display a vast range of "business premises, shop fronts, arcades, and every conceivable outdoor structure for recreation, shelter, rest, shade and ornament," which could be exported and erected anywhere. In America, similarly, Sears Roebuck was selling prefab houses by 1908: all you had to do was check the catalogue, fill in an order, and your house would be delivered to you by rail, ready for a quick barn-raising-style assembly. Examples of MacFarlane & Co.'s iron foundry work can still be found today in Africa and Australia, while Downers Grove in Illinois, a suburb of Chicago, boasts the largest number of still-standing Sears Modern Homes. For the triumph of architectural standardization, modularization, industrial production, distribution—and thus, latterly, for IKEA—we can thank paper.

The disadvantage of doing architecture on paper, of course, is that paper allows architects to design by *drawing*, rather than by doing, and thus removes them from actual buildings on actual building sites. The kind of new forms of housing and urban space proposed by Le Corbusier, for example, may have

looked fantastic on paper, but were often disastrous to live in. The obvious problem with paper as a design tool is that although it might be able to indicate the proportionate width, length and height of structural elements, and their relation to one another, it cannot—in flatland, in 2D, on the horizontal plane—indicate the mass and shape of the built space itself. Traditionally, this is where architectural models have come in—those scale models submitted for architectural competitions, or for display to clients, or for mad Romanian dictators to plan their mad palaces, and usually made from paper, or card, or polystyrene, or plastic, or plywood, or epoxy resin cast in silicone molds, and which give a useful sense of the size and scope of the proposed building. The gap remains, however, between the design and the building: what we might call the paper gap, or the gap made by paper. This gap is fast being closed by computerized 3D modeling.

For architects, designing in digital space is different. Early computer-aided design (CAD) programs—AutoCAD version 1.0 was released in 1982—allowed architects to work on screen, but still much in the manner they had done on paper. Early CAD was basically a form of imitation paper. But the latest 3D drawing tools, which incorporate animation and motion graphic software—known as Building Information Modeling systems—have gone far beyond drawing-board geometry and paper into the complex modeling of space and time. Combined with the use of CNC (Computer Numerical Control) machines for making architectural models, this means that an architecture office potentially has no need for paper, cardboard, scalpels, scissors, or any of the other paper-related paraphernalia of the past few centuries. This clearly has implications: "Is

drawing dead?" has become the architectural equivalent of the perennial "Is this the end of paper?" question.

Answer: well, yes, no and maybe.

Greg Lynn, one of the prophets of a postpaper architecture, claims that the modes and methods of the profession are changing for the better, from paper-based design to computer modeling, and from a fixation upon patterns of lines and grids to an attention to fluid surfaces, resulting in new biomorphic building forms. Lynn is credited with coining the term "blob architecture," or "blobitecture," as critics of this new style prefer to call it (for obvious examples, think of Frank Gehry's Guggenheim Museum in Bilbao, or his Walt Disney Concert Hall in Los Angeles, or the bobbly Selfridges building in Birmingham). As these extraordinary new forms seem to suggest, architecture has been liberated from the constraints of paper design. Of course, some architects are staging a rearguard action and resisting the computer and all its blobtastic ways; and not just fuddy-duddies. The great radical architect Yona Friedman, for example, claims to have "decomputerized" as long ago as 1973 because he recognized in computer design a form of dictatorship: "All the pre-fabricated software has implications that are not stated. I am not free to use them as I want. It would be better to simply teach people how to do their own software. Computers give no real choices. With paper, it is different. I can crumple it, I could not do this by computer." Other defenders of the art and craft of drawing in architecture argue that it develops a particular form of skill and attention, and establishes an important, intimate relationship between hand and eye that is reflected in the human forms and dimensions of buildings themselves, and that computers, for all their capac-

ities, actually distance us from the real world, and that Frank Lloyd Wright, with his colored pencil drawings, and Aalto with his cigarette-pack sketches, bring us closer.

So, the computer may or may not be trumping paper and transforming architecture from the outside in, but what about from the inside out? What of the paper inside our homes—not the books and the bookmarks, or the cards and coupons, but the actual fixtures and fittings, the furniture?

If your home happens to be in Japan, of course, your house may actually be made of paper, with *byōbu* folding screens and *shōji*, the wall-like partitions fixed into grooved channels

Japanese house with sliding paper screens

that give the traditional house its peculiar qualities of suffused light. The great Japanese novelist Junichirō Tanizaki wrote a famous essay, "In Praise of Shadows" (1933–34), in which he emphasized the importance of paper in creating the rich variations of shadow that characterize the interiors of traditional Japanese homes. The interiors of modern Japanese homes, it should be admitted, tend to be lit by bright fluorescent lights, while outside all is neon, and even Tanizaki, despite his praise of the depth and subtleties of the half-dark paper home, admitted that "I could never *live* in a house like that." In a strange

passage in his essay—which makes much of the contrast between a shadowy Asia and a bright, gleaming West—Tanizaki goes so far as to claim some kind of connection and correspondence between the aspects of light through paper and the "slight cloudiness" of the Japanese complexion: "When one of us goes among a group of Westerners it is like a grimy stain on a sheet of white paper." This is perhaps a Japanese version of *Jüdischer Selbsthass*, and a notion to be resisted, but we might nonetheless be inclined to agree with the rather less controversial contention by the paper historian Sukey Hughes that "A people living in houses divided by sliding paper partitions and windowed with translucent paper screens will behave and think quite differently from a people surrounded by stone walls, stout wooden doors, and glass windows."

For those of us imprisoned by stone walls, and stout wooden doors, and glass windows—which would of course include most Japanese—the closest we come to the soft luminosity of a traditional *shōji*-paneled Japanese room might be through our giant white moon-shaped paper lamp shades, with their spiral bamboo supporting structures, central metal struts, and thin paper coverings, possibly bought from Habitat in the 1970s, though just as likely from BHS or an out-of-town superstore. Historically, these derive from the ancient folding paper lanterns known in Japan as *chōchin*, introduced during the fourteenth century from China, widely used during the Edo period (1603–1867), and popularized in the West by the Japanese-American artist and designer Isamu Noguchi in the 1950s, when he began making what he called *akari* lanterns, having been inspired by a visit to a traditional lantern-making factory in the Japanese town of Gifu. As our ersatz-Gifu lamps cast their limpid glow over our stripped pine

floors and ethnic rugs, we might once again contemplate one of the paradoxes of paper; that it can so often be misread: Noguchi's big round paper lamp shades never really caught on in Japan.

Japonism in the home is also evident in japanning, the imitation lacquerwork derived from methods used in China and Japan, which became popular in the eighteenth and nineteenth centuries to decorate papier-mâché furniture and fancy goods. Beds, wardrobes, dressing tables, washstands, tea trays and whatnots—at one time, just about anything and everything in the home might have been made of cheap papier-mâché tricked out with inlaid mother-of-pearl, some transfer print floral designs and some good plain black japanning. "Frames for pictures and divers fine pieces of embossed work with other curious movables, may, as trial has informed us, be made of it . . . either painted or overlaid with foliated silver or gold, as the artist pleases," wrote the inventor and alchemist Robert Boyle in the seventeenth century: papier-mâché was like a base metal ready to be transformed into gold. (Indeed, Tiffany & Co. produced papier-mâché trinkets in the late nineteenth century, though the most curious nonprecious precious object ever made from paper was probably the jewel-encrusted papier-mâché papal tiara made for the coronation of Pope Pius VII in 1800.) The term "papier-mâché," according to the *Oxford English Dictionary*, is used to describe a "substance consisting of paper-pulp or paper reduced to a pulp (often mixed with other substances), and shaped by moulding" ("Not of French origin," notes the *OED*, witheringly; the phrase seems to have originated in England, perhaps among paper-chewing paper workers). The technique was used in China, to make helmets, spread to Japan and to Persia, where it was used to make

masks, and eventually developed into an industry in England in the eighteenth century, with a Henry Clay—onetime assistant to the typefounder John Baskerville, himself a pioneer of japanning—taking out a patent for pasting together sheets of paper over molds of metal in 1772. Strong, durable and capable of being sawn and planed like timber, Clay's papier-mâché could be used to make not only snuffboxes and bibelots, but window shutters, dressing tables, and even a sedan chair for Queen Caroline. Developments in Clay's production process followed, accompanied by ever more elaborate forms of ornamentation: in 1866 the *Art Journal* decried "these glaring absurdities of colour and pearl shell that manufacturers less intelligent consider to be the absolute requirements of the art." Modern manufacturers more intelligent—including Dutch-born German designer Mieke Meijer, with her Newspaper-Wood, and David Stovell, with his Sunday Papers stools, and those numerous others who make variously pleated, plaited and puffy paper chairs—tend to make a virtue of paper as their material. (Frank Gehry, who dabbled with cardboard furniture back in the early 1970s, remarked that "The nice thing about it is that you can simply tear off a bit and throw it away if you don't like it.") In current design practice, paper is to be celebrated: in the nineteenth century the point was to make it look like something else; it was an elegant illusion.

Which brings us, finally, to wallpaper. (We shall draw a veil of decency over other household goods and products that have sometimes been mimed and mimicked by paper, including doilies, curtains, blinds—and carpets. Or at least certainly a carpet, manufactured by Holdship's Paper Mill in Pittsburgh, Pennsylvania, that seems, according to an account in the *Pittsburgh*

Statesman in 1829, to have been a large, decorated, varnished piece of paper made for a man with more money than sense.)

Traditions of wall decoration go back at least to the Romans and Egyptians, with their frescoes and friezes, and beyond that to the painted stone slabs in Namibia, the vast murals in the Ajanta caves in India, and the Paleolithic paintings at Lascaux in France. Cloth ("stuff") and fabric wall hangings came next, with early European wallpapers, dating from the fifteenth century, appearing as fabric substitutes, consisting of small squares of woodblock-printed paper used to decorate movable panels (Louis XI of France liked to take his angel-print wallpaper with him wherever he was traveling). The Chinese were almost cer-

Twentieth-century printed wallpaper based on a hand-painted Chinese original

tainly producing wallpaper first, but the earliest known wallpaper in England, discovered at Christ's College, Cambridge, in 1911, dates back to 1509: disappointingly, it consists merely of a woodblock print on the back of an old proclamation; more like a tatty poster than actual wallpaper. Paper wall hangings became fashionable in England during the seventeenth century: we know they became fashionable because the government imposed a tax on any paper that was "painted, printed or stained to serve as hangings" in 1712, and falsification of wallpaper stamps soon became punishable by death.

The repeal of the wallpaper tax in 1836, and the development of a surface roller printing machine in 1839–40 meant that by the end of the nineteenth century wallpaper was inescapable. Sugden and Edmondson—not a firm of family lawyers but the authors of a standard history of wallpaper—estimate that in the 1830s around 1.25 million rolls per annum of hand-printed wallpaper were being produced in England. By 1874 this figure had risen to thirty-two million rolls. It got everywhere. When Gustave Flaubert climbed the Great Pyramid in 1849 he was appalled to find an advertisement for wallpaper at the top—"Imbeciles have written their names everywhere: 'Buffard, 79 Rue Saint-Martin, wallpaper manufacturer,' in black letters." Oscar Wilde, in his lonely first-floor room in the Hôtel d'Alsace in Paris, was famously reputed to have remarked, "My wallpaper is killing me, one of us must go." The hotel still stands: the room has been redecorated. Wilde in fact died of cerebral meningitis, but many of his true words were spoken in jest. Nineteenth-century wallpaper really was killing people: the addition of arsenical pigments into paper had been slowly poisoning the many middle-class and poorer families who tried to brighten up their lives with a splash of

Three-color block-printed wallpaper from the William Morris workshops, 1897

color. William Morris, one of the century's most prolific wall-paper designers, dismissed the "arsenic scare" and continued to use the pigments in his swirling botanical creations, though at his own house at Kelmscott he preferred to hang tapestries—the real thing. Wilde, meanwhile, advised others to choose "joyous paper on the wall, full of flowers and pleasing designs," while for his own London house on Tite Street he chose imitation leather Japanese paper—much rarer, darker and stranger. Do as they say seems to be the lesson of the nineteenth-century aesthetes, not as they do.

Wallpaper, then, is paper at its most deceptive, designed specifically to echo, imitate or allude to other more expensive materials, such as marble or textiles. (In 1912 Georges Braque famously picked up some wood-effect wallpaper in a shop in Avignon and used it for his *Bowl of Fruit and Wineglass*, the first of his celebrated *papiers collés*.) It can also transport you else-where. William Morris asked his wallpaper-buying public, "Is

it not better to be reminded however simply of the close vine trellises which keep out the sun . . . or of the many-flowered meadows of Picardy . . . than having to count day after day a few sham-real boughs and flowers, casting sham-real shadows on your walls, with little hint of anything beyond Covent Garden in them?" Home *and* away. There is even wallpaper that imitates other wallpaper: mock flock, which imitates the flock wallpaper that was itself designed to imitate velvet wall hangings; wallpaper as infinite regression. "The difficulty of choosing wallpapers is one which has been felt by all those lucky or unlucky enough to have had at any period to face the ordeal of furnishing a house," mused the *Art Journal* in 1899. "The variety of styles, colours and designs still further tend to bewilder the chooser." One might almost prefer the strange but practical wall coverings chosen by Gaffer Hexam in Dickens's *Our Mutual Friend* (1865), whose house is papered with handbills announcing the dead:

> Taking up the bottle with the lamp in it, he held it near a paper on the wall, with the police heading, BODY FOUND. The two friends read the handbill as it stuck against the wall, and Gaffer read them as he held the light . . . "Now here," moving the light to another similar placard, "his pockets was found empty, and turned inside out. And here," moving the light to another, "her pocket was found empty, and turned inside out. And so was this one's. And so was that one's. I can't read, nor I don't want to it, for I know 'em by their places on the wall . . . They pretty well papers the room, you see; but I know 'em all. I'm scholar enough!"

Here, at least, the integrity and purpose of the paper is acknowledged: Josef Albers would have approved.

8

THE SECRET IS
THE PAPER

Drawings are only notes on paper . . .
The secret is the paper.
JOHN BERGER, "Drawing on Paper" (2005)

21/4ᵗʰ

Stencil cutout figures, their shape determined by the fragments of paper
holding the sheet together

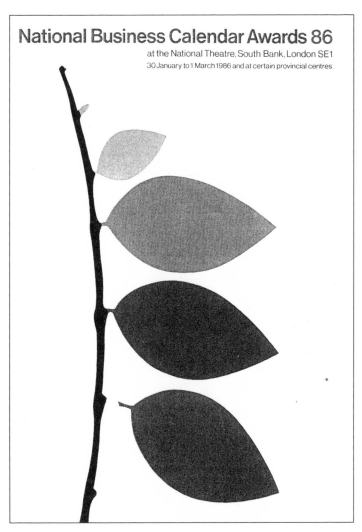

National Business Calendar Awards 86

at the National Theatre, South Bank, London SE1

30 January to 1 March 1986 and at certain provincial centres

Poster by Tom Eckersley in cut paper

Of course, not all art takes place on paper. And not all art on paper is paper art. And some paper art may not be everyone's idea of art at all: anyone for Lucio Fontana's paper piercings? Or Gordon Matta-Clark's paper slits and cuts? Joe Goode's pellet-peppered paper? Martin Creed's *Work No. 88, A sheet of A4 paper, crumpled up into a ball* (1994)? Or—my own favorite, a masterpiece of its kind—Tom Friedman's *1000 Hours of Staring* (1992–97), stare on paper, 32½″ x 32½″, which is, as you might guess, nothing more than a plain white piece of paper that has been stared at. For a long time. Probably by you, the viewer. (Or more probably by you, the buyer, seeking enlightenment and an answer to the obvious question, "I bought what?") If not a long hard stare, then at least let us take a quick glance at paper and its role in the history of art.

The phrase "works on paper" in a *catalogue raisonné* often refers to that part of an artist's oeuvre that is somehow less achieved and less significant than the rest of the work, the words echoing the idea that something that might look good on paper wouldn't really work in the real world, when properly translated onto canvas, say, or into bronze or marble. Picasso, works on paper? Meh. What about the proper stuff? The big stuff. The Art. There are of course artists who make capital "A" art mainly *in* and *through* paper, rather than merely *on* paper: Mark Langan, for example, and Annika von Hausswolff, who both make

art from corrugated cardboard; and Ron Resch, with his elaborate paper-folding experiments; and Andreas Kocks and Mia Pearlman, who make large-scale paper installations; and Oliver Herring, with his photo-sculptures, in which he builds up multi-colored patches of paper over people's bodies; and many, many other contemporary artists, in fact, in what one might almost suggest is a worldwide artistic "turn to paper," so many of them are there; so many that it would seem churlish not to give lots more of them a mention. So: Su Blackwell, Peter Callesen, Thomas Demand, Brian Dettmer, Amy Eisenfeld Genser, Christina Empedocles, Franz Gertsch, Osang Gwon, Anna-Wili Highfield, Bovey Lee, Winifred Lutz, Jade Pegler, Andrew Scott Ross, Simon Schubert, Lu Shengzhong, Ingrid Siliakus, Bert Simons, Karen Stahlecker, Richard Sweeney, Kako Ueda. Paper artists all. But let us begin with artists' paper.

Until the beginning of the nineteenth century all artists' paper was handmade—because, of course, all paper was handmade. It was therefore expensive. The price of a ream of paper in the seventeenth century was the equivalent of an average week's wages: apprentice artists tended to use erasable drawing tablets in order to learn their craft, and even established artists were not likely to waste paper on mere sketches and drawings. There are oil paintings on paper by Rembrandt, and Delacroix, and Holbein the Younger, but these were usually pasted to other surfaces, and paper was by no means the first resort as an artists' material, even in China, where proprietary brands of paper (including the most celebrated, *Ch'êng Hsin T'ang*, "Mind-clarifying Hall") were available as early as the tenth century. Naturally, this brings us to an important question, what the great art historian Martin Kemp calls *"die Materialfrage,"* the materials ques-

tion: how far does the material available to an artist determine the nature of his or her work?

Paper—unlike, say, a block of marble, or a large wall in a temple or a church—tends to allow artists second, third, fourth, fifth and infinitely further thoughts. Leonardo da Vinci was arguably the first artist to develop a style on paper in the late fifteenth century, through his process of continual, incessant sketching and drawing, creating what E. H. Gombrich calls a "welter of *pentimenti.*" Is it possible that artists before Leonardo never had second thoughts, asks Gombrich, trying to comprehend the sheer scale and sketchiness of Leonardo's works on paper. It's possible that they didn't, but it seems just as likely that they simply weren't using a material that allowed them first to express and then to store and keep their second thoughts for us to study. Like a generous grant from the Arts Council, paper provides an artist with both the time and the space to develop his or her ideas. Leonardo probably started keeping his famous notebooks at around the age of thirty-five, and scholars have estimated that he wrote at least one or two pages every day for thirty years: the astonishing six thousand sheets of notes and drawings that were bequeathed to his friend and pupil Francesco Melzi and which survive are thought to represent only about a fifth of what he actually produced. Leonardo didn't just think *on* paper: he thought *through* paper. Paper was not the preliminary to other work: it *was* the work. On March 22, 1508, he wrote of his own notes, in his famous mirror handwriting, *"e questo fia un racolto senza ordine, tratto di molte carte le quali io ho qui copiate sperando poi metterle per ordine alli lochi loro, secondo le materie di che esse tratterano"* ("And this is to be a collection without order, taken from many papers which I have copied

here, hoping to arrange them later each in its place, according to subjects of which they may treat"). Paper enabled Leonardo to experiment without restraint and without order: it's what made him modern.

And what is true of Leonardo is true—eventually, and to much a lesser extent—of us all. Ann Bermingham, in her magisterial study *Learning to Draw: Studies in the Cultural History of a Polite and Useful Art* (2000), argues that paper was the crucial medium that allowed for the development not only of great art, but also of amateur art, and of DIY subjectivity: "The construction of the modern subject cannot be considered apart from the privatization and standardization of information initiated by the introduction of paper. Paper helped to create a new enunciative space in which modes of individuality could be formed and expressed." Have hardback, spiral-bound Daler-Rowney sketchbook, or a nice sheaf of sized papers, will express myself; it's a story that has been repeated again and again throughout the history of modern art.

In the French town of St. Quentin, for example, in 1890 a young man, twenty years old, a lawyer's clerk, was admitted to the hospital with suspected appendicitis. He had been rather drifting through life, unfocused and unsatisfied. He particularly resented his dull daily work in a lawyer's office, where he filled endless pointless pages with endless pointless writing. In the bed next to him was a patient who was amusing himself by copying a picture of a Swiss chalet. Painting was relaxing, this other patient told the young man, he should give it a go; also, he enthused, "You end up with something to hang on the wall." Intrigued, the young man decided to try his hand with a sketchbook and paints. "From the moment I held the

box of colours in my hand, I knew this was my life . . . It was a tremendous attraction, a sort of Paradise Found in which I was completely free, alone, at peace . . ." The work the young man later proudly called *"Mon premier tableau"* was a still life with books placed on a sheet of torn newspaper. He dated and signed it in the corner, *"Juin 90 essitam, H."*—his signature in reverse. Henri Matisse's love affair with art had begun.

Fast forward fifty years and Matisse is again recovering from a serious illness. He is now a semi-invalid, often confined to bed or to a wheelchair. What's remarkable is that this second bout of illness and convalescence leads to possibly an even greater outpouring of creativity than the first. The first illness led Matisse to paint. The second led him to paper.

Matisse had first used paper cutouts for his costume designs for a ballet by Diaghilev in 1920, and had returned to experimenting with the medium in the early 1930s, when he had used them as models for his work on murals and magazine covers; but he didn't start working seriously with paper until 1943–44. He completed his last sculpture in 1950, and his last painting in 1951: the remaining few years of his life he devoted entirely to cutting paper. "The cut-out paper," he explained in a letter in 1948, "allows me to draw in colour. It is a simplification." Paper allowed Matisse to get back to basics, to return to what mattered: this was *"une seconde vie,"* his second life. "I have needed all that time to reach the stage where I can say what I want to say," he wrote, and he could only say it through paper.

The process Matisse described as "drawing with scissors" worked like this: first, he had his paper colored with gouache, in colors so bright that his doctor advised him to wear dark glasses. He would then take up his scissors and create his motifs and

figures, as well as the negative shapes from the paper discards. He would then arrange, or rather direct the arrangement of, the cutouts on a wall: he liked to surround himself with them, to be with them and even to sleep among them. "You see as I am obliged to remain often in bed because of the state of my health, I have made a little garden all around me where I can walk . . . There are leaves, fruits, a bird." Photographs of Matisse's paper-hung house at Vence, the Villa le Rêve, and at the Hôtel Régina in Nice, look like paintings by Henri Rousseau.

Matisse's first major work in paper as a medium was, appropriately, a book, *Jazz* (1947). (The history of artists' books—among which we might include the works of William Blake and Ed Ruscha and Sol LeWitt, and the magazine *Poor. Old. Tired. Horse*, and, for the sake of argument, the philosopher Jacques Derrida's *Glas* (1974)—is another neglected area of study that we too shall have to neglect.) *Jazz* contained color plates of the cutouts, along with Matisse's handwritten thoughts on his subject matter and his new method: "Cutting into living colour reminds me of the sculptor's carving into stone." In his final years, the paper cutouts were also used as the basis for his work in other media—stained glass, ceramics, textiles, printing. Even the various designs for the Chapel of the Rosary of the Dominican nuns at Vence, which Matisse regarded as his masterpiece, started out with the paper and scissors. But it is in the large cutouts themselves, the *gouaches découpés*, that Matisse really found full expression for what the art critic Robert Hughes in a memorable phrase described as his "flat-out chromatic intensity": paper cutouts allowed him to be both flat-out, and intense. The famous *L'Escargot*, the four seated blue nudes (*Nu Bleu I, II, III* and *IV*), and the fifty-four-foot-long *La Piscine*: in these works, through the medium of paper, Matisse

achieves an extraordinary effect of both complete density and total light. "When I am doing the cut-outs," he remarked in an interview in 1952, "you cannot imagine to what degree the sensation of flight which comes to me helps me better to adjust my hand as it guides the path of my scissors." The tensions and anxieties and struggles that are apparent in all of his earlier work as a painter (most obviously in *La Conversation*, a painting as good as a divorce) are finally overcome in Matisse's obvious, physical pleasure in contact with paper. "I have attained," he wrote, "a form filtered to its essentials." Critics, of course, were snippy. They found the work infantile: "Need we even concern ourselves with these cut-outs?" asked a reviewer in *Cahiers d'art*, after an exhibition in 1949.

Escaping from the demands of paint and canvas, artists have often found themselves fleeing into the welcoming arms of paper (as Matisse himself eventually fled from his wife Amélie, turning toward both his work and his model and assistant, Lydia Delectorskaya). Indeed, it's possible to argue that the development of modern art and sculpture derives entirely from what the critic Clement Greenberg called the "pasted-paper revolution." The use of paper collage in the early twentieth century, according to Greenberg, liberated art from being merely decorative, an illustration of reality. Take, for example—as Greenberg does not, but we shall—Joan Miró, who decided in the 1920s that his aim was to "assassinate painting." Miró's first, rather halfhearted act of rebellion was to stick postcards on canvas, but then in 1933 he began cutting images of machines and tools from catalogues and sticking them to large sheets of Ingres paper. He then began to use the outline shapes formed by these cutouts as models for his paintings: this was

his revelation, his big breakthrough. Released from the constraints of self-expression and spontaneity, Miró had found an unexpected route to the vague symbolic language that characterizes his later work, with its unique constellations of shapes, signs and lines. In order to find the true language and expression of his art, Miró, like Matisse, had to start with scissors and paper. Indeed, famously taciturn with visitors, it's said that Miró would become suddenly animated when speaking of his collection of fine papers—pastel paper, sandpaper, tar paper, deckle-edged paper. Paper brought him alive.

But before Miró's weird symbols, and before Matisse and his massive color bursts, there was of course Picasso: he went through his paper phase earlier than anyone. (And returned to it later. His bent and folded metal sculptures of the early 1960s— *Woman*, *Standing Woman* and *Standing Nude (Bather)*—not only resemble Matisse's paper cutouts, but might even be regarded as a kind of homage to them, and to Matisse's techniques.) Picasso's friend Georges Braque—who had trained as a painter and decorator—had started making cardboard models sometime around 1912, though these are all now lost or destroyed. Picasso, who had early mastered the art of one-upmanship, went one further than Braque. He made his own cardboard model—of a guitar—and then made a model of the model from pieces of sheet metal and wire, and thereby, according to the art historian Tim Hilton, "effected a sculptural revolution . . . that at one stroke changed the nature of sculpture for ever." *The Guitar* (1913) is revolutionary because it's assembled rather than having been carved or crafted. This principle of assembly became standard practice in twentieth-century art—and so, arguably, from a couple of cardboard models, we get readymades,

unmade beds and pickled sharks. (The role of cardboard in the development of modern art is, alas, another subject that we cannot pursue at any great length, though it is worth noting at least in passing that at his nightclub, the Cabaret Voltaire, in Zurich around 1916, Hugo Ball used to recite his poems in a cardboard suit made for him by fellow Dadaist Tristan Tzara; that Robert Rauschenberg in the 1970s, in his Cardboard series, confined himself entirely to working with used cardboard boxes; and that for the now legendary "Freeze" exhibition in 1988, the exhibition that inaugurated Britart, the best that Damien Hirst could manage was a few small cardboard boxes mounted on the wall.)

Picasso and Braque further destroyed the illusionistic and handmade appeal of art—and "challenged the whole bourgeois concept of art as something precious, valuable, and to be prized like jewellery," according to John Berger—by doing nothing more complicated than pasting paper onto paper. Picasso's *Man with a Hat* (1912), for example, is made of three pieces of rectangular paper, two from a newspaper, strategically placed on a larger sheet of paper, with a few charcoal marks to suggest a face—a kind of amateur Arcimboldo—and between 1912 and 1914 he pasted sheet music, wood-grained paper, colored paper, wallpaper, visiting cards, packs of cigarettes, playing cards and a box of matches onto his canvases. The illusion of painting's privileged surfaces and space was over. "We tried to get rid of *trompe l'oeil* to find a *trompe-l'esprit*," explained Picasso. For a show of Cubist pasted-paper work at the Galerie Goemans in Paris in 1930 Louis Aragon published a little book on collage, *La peinture au défi* (*In Defiance of Painting*), in which he writes of Picasso, "And it was his pleasure to paste a piece

of old newspaper, to add a few lines in charcoal, and that was that: that was painting." Paper was being used to expose itself and its own illusions. In this sense, *papier collé* (pasted paper) is a form of *écorché*, like one of those illustrations by Vesalius, with the skin stripped off to show the workings of the muscles.

The techniques of Cubist paper collage caught on and were adopted by, among others, German Surrealist Max Ernst, who also invented the technique known as *frottage* (which involves rubbing through paper onto surfaces beneath); Spanish Surrealist Óscar Domínguez, who developed the technique of decalco-mania (which involves painting gouache onto paper and pressing it onto other surfaces); and just about every other self-respecting twentieth-century avant-gardist of any kind, including Dadaists, Lettrists and Situationists; but perhaps most remarkably by the German artist and poet Kurt Schwitters, who went beyond any "-ist" and whose all-encompassing work *Merz* was a combination of "all conceivable materials," manifesting itself eventually in his *Merzbau*, or *Kathedrale des erotischen Elends* (Cathedral of Erotic Misery), a paper-collage and found-materials sculpture incorporating sliding doors, passageways and grottoes that took over his entire studio in his house in Hannover and which was abandoned only when he had to flee the Nazis in 1937. The obvious appeal of paper as a material for artists of a conceptual inclination is that it is cheap, widely available, comes in multiple forms, and is easy to reproduce. Among the Britartists of the late 1980s and 1990s, Sarah Lucas, for example, produced work using newspaper clippings, including *Sod You Gits* (1990), which consists of a photocopied enlargement of a page from the *Sunday Sport*. And among Joseph Beuys's many "multiples"—works of identical objects produced

in limited editions—one finds lists, letters, boxes, photocopies, postcards, writing paper, envelopes, tissue paper, catalogues, photographic proofs, magazine covers, LP record sleeves, flyers, wills, menus, packing paper, customer survey cards, newspapers, forms, maps, ballot papers and various paper bags ("dimensions vary"). Beuys speaks of the "vehicle" quality of his multiples, referring to their capacity to carry meanings and ideas, the main idea presumably being that everybody is an artist and everything is potentially art, particularly paper.

Surprisingly perhaps, paper remains the medium of choice for many of the most radical and politicized of contemporary artists. "I choose paper because of its accessibility," says German sculptor Thomas Demand. "It's an 'open' material. We all have the same memories of paper, and I can use your experience to make you understand what I am saying." One might easily construct not only a history of modern art but also a history of modern politics from artists' works on paper—prints, posters and drawings—all the way from Goya to Otto Dix and George Grosz, to Aleksandr Rodchenko and the Soviet poster makers of the 1920s and 1930s, to the revolutionary art of Mexico and China, and the work of printmakers today (see, for example, www.streetartworkers.org). When the French painter and printmaker Honoré Daumier made lithographs denouncing the corruption of the court of King Louis Philippe in the 1830s, he was thrown into jail. When the artist Shepard Fairey used—without permission—a photograph of Barack Obama as the basis for his much-reproduced stenciled "Hope" poster during the 2008 American presidential election campaign, the photographer took him to court. The Obama poster, initially printed by hand in a small batch by Fairey, and eventually

reproduced everywhere on signs, flyers, stickers and badges, has an immediate, low-tech, anachronistic appeal: it suggests the workmanlike pull of ink through a screen with a squeegee, and thus the human scale of the Obama project. Paper, somehow, despite all the odds, remains radical. The contemporary political printmaker Mathew Curran says that "When I'm cutting out stencils I'm resisting the machine. It's me, a blade, and a sheet of paper." The artist Daniel Alcalá: "I use cut paper—a demanding and obsessive technique—to underscore the craft of making and the direct involvement of the artist in the work." And to go back to Thomas Demand: "Paper is the material of temporary notation. It doesn't make a big difference whether this is in writing or is three-dimensional . . . It's a strange anything-material that can be anything, but is rarely itself . . . Basically it's the 'Zelig' of all materials."

9

THE SQUIGGLE GAME

This game that I like playing has no rules.
I just take my pencil and go like that . . .

D. W. WINNICOTT, "The Squiggle Game" (1968)

Handmade paper incorporating flower petals

HOW TO MAKE YOUR OWN LIGHTNING

You will need:

A balloon; wool clothing (such as a wool sweater);
a metal surface (such as a filing cabinet)

1. Inflate the balloon
2. Darken the room as much as possible.
3. Rub the balloon against the wool sweater about 10 times.
4. Move the balloon close to the metal surface.

The balloon is being used to create static electricity. A flash or spark
will jump, like lightning, from the balloon to the metal.

The story goes that Bodhidharma, the big-bearded, mad-eyed monk who brought Zen Buddhism from India to China, and who taught martial arts to the Shaolin monks, once spent nine years meditating, facing a wall. *Nine years.* He spent so long meditating, in fact, that his image became engraved on the wall and his legs fell off: tales of Bodhidharma make Butler's *Lives of the Saints* seem like a walk in the park. In another story, Bodhidharma is said to have nodded off while meditating: on waking, he promptly cut off his eyelids in self-disgust. According to the story, when his eyelids hit the ground, tea plants sprang miraculously from it, which is why tea is used as a stimulant to keep students of meditation awake. In yet another story, Bodhidharma is said to have refused to teach a student until the student had cut off his arm in order to demonstrate his sincerity, a teaching method that, like many teachers, I am sorely tempted to employ. And in yet another tale, the Emperor Wu is said to have asked Bodhidharma what was the meaning of truth, to which he winningly replied that there was no truth, only the eternal void. But to return to the nine-years-meditating-and-legs-withering-away story: this explains why the Japanese papier-mâché dolls known as Dharma or Daruma dolls, which are representations of Bodhidharma, have no legs. They are round and hollow, and weighted at the bottom—like Weebles they wobble, but they don't fall down, wherein lies

their moral—and each spring, fairs are held in Japan at which the dolls are sold and blessed, to act as good-luck charms for the coming year. The previous year's dolls are ceremonially burned. So it goes: the great Buddhist holy man becomes first a legend, and then a papier-mâché doll destined for the flames.

Toys are not only an expression of culture, they are a fundamental means of acculturation, the means by which and through which we teach ourselves about ourselves. The cultural theorist Walter Benjamin—who collected not only toys and word games, and puzzles and brainteasers, and nice stationery, but also the odd and amusing remarks of his young son, Stefan—asks in one of his several essays on toys, "For who gives the child his toys if not adults? And even if he retains a certain power to accept or reject them, a not insignificant proportion of the oldest toys . . . are in a certain sense imposed on him as cult implements that became toys only afterward, partly through the child's powers of imagination" ("Toys and Play," 1928). Paper has played a central role in this two-way system of imposition and emancipation: infinitely scriptable and flexible, paper is the cult implement to beat all cult implements. Paper playthings, and playthings made of paper, abound and surround us from childhood to old age, from pin the tail on the donkey and pass the parcel at children's parties, to London *Times* and *Daily Telegraph* cryptic crosswords, and from board games to card games, to puzzles to Pokémon cards, and from dress-'em-up paper dolls to knock-'em-down piñatas. If toys represent a primitive form of expression and self-expression, a form of consolation and representation—a miniaturization and schematization of life itself, no less—then paper has often been the means by which that expression takes place. In Japan a game called *Fukuwarai* (Lucky

Laugh) requires blindfolded players to pin a nose, eyes, ears and a mouth onto an image of a blank face—a game that epitomizes creative paper play. So, let's play *Fukuwarai*.

We'll begin with a paper chase (*the* paper chase, or, rather, *The Paper Chase* was of course a TV series that ran during the late 1970s and mid-1980s, set at Harvard Law School, in which the veteran actor John Houseman played irascible Professor Charles W. Kingsfield, who would begin each episode with the memorable admonition, "The study of law is something new and unfamiliar to most of you, unlike any other schooling you have ever known before. You teach yourselves the law, but I train your minds. You come in here with a skull full of mush and, if you survive, you leave thinking like a lawyer"). Perhaps the most famous paper chase in history takes place in E. Nesbit's *The Railway Children* (1906), which is itself a kind of paper chase. In the novel—as you will doubtless recall from the film—the railway children's father has been sentenced to prison, having been charged with selling state secrets, on the evidence of some letters found in his desk. Eldest daughter Bobbie discovers this fact from a chance glance at a pile of papers ("A sheet of old newspaper wrapped round a parcel—just a little chance like that—had given the secret to her"), and the novel's pivotal paper chase—a game of hare and hounds, in which one of the participants gets injured in a railway tunnel, and is rescued by the children—serves as a device to bring the children together with the kind but nameless "old gentleman" who then assists them in their quest to free their father. Thus, the paper chase resolves the initial paper misunderstanding: plot almost as a form of paper folding, or gift wrapping. (Might one suggest a kind of paper *Poetics*? An origami Aristotle? A fold-up Freytag triangle? Rising

action as creases; crisis and climax as folds; denouement a form
of unwrapping?)

I can trace my own paper trail back to its roots in family gath-
erings and special occasions long ago, when my grandfather—
my mother's father, who was one of the first Allied troops
into Belsen, a man of few words who spent all his money on
greyhounds, and whom we all adored, and who died young,
and for whom my sister and I would dutifully make cigarettes
from Rizlas and Golden Virginia in his solid-brass cigarette
machine—would roll sheets of newspaper into a tube, tear out
a section from the middle, and then magically pull up a ladder.
He called it Jacob's Ladder: "And he dreamed, and behold a
ladder set up on the earth, and the top of it reached to heaven:
and behold the angels of God ascending and descending on
it . . . And he was afraid, and said, How dreadful is this place!
this is none other but the house of God, and this is the gate of
heaven" (Genesis 28:11, 19). If not exactly the gate of heaven,
it was at least my introduction to the possibilities of paper as
a source of fun and entertainment, a source that never seemed
to dry up: one uncle's party trick was to pass his body through
a sheet of paper; another played paper and comb; and my fa-
ther could pour water into rolled-up cones of paper and make
the water disappear. Paper was cheap and it was plentiful: the
stuff of everyday magic. Houdini's *Paper Magic: The Whole Art
of Performing with Paper, Including Paper Tearing, Paper Folding
and Paper Puzzles*, published in 1922, remains a fine compila-
tion of all the essential party paper tricks (including, I now dis-
cover, all the tricks performed by my family), and is dedicated
by Houdini to his private secretary, John William Sargent, "to
whom I am indebted for many a cheerful hour of interesting

conversation, and who always endeavored to make me look upon life as a pleasant voyage instead of a continual struggle for existence and survival of the fittest." Paper eases our passage through life, through games, tricks and puzzles.

Left to our own devices, there are a thousand ways to pleasure ourselves with paper. We might doodle or squiggle, revealing ourselves on the page (and to the likes of D. W. Winnicott, who devised what he called a Squiggle Game, in order to elicit and intuit the thoughts and feelings of children in psychotherapeutic conversations). We might try our hand at crosswords. We might go spotting trains. With a friend we might play hangman, or tic-tac-toe, or—much better—sprouts, a marvelously simple and infuriating game invented by two Cambridge mathematicians in the 1960s, which makes tic-tac-toe look like child's play (for sproutster rules and regulations see the World Game of Sprouts Association online, www.wgosa.org). At a party, we might hit a piñata, which is not necessarily made of papier-mâché, though often it is. (The word derives from the Italian *pignatta*, meaning "fragile pot," and a piñata *could* be a fragile pot, though these days it's much more likely to be a cardboard donkey, or a child-size Homer Simpson made in China and filled with Haribo, an ugly mass-market version of the classic piñata, which is one among the many products of the traditional Mexican paper crafts of *cartonería, amate* and *alebrije*.) Exhausted from our piñata-smashing, we might then retire to the parlor to make paper models or dress up paper dolls: personally, I have a working paper clock kit that I'm saving for retirement, and I dream of the Micromodels Vatican; in Japan, the making of *anesama ningyo* (paper dolls) remains popular; the French still have their *pantin*, the little paper puppet; and

there are, or there were, paper Barbies, and countless other cut-out-and-keeps from children's and women's magazines, the first English paper doll, produced in the early 1800s, being the memorably named Little Fanny. Of paper planes, more later.

By the mid-nineteenth century, in Europe at least, the manufacture of paper toys and amusements had grown into an industry—there were peep shows and panoramas, and slot books, and of course the famous toy theaters, those miniature theaters with their actors made from printed cardboard that could be cut, pasted, colored and embellished, and through which and within which and upon which generations of children first found imaginative expression. We know from stories and letters and memoirs that toy theaters and their theatricals were important in the formation of the imaginative lives of, among others, Dickens ("Out of this delight springs the toy-theatre . . . a teeming world of fancies so suggestive and all-embracing, that . . . I see dark, dirty, real Theatres in the day-time, adorned with these associations as with the freshest garlands of the rarest flowers, and charming me yet"); Lewis Carroll (who exhibited his toys and gadgets in his rooms at Christ Church); John Gielgud (who for Christmas in 1911, aged seven, was given an elaborate toy theater, which became his childhood obsession); the novelist Elizabeth Bowen (who wrote an essay on the influence of toys on the imagination); and perhaps above all, Robert Louis Stevenson, a writer who never lost touch with his inner child. In a little essay, "A Penny Plain and Twopence Coloured" (1884), Stevenson recalls the childhood thrill of shopping for paper characters for his theater: "Every sheet we fingered was another lightning glance into obscure, delicious story; it was like wallowing in the raw stuff

Toy theater from the Pollock collection

of story-books." Stevenson praises in particular the work of one of the publishers of what were called "juvenile dramas," Skelt, going so far as to call all true works of art "Skeltery," born of the kingdom of "Skeltdom":

> What am I? what are life, art, letters, the world, but what my Skelt has made them? He stamped himself upon my immaturity. The world was plain before I knew him, a poor penny world; but soon it was all coloured with romance . . . Indeed, out of this cut-and-dry, dull, swaggering, obtrusive, and infantile art, I seem to have learned the very spirit of life's enjoyment . . . acquired a gallery of scenes and characters with which, in the silent theatre of the brain, I might enact all novels and romances; and took from these rude cuts an enduring and transforming pleasure.

A moving testimony to the power of paper. But then suddenly, at the end of his essay, in characteristic fashion (this is the author, after all, not only of *Treasure Island*, but also of *The Strange Case of Dr. Jekyll and Mr. Hyde*), Stevenson torments himself with a horrible vision:

> I have a dream at times that is not all a dream. I seem to myself to wander in a ghostly street . . . There in a dim shop, low in the roof and smelling strong of glue and footlights, I find myself quaking treaty with great Skelt himself, the aboriginal all dusty from the tomb. I buy, with what a choking heart—I buy them all, all but the pantomimes; I pay my mental money, and go forth; and lo! the packets are dust.

And so the paper drama concludes the way all human dramas must: in destruction. Paper goes the way of all flesh.

The production of toy theaters for children seems to have developed from the production of theatrical prints—collectible images of actors and actresses. But what of all our other myriad games and toys? Where did they all come from? And how did they begin? Monopoly? Scrabble? Ludo? Clue? Scrabble? Pictionary? Trivial Pursuit? In the standard Oxford history of board games, *A History of Board-Games Other Than Chess* (1952), H. J. R. Murray, having catalogued some 270 games, including the Tibetan "Migmang" ("Said to resemble chess, but more likely draughts"), the Indian "Ratti-chitti-bakri" and the Icelandic "Ofanfelling," speculates about the ancient origins of such games:

> In the heat of the day when work in the open air is too arduous, or when the day's work is over and the daily needs of his family are met, man's innate urge to be something still impels him to action, if only to the handling of objects at

hand, whether natural like pebbles, or some of his household goods of his own making, at first aimlessly, but as soon as his attention is held, to explore their capabilities for new uses.

As we've seen before, capabilities for new uses emerge particularly quickly with the addition of paper—new forms of advertising, new possibilities in art, new ways of thinking. Paper as manure: plant stuff in it and watch it grow. Many board games have been played perfectly well for centuries with or without paper—draughts and chess, Parcheesi, lotto—but during the nineteenth century, with improvements in printing and in papermaking, and particularly with the invention of chromolithography in the 1870s, board games became not merely popular but *products*.

Late-nineteenth-century board game

In America, board-game manufacturers sprang up every-where—from Parker Brothers and Milton Bradley in Massa-chusetts, to Selchow & Righter and Clark & Sowdon in New York—and it's possible to trace the family history of almost all of today's board games back to their cardboard-boxed, chromolith-ographed nineteenth-century American ancestors. Monopoly, for example, is clearly derived from games such as Monopolist (1885), The Checkered Game of Life (1860), The Mansion of Happiness (1843) and Bulls and Bears: The Great Wall St. Game (1883). Trivial Pursuit bears more than a passing resemblance to The World's Educator, produced by the W. S. Reed Toy Company in 1887, which came in a sturdy wooden box containing two thousand questions on sets of beautifully colored cards. Scrab-ble is based on Anagrams. Etcetera, etcetera—all board games come to resemble one another the closer one looks, receding as far as the eye can see.

The dominant player in the American board-games indus-try during the late nineteenth and early twentieth centuries was McLoughlin Brothers, which claimed in its catalogues that "Games are a necessity in every family, and parents should see to it that their children are well supplied with them. They not only amuse, but serve to instruct and educate them." Instruction and education took many forms—McLoughlin and its rivals pro-duced alphabet boxes, spelling slips and word games aplenty, encouraging numeracy, literacy and good old-fashioned reason-ing skills. They also encouraged competitiveness, ruthlessness and an echt American can-do spirit, with rags-to-riches games such as Game of the District Messenger Boy, Or Merit Rewarded (1886) and its various spin-offs, including The Game of the Telegraph Boy, Or Merit Rewarded (1888) and The Game of the

Little Volunteer (1898). Parker Brothers' Pit (1904) taught commodity trading; J. Ottmann's The Sociable Telephone (1902) taught good manners; and the Rhode Island Game Company's The Great Game: Uncle Sam at War with Spain (1898) reminded children of the new nation's proud history.

All of this educational earnestness may explain why so many proprietary board games, even to this day, are—frankly—so utterly and profoundly dull, and why many of us are much happier with an entirely different kind of cardboard amusement at Christmas and on holidays and holy days: the humble jigsaw. The novelist Margaret Drabble provides a useful reminder of the great solitary pleasure to be had from "assembling little pieces of cardboard into a preordained pattern" in her fully interlocking memoir, *The Pattern in the Carpet: A Personal History with Jigsaws* (2009), in which she classifies puzzling as one of the *Halbkünste*, a half-craft, somewhere between an "idle diversion and domestic economy."

In fact, as Drabble acknowledges, even puzzles originated with a serious educational purpose. The origins of the modern puzzle are usually traced to the work of one man, John Spilsbury, who made a dissected map in 1762 while serving as apprentice to Thomas Jefferys, geographer to George III. Young Spilsbury quickly established himself as a commercial mapmaker specializing in dissected maps, and was soon advertising himself as an "Engraver and Map Dissector in Wood, in order to facilitate the Teaching of Geography." The children's literature historian Megan A. Norcia claims that puzzles were indeed an important part of teaching geography to children, particularly in Britain, and particularly in relation to the nation's imperial achievements and ambitions. Puzzles, according to Norcia,

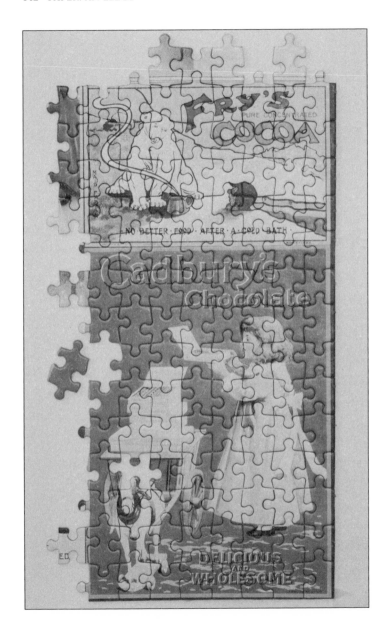

helped teach generations of British children "imperial skills such as discovery, collection, administration, organization and discipline." This grand imperial puzzle purpose may perhaps have pertained during the late eighteenth and early nineteenth centuries, when a puzzle was printed on paper, colored by hand, and pasted on mahogany or cedar about an eighth of an inch thick—more like a tool than a toy—but by the 1880s the puzzle industry was mostly using thin cardboard instead of wood, and by the 1930s steel die-cutting had replaced the need for costly fretsaw or bandsaw workmanship, allowing for cheap mass production, and so finally the puzzle became a disposable item of cheap amusement, available to all. (The puzzle historian—there are such—Anne D. Williams traces the beginning of the "puzzle craze" in America to one year, and one particular month, June 1932, when the Prophylactic Brush Company of Florence, Massachusetts, offered a free fifty-piece puzzle to toothbrush buyers; the craze so gripped the nation that by 1933, the American puzzle industry was turning out ten million puzzles per week, with the Eureka Jig Saw Puzzle Company producing a gargantuan thirteen-foot-long puzzle of fifty thousand pieces.)

Paper toys and games can be used to educate, then, and to establish and encourage social norms, behaviors and understandings. They can be used to amuse and to entertain. And they can of course be used for gambling. Any thin, stiff piece of material can be used as a playing card: playing cards can and have been made from metal, from leather, and from wood; an iron pack of cards produced in Vienna in the nineteenth century is estimated to have weighed over a pound, and in India there have been cards made of ivory, of stiffened fabric

and of mother-of-pearl. But there's nothing quite as handy for a rubber of bridge or a quick game of canasta as a deck of round-cornered, pneumatic-finished, double-ended quality card stock playing cards. Detlef Hoffmann notes in *The Playing Card: An Illustrated History* (1973) that "This is the advantage of playing cards: they can be painted or printed in any manner desired and it is only necessary for their value to be shown at some point on the card." The obvious advantage of paper playing cards is that they are also infinitely reproducible: one deck is as good as another, although anyone who has ever been on vacation will have been shocked to find that suit marks differ from country to country (the Spanish and the Italians with their cups and batons and money and swords; the Swiss with their shields, flowers, bells and acorns; the Germans with their hearts, leaves, bells and acorns; and the Koreans . . . the Koreans traditionally had an eight-suit deck of man, fish, crow, pheasant, antelope, star, rabbit and horse, which must have made for quite a game of rummy). Some nations, furthermore, have only twenty-four cards to a deck, and others more than a hundred. Japanese *karuta* card games, which include the poetry game *uta-garuta*, and the monster-matching game *obake karuta*, use many more. The permutations—and the games—are endless, but the cards remain the same.

One legend has it that playing cards were invented by the wife of an Indian maharajah in an attempt to stop her husband fiddling with his beard; another, that they developed among the concubines of the Chinese imperial harem, to while away the long evenings in the inner chambers. It's more likely that paper playing cards date back to about the twelfth century in China and Korea, and somehow found their way to Europe—

maybe via India or Persia—where, according to Roger Tilley in *A History of Playing Cards* (1973), "The love of card games proved highly contagious, in the manner of a pandemic disease infecting people far and wide." And nowhere more contagious than in gambling-friendly Russia, where in the late nineteenth century 14,400 packs of cards were being produced per day. In his 1928 essay "Dostoevsky and Parricide," Freud famously connected the gambling instinct with a kind of masochistic criminality, a trait perhaps as common among writers as among Russians. (Dostoevsky's short novel *The Gambler*, published in 1867 and written to pay off gambling debts, while gambling at Baden-Baden, offers an insight into the mind not only of the gambler, but of the artist.) In America during the late nineteenth century, the manufacturers Russell, Morgan & Co. were dealing out just 1,600 packs a day, though as the greatly enlarged and amalgamated United States Playing Card Company, they are now the largest manufacturer of playing cards in the world, selling around a hundred million decks per year: we're all masochists now. The paper-borne disease persists.

It seems a truism that without playing cards, many of us would have more money, but in fact without playing cards, we wouldn't have any money at all. Or certainly not money as we know it today. It was through developments in the making of specialist paper and inks for the manufacture of playing cards that printers devised what are now the standard methods for security printing—which is to say, the printing of money, stamps, passports and official papers and licenses. And so, briefly, in conclusion, for masochists and gamblers worldwide, the cheering tale of how cards once made money, rather than helped us to lose it.

In 1830, Thomas de la Rue, a printer born in Guernsey, having experimented with a brief, unlikely career making straw hats, established himself in business with a couple of partners in London as "Cardmakers, Hot Pressers and Enamellers." The business flourished—and the success was built on playing cards. (It's said that Thomas Andros de la Rue, grandson of Thomas, had the houses on Cadogan Square renumbered so that his would be number 52, to honor the source of the family's fortune.) In order to produce identical, patterned card backs—and thus to prevent players from being able to cheat by identifying marks on the backs of plain white cards—Thomas de la Rue developed a method of making lines "like the checks of tartan" using a "cloth of wires" on a Jacquard loom. In 1840 he was awarded a patent for "Improvements in printing calicoes and surfaces," applying his card-making methods to printing "bankers checks, bills, etc. bank notes, post office envelopes or any work requiring great difficulty of invention." By 1853, de la Rue had secured a contract from the Inland Revenue to produce adhesive revenue stamps for drafts and receipts; by 1855 the company had produced its first postage stamp; and by 1860 it had begun printing banknotes. And it produces them still today, for over 150 countries. According to company records, de La Rue's pretax profits for 2011 rose to £57.7 million (approximately $98.7 million), and at the time of writing, in May 2012, it was busy denying rumors that it was producing drachmas in anticipation of Greece leaving the eurozone. *Le jeu pour le jeu?* Serious business.

10

A WONDERFUL
MENTAL
AND PHYSICAL
THERAPY

Origami is not meant to be a simple art.
To the expert, it is a challenge to the eye,
the brain, and the fingers, a wonderful mental
and physical therapy.

ROBERT HARBIN, *Origami: The Art of
Paper-Folding* (1968)

Three-dimensional paper construction made from brown wrapping paper

On Friday, July 24, 1992, a Mrs. Lillian Rose Vorhaus Oppenheimer, ninety-three years old and a native New Yorker, died of complications after a heart operation at the Beth Israel Medical Center in Manhattan. Mrs. Oppenheimer was survived by her four children by her first husband, Mr. Joseph B. Kruskal, by her four stepchildren by her second husband, Mr. Harry C. Oppenheimer, by her twenty-six grandchildren, thirty great-grandchildren, and by anyone who has ever had a serious interest in origami.

There is a common belief that origami is an ancient art with mystical origins in Japan that was brought to the West long ago by nameless pioneer paper folders. In fact, origami as we know it today has its origins in Lillian Oppenheimer's apartment on top of the Hotel Irving, in Gramercy Park, Manhattan, where she established the Origami Center of America in 1958. Indeed, the entire history of origami in the twentieth century might be told as Oppenheimer's story, the uplifting tale of a New York socialite who overcame tragedy and found purpose in life through paper folding. Or it might equally be told as the cautionary tale of a maverick Jewish sexologist whose pioneering work on a bibliography of an obscure subject brought origami to worldwide attention, but whose controversial opinions and behaviors consigned him to the margins of the very enterprise he had helped to establish. Or indeed as the story of a South African

stage illusionist who achieved everlasting fame through folding tiny figures on TV. Or perhaps as a heroic folktale, of how a humble, self-taught Japanese paper-folding genius was saved from a life of obscurity as a door-to-door salesman by a series of chance encounters. These are all versions of the incredible recent history of paper folding—a history with as many folds and creases as an origami rhombicuboctahedron, or one of origami master Satoshi Kamiya's famous one-sheet, folds-only, super-lifelike scaly dragons. Paper doesn't merely record drama: it enacts drama. It doesn't merely tell a story: it is a story.

Lillian Oppenheimer first took up paper folding in 1928, when her young daughter was in the hospital recovering from a serious operation and Lillian found that she had 1) time on her hands; and 2) a copy of a popular new book by William D. Murray and Francis J. Rigney, titled *Fun with Paperfolding*—the first book in English devoted solely to the art and craft of paper folding. Lillian sat in the hospital waiting room making models, her daughter recovered, they returned home, and Lillian got on with the serious business of raising her family. Twenty years later, when her husband became ill, she once again found herself stuck in hospital waiting rooms, and once again found herself playing with paper. After the death of her husband, she took handicraft classes at the New School for Social Research in New York with a young woman who had trained as a kindergarten teacher in Germany, and who taught the class some basic paper-folding techniques. Enthused, Lillian started reading books about the craft, and began meeting friends and others to share models and ideas: she preferred the exotic term "origami" to plain old "paper folding." (In its original context, origami—from *"oru,"* to fold, and *"kami,"* paper—refers spe-

cifically to folded certificates rather than to recreational paper folding, but it had gradually been adopted as a common term for paper craft in Japan.) When an article about Lillian and her origami evenings appeared in the *New York Times* in June 1958, people started asking for lessons and demonstrations, and so the Origami Center of America was born, meeting on Monday evenings and Tuesday afternoons in Lillian's apartment in the Hotel Irving. In the words of her friend and fellow paper folder Florence Temko, "In these meetings, Lillian established the spirit that pervades the origami world to this day. We all folded together and whoever had come across something new or created a model, shared it with the others." Late in life, Lillian had found her role. She helped organize the first origami exhibition in America, at the Cooper Union Museum in New York in 1959, she began producing a newsletter, *The Origamian*, and she visited and corresponded with origamists and enthusiasts around the world. She was also, incidentally, a puppeteer, one of the founding members of the Puppetry Guild of Greater New York, and an amateur ventriloquist, writing books with her friend Shari "Lamb Chop" Lewis. She was, in other words, a phenomenon. International Origami Day is rightly celebrated on October 24, Lillian's birthday: she is, without doubt, the founder of origami as a popular modern recreation.

As for the maverick Jewish sexologist . . . Gershon Legman was the amazingly freethinking son of immigrants, born in Scranton, Pennsylvania, in 1917. He was a man of broad tastes and enormous energies: often credited as one of the inventors of the modern vibrating dildo, an achievement more than sufficient to secure both his notoriety and his fame, he also worked for the sex researcher Alfred Kinsey, and at the

age of just twenty-three he published a book memorably titled *Oragenitalism: An Encyclopaedic Outline of Oral Techniques in Genital Excitation. Part 1: Cunnilinctus* (1940), with ambitious plans for a follow-up book on fellatio. (His poor parents had hoped he'd become a rabbi.) *Oragenitalism* was effectively banned when its publisher's premises were raided by police. Undeterred, Legman went on to publish numerous other studies of sexual behavior and folklore, including *The Horn Book: Studies in Erotic Folklore and Bibliography* (1964) and *The Rationale of the Dirty Joke: An Analysis of Sexual Humor* (1968). Apparently, allegedly—the legends of Legman are legion—he took up paper folding merely as a hobby after an accident, but he pursued it with the same enthusiasm and determination as his wide-ranging studies in sex. He researched both the history and the contemporary worldwide practice of paper folding, and compiled and published a bibliography of his findings in 1952. He named the standard four-cornered origami fold the "blintz" fold (though somehow he seems to have confused his blintzes with his knishes, a blintz being a kind of rolled pancake, and a knish something more recognizably folded), and in the early 1950s he sought out an obscure paper folder in Japan, named Akira Yoshizawa, and brought his work to Europe.

Legman's place in the pantheon of paper folding was therefore assured—except that he managed to fall out with many of his fellow paper folders, and so became the black sheep of the family. He resigned from the United States Origami Association, according to his biographer, Mikita Brottman, over an argument about "a badly bent corner," and David Lister, a retired solicitor from Grimsby who is perhaps the most unlikely but undoubtedly the greatest living Western authority on origami history, re-

marks, with studied understatement, that "It is unfortunate that Legman often adopted an aggressive personal manner." A friend, the writer John Clellon Holmes, described Legman as a "psychiatric Genghis Khan." If Oppenheimer is origami's mother figure, Legman is undoubtedly the wayward uncle.

And that obscure paper folder, Akira Yoshizawa? Yoshizawa

Paper-folded dragon

is in fact modern origami's great-grandfather, the father of the multitude. Born into a family of farmers, Yoshizawa worked as a draftsman and studied for the Buddhist priesthood before deciding to pursue origami full-time, surviving by selling condiments and snacks door-to-door. Already age forty, in 1951 he was invited by the editor of a prestigious Japanese pictorial magazine, *Asahi Graph*—similar to *Life* magazine in the USA— to produce some models to be photographed for publication. Finally, his reputation began to spread. In 1953 he was contacted by Legman, who helped organize an exhibition of his work in Amsterdam, and in 1954 Yoshizawa published his

first book, *Atarashi Origami Gejijutsu* (*New Paper-Folding Art*). With fellow origami artist Sam Randlett he established the internationally accepted system of notation for origami folds, the Yoshizawa-Randlett system, with its now-familiar little arrows and dotted lines; he also developed the technique of so-called wet folding, which is exactly as its name suggests; and, most important, he produced models of exquisite beauty. His trademark gorillas are a wonder: perfectly proportioned baby Kongs. He was, simply, a great artist.

And to complete this strange family picture? The bespectacled, balding South African stage illusionist Robert Harbin: modern origami's father figure. I should perhaps admit an interest here: the first book I ever bought, long before I bought a novel or any slim volume of verse, was one of Harbin's guides to origami, *Origami 3: The Art of Paper-Folding* (1972). I'd missed *Origami 1* and *Origami 2*, but as a teenager I seem to have been attracted to the idea of being able to make creatures out of almost nothing, and with no tools, using only my hands—*Origami 3* features a couple of startlingly bright green turtles on the cover, crawling across sand as if they've just emerged, fresh spawned, from the primordial swamp—and I was inspired also by Harbin's TV series, *Origami*, which used to be on when I got home from school.

Harbin was a conjuror who had become fascinated by paper folding as a kind of trick or show, and whose *Paper Magic* (1956) was one of the pioneering English works on the subject. He got to know Legman and Oppenheimer, corresponded with Yoshizawa, and became the first president of the British Origami Society—he was an authority—but on television he would simply sit at a table, address the camera familiarly and

directly, and talk you through the making of a model, step-by-step. He made it sound easy. Watching Harbin I think I realized that paper folding was in some profound way about making things smaller and simpler, and as a teenager I perhaps had the sense, like a lot of teenagers, that I myself wished to be smaller and simpler, to be able to disappear almost, to enfold and enclose myself and to become something different, and of the essence. Unfortunately, although I had Harbin's book as a guide, I soon discovered that there was no actual origami paper to be had in Essex in the 1970s. Indeed, in our house, there was hardly any paper to be had at all. My father would occasionally smuggle some A4 sheets home from work, and I would cut these down into squares, but it was too thick and too white to be able to make satisfactory models. I eventually found that carbon paper was much better for folding, except that it left your hands blue-black; so throughout the mid-1970s I fought a long and lonely battle with paper, attempting to fold mucky, flimsy dolphins, and birds, and dogs, and weird little pointless boxes. I never could do Harbin's turtle.

Oppenheimer, Legman, Yoshizawa, Harbin: these are just some of the characters in the strange history of paper folding. There are many others, as amazing as they are unexpected: Miguel de Unamuno, the Spanish novelist and philosopher, who loved to fold *"parajitas,"* little birds; Adolfo Cerceda, the Argentinian professional knife thrower turned paper folder; the matronly and massively prolific Florence Temko, every beginning folder's best friend; polymathematic Martin Gardner, the popular science writer who promoted origami through his long-running column in *Scientific American*; dear Alfred Bestall, the children's illustrator and cartoonist who drew Rupert Bear

for the *Daily Express*, and whose Rupert annuals traditionally included an origami model; the magnificently prosaic John Smith, who in the 1970s invented what is now called Pureland origami, which allows only for the simplest of folds; the incredible Robert Lang, the onetime research scientist turned full-time paper folder and one of the new wave of precision paper folders to emerge in the 1980s and 1990s, who works with laser cutters to make his folds, and designs his work using his own specialist origami software; and of course Sadako Sasaki, the little girl who survived the bombing of Hiroshima, but who developed leukemia, caused by the radiation, and who in the hospital, dying, folded a thousand paper cranes, that they might bring her good luck, and whose friends and classmates built a memorial for her in the Peace Memorial Park in Hiroshima, where to this day people fold paper cranes to honor her memory.

But enough about the people. What about the paper? The first thing to be said about origami paper is that it's not ordinary paper, as I discovered to my cost as a teenager. Ordinary paper is usually rectangular, while origami paper is usually square. (David Lister suggests that origami paper is square not merely because a square has unique geometrical properties—what doesn't?—but because a square always has the *same* geometrical proportions, and so patterns and diagrams for folding square paper are easily transmissible; origami's fundamental squareness, one might say, is the reason for its popularity.) Ordinary paper is white; origami paper comes in many colors. Ordinary paper can be bought by the ream at stationery stores; origami paper is available mostly in Japan, or on the Internet. In the West, the most widely available origami paper is *kami*,

which comes in packs of thin, square, uncoated paper, six-inch or ten-inch, colored on one side and white on the other. This is what we think of as traditional origami paper. And as with most traditions, it's about as traditional as a ploughman's lunch, Christmas trees—or, indeed, Christmas itself. (Everyone knows it was the Victorians who invented Christmas, but it might be more accurate to say that it was the Victorians who invented Christmas as a cheap pulp Saturnalia, complete with cards, puzzles, board games and decorations. Paper makes Christmas. And so does origami: the entomologist Alice Gray, a curator at the American Museum of Natural History, who was a friend of Lillian Oppenheimer's, used to dress the Christmas tree at the museum with origami models, and the origami Christmas tree is now a museum tradition of long standing. Gray's book *The Magic of Origami* (1977) contains an excellent section on origami Christmas models, though the great Florence Temko trumps it with her all-inclusive *Origami Holiday Decorations* (2003), which contains paper decorations suitable also for Hanukkah and Kwanzaa.)

The nontraditional traditional Western *kami* paper—the word in Japanese can refer to any kind of paper—seems to have been developed for use by children, and perhaps derives from the style of paper used by the Froebel kindergartens. Friedrich Froebel was a nineteenth-century German educationalist who believed in educating children through play, using a number of what he called "gifts" and "occupations." The gifts consisted of wooden blocks and balls and sticks, and the occupations were exercises in understanding the properties of solids and surfaces and lines, using the gifts and other materials including beans, seeds, pebbles and pieces of string. *Papierfalten*—paper folding—was one

of the occupations designed to teach children about surfaces. An enthusiastic account of the newfangled Froebelian methods in Dickens's *Household Words* in 1855 noted in particular that "By cutting paper, patterns are produced in the Infant Garden that would often, through the work of very little hands, be received in schools of design with acclamation." Froebel kindergartens usually used paper that was blue on one side and white on the other, the contrast being useful because it aided the understanding of geometry and shape, and useful also because it was cheaper to have one side uncolored. The first Japanese Froebel kindergarten was opened in Tokyo in 1876, and the idea of the gifts and occupations—including paper folding—influenced the development of Japanese educational practice and philosophy. In an example of what one might call reverse-fold colonialism, origami paper has therefore made a long journey first from Germany to Japan, and then from Japan back to the West.

Serious paper folders, like all serious people—except writers, who are often content with pens and backs of envelopes—tend to use specialist equipment in order to practice their art. Most specialist paper used for origami is made not of wood pulp, but of other plant fibers, which haven't been brutally chemically mashed and ground, and which don't contain lignin, the chemical compound that usefully binds and strengthens wood cells but which tends to make paper turn yellow and brittle. Classic papers for origami include Japanese *kozo* and *gampi*, Korean *hanji*, *lokta* from Nepal and *unryu* from Thailand. A particular favorite among European paper folders is Zanders Elephant Hide, which weighs in at around 110 gsm (compared to the standard 70–80 gsm weight of copier paper and 120 gsm for card stock) and has a rugged, parchmentlike texture, high

tensile strength, and a profound memory for creases, which means a fold will last forever. I have about a dozen sheets that at £10 (approximately $16) a pop I'm too scared to fold. When I die, I want to be wrapped in my Zanders Elephant Hide and buried in a paper coffin (an Ecopod, produced by a company in Brighton, made from recycled newspapers and finished with paper made from 100 percent mulberry pulp, each coffin equipped with carrying straps and a calico mattress; I'm going for the Indian red, screen-printed with an Aztec Sun). To create Yoshizawa-style soft creases and curves, you need to wet-fold, which requires a certain kind of paper prepared with a lot of sizing that dissolves when wet, making the paper malleable and soft but not soggy. A good cheap wet-folding paper is standard watercolor paper, which you can dampen with a cloth and then fold as you would normally. For folding intricate models, Robert Lang has a cheap DIY method for making springy, malleable paper, which requires a roll of tinfoil, some tissue paper and a can of artist's spray adhesive. Lang calls this paper "tissue foil." Once you go to tissue foil there's no going back.

But there is going over. For the foolhardy and the very intrepid, extending and exploring the full possibilities of paper folding might seem logically to lead to paper *cutting*, though in Manichean fashion, paper cutting is also, logically, the *opposite* of paper folding: a fearful symmetry. Paper folding decreases area; paper cutting increases perimeter. Paper folding honors unity; paper cutting enacts separation. Just as paper folding evolved in similar forms throughout the world, so paper cutting has a global history of great variations and similarities, a global history that is yet to be written. The Japanese have *kirigami*. The Chinese have *jian zhi*. The Spanish, *papel picado*. In

Germany, *Scherenschnitte*. In Poland, *wycinananki*. India has *sanjhi*, and a Jewish family traditionally has about the home both a *ketubah*, a paper-cut marriage contract, and a *mizrach*, a paper-cut wall plaque indicating the direction of prayer. These are all traditional forms and practices. One of the most accomplished contemporary paper cutters, Rob Ryan—whose work has graced *Elle* magazine, *Vogue*, book covers and Erasure's neglected album *Nightbird*—explains the appeal of the form:

> To me, papercutting means that everything is stripped down as much as possible. There is no tone, no variation of colour, no pencil mark, no brush strokes. There is only one piece of paper, broken into by knives; within this is the picture, the message, the story, written and traced in silhouette . . . We all really share only one story, and my work tells that story over and over.

Another artist who told one story over and over was Hans Christian Andersen. Renowned, obviously, for writing fairy tales, Andersen was also an obsessive paper cutter. About 250 of his paper cuttings have survived: unique in style and extraordinary in range, they deserve to be as well known as his writing. When Andersen was a child, his father made him a paper toy theater, with paper puppets, and in his autobiography Andersen writes that his "greatest delight" was making clothes for these puppets. In a sense, it became his life's work: fashioning paper as he refashioned stories. Andersen—lowly born, self-obsessed, forever craving acceptance, and who never married, never had children, never even owned a house, and indeed seemed barely able to function as a normal human being—loved above all to perform his stories for an audience. As he spoke he would simultaneously cut out paper figures to illustrate what he was

saying, a kind of paper performance art. One contemporary, describing such an event, recalled that "When he had finished his tale, he would spread a whole string of ballet dancers in front of us. Andersen would be delighted with the success of his work. He enjoyed our praise of it more than the impression made on us by his story." The paper cuts were perhaps his in a way the stories could never be. Indeed, in one of his sad little poems, Andersen reflected, "In Andersen's paper-cuts you see/His poetry!" How true! His paper cuts feature stylized swans, cinch-waisted dancers, hoop-earringed ghouls, grinning skulls, misshapen hearts, gibbets and palaces, the very stuff of his folk-tales, but made entirely, vividly his own.

Andersen always used white paper for his cutouts: it's what gives them their ghostly quality, like intimations, or photographic negatives of the other world, or of the world of hidden emotions; paper again providing an important bridge into the human interior and our endless unwritten hinterlands. In his methods and in his fantastic style Andersen was, in effect, an antisilhouettist. Silhouettes, or shadow portraits, as they were sometimes known—or shadow pictures, shades, profile miniatures, shadowgraphs, skiagrams, scissortypes, black shades or, simply, likenesses—were the most popular form of portraiture in the eighteenth and early-nineteenth centuries. The word "silhouette" derives from the name of the ill-fated minister of finance under Louis XV, Étienne de Silhouette, who attempted to levy taxes on the rich and even to curb royal spending: he lasted all of eight months in his post in 1759. The use of the word "silhouette" to describe black profile portraits may derive from the idea of Monsieur Silhouette as a skinflint, and thus a silhouette as a cheap form of portraiture—*à la silhouette,*

on the cheap—or it may refer to M. Silhouette's fleeting tenure as minister, or perhaps to the fact that he liked to cut profiles himself. Whatever the etymology of the word, the art of the silhouette can in fact be traced back long before poor Silhouette, to the black profiles on Greek pottery (the very first silhouette was often said to have been made by Dibutade, the "Maid of Corinth," the daughter of a Corinthian potter who, according to Pliny the Elder, traced her profile as it was cast by candlelight on a wall).

The physiognomist Johann Kaspar Lavater was a great enthusiast for silhouettes, as he was a great enthusiast for many other things, describing them in his bestselling *Physiognomische Fragmente zur Beförderung der Menschenkenntnis und Menschenliebe* (1775–78) (*Essays on Physiognomy; Designed to Promote the Knowledge and the Lore of Mankind*) as the "truest representation that can be given of man." As well as being a great enthusiast— or perhaps because of it—Lavater was also a terrible exaggerator. Despite his meticulous instructions and recommendations for the creation of perfect machine-cut paper profiles, using a pantograph and particular paper ("the shade should be taken on post paper, or rather on thin oil paper, well-dried"), the

silhouette soon became a cheap and cheerful sideshow enter-
tainment, a vulgar art form knocked off in a couple of min-
utes by hawkers and hucksters. Indeed, the art of paper-cut
silhouettes eventually became so lowly regarded that the col-
lector Desmond Coke, in his book *The Art of Silhouette* (1913),
was at great pains to point out—in strained italics—that *"The
best silhouettists never touched a pair of scissors."* Coke notes that
the "quartette supreme" of eighteenth-century silhouettists—
John Miers, Isabella Robinson Beetham, Charles Rosenberg
and A. Charles of the Strand—all painted their portraits on
card, glass or plaster, though even Coke has to admit that the
most famous silhouettist of all time, Auguste Amant Con-
stance Fidèle Edouart, did indeed work with lowly scissors and
paper.

Edouart was the Johnny Cash of paper cutters, a wayfar-
ing stranger who called himself the "black shade man." "The
beauty of those Likenesses," he wrote, "consists in preserving
the dead black, of which the paper is composed." (Research
at the National Portrait Gallery on Edouart's work shows that
he used paper treated with bone black and Prussian blue, the
blue to make the black seem blacker.) Edouart arrived in En-
gland from France in 1814, and after more than a decade per-
fecting his art and sharpening his wits—his portrait of William
Buckland and his wife and son examining Buckland's natural
history collection (*c.* 1828) is typically whimsical—he traveled
on to the United States. Edouart's method was consistent and
simple: he would fold his paper once, with the black side in,
so that two copies would be produced, one of which he would
keep for reference in an album, and then he would make a
quick sketch, pick up his embroidery scissors—small, sharp

and with long handles—and begin to cut. On completion he would sometimes touch up the edges of the paper to accentuate the contrast between the black and the white mount, or paste the silhouettes onto an appropriate lithographed background (images of drawing rooms, battlefields, seascapes). To his great delight—he was not a modest man—Edouart made it in America. He was a silhouettist superstar. But as he was returning to England in 1849, tragedy struck. The ship he was traveling on, the *Oneida*, hit a fierce storm off the coast of Guernsey, and although Edouart was saved, almost all of his precious albums were lost: tens of thousands of silhouettes drowned in the depths of Vazon Bay, black on black. It's said that he never cut silhouettes again. With the invention of photography the industry would anyway soon come to an end, though of course as silhouettes disappeared, the paper remained: William Henry Fox Talbot's early "photogenic" method of producing photographic images was effectively a form of paper photography.

Both before and after photography there are many other paper arts and crafts, some of them half forgotten, many of them regarded merely as quaint, that combine folding and cutting and yet are neither: decoupage, embossing, quilling and paper cast as bas-relief. The patron saint of paper craft in all its bastard forms is, or certainly should be, the wonderful Mary Granville Pendarves Delany, friend of Handel, friend of Swift, and, one suspects, someone who would have been a very good friend of Lillian Oppenheimer. The story of Mrs. Delany's discovery, and her self-discovery, are well known. In 1772, elderly, widowed, but still lively as a grig, she was staying at Bulstrode, in Buckinghamshire, the estate of her friend the

Dowager Duchess of Portland. One morning, so the story goes, Mrs. Delany noticed the similarity in color between a piece of discarded paper and a geranium petal, whereupon she took up a pair of scissors and began to make a paper flower, which she then pasted and mounted onto black paper. Instantly, she had invented a new art form. She was seventy-two years old, but not unaware of her accomplishment: "I have invented a new way of imitating flowers," she wrote excitedly to her niece. She called it "paper-mosaick." Over the next sixteen years Mrs. Delany continued to work with scissors and tweezers and bodkin to make more and more of her paper flowers, almost a thousand of them, collecting them alphabetically in albums, which she named her *Flora Delanica*. The images—"intense and vaginal," according to one of her recent biographers, full of "precision and truth," according to Horace Walpole—are painstakingly composed from tiny pieces of rag paper painted with water-color and pasted onto pitch-black paper using flour and water. As a child Mrs. Delany had been taught the art and craft of making paper shades, or silhouettes, but with her paper flow-ers she transformed shades into color, and turned man-made paper back into the botanical.

Mrs. Delany's flowers have long outlived her. Her work can be seen today at the British Museum, and is periodically re-discovered by artists, writers and feminists, though Germaine Greer dismisses them entirely as "yet more evidence that, for centuries, women have been kept busy wasting their time." Greer hits the nail on the head but entirely misses the point. Paper, which derives of course from the word "*papyrus*," the Latinized Greek name of a plant called by the Egyptians *bublos*, which gives us the Greek *biblion*, and which in turn gives us the

Bible, is forever reminding us that we live in the land of darkness and the shadow of death, and that we shall all be changed, for this corruptible must put on incorruption, and this mortal must put on immortality. Is paper art a waste of time? Yes, absolutely. Of course. What isn't?

11

LEGITIMATIONSPAPIERE

Here are my papers [*Legitimationspapiere*],
now show me yours.

FRANZ KAFKA, *The Trial* (1925)

Deckle-edged handmade paper, the deckle in a contrasting color

PAPER

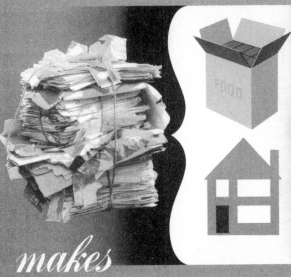

makes
containers and
building-boards

Save it for Salvage

I t is a single sheet of paper, with a British government crest at its head, containing three short, typewritten paragraphs, two handwritten signatures, and beneath the signatures a date, "September 30, 1938." It is probably the most famous piece of paper in twentieth-century history. It reads:

> We, the German Führer and Chancellor, and the British Prime Minister, have had a further meeting today and are agreed in recognising that the question of Anglo-German relations is of the first importance for our two countries and for Europe.
>
> We regard the agreement signed last night and the Anglo-German Naval Agreement as symbolic of the desire of our two peoples never to go to war with one another again.
>
> We are resolved that the method of consultation shall be the method adopted to deal with any other questions that may concern our two countries, and we are determined to continue our efforts to remove possible sources of difference, and thus to contribute to assure the peace of Europe.

Neville Chamberlain arrived back from Munich at Heston Aerodrome in west London, on British Airways Lockheed 14 G-AFGN, just before 6 p.m. on Friday, September 30, 1938. It had been his third trip to Germany in just over two weeks. Europe was in crisis and war looked imminent. After the Anschluss of March 1938, Hitler's territorial claims had only increased: he had set a deadline of September 28 for the Czech government to secede

the Sudetenland, its border territories, and his widely reported speech at the Berlin Sportspalast on September 26, according to his biographer Alan Bullock, was "a masterpiece of invective which even he never surpassed." In Britain, the Home Office had already posted to every household a handbook on protection against air raids. Gas masks had been issued. Trenches were being dug, and air raid shelters constructed. According to one historian, R.A.C. Parker, "On the morning of 28 September the inhabitants of British cities expected to endure German bombing within days or even hours." The Munich Agreement, signed in the early hours of September 30 by Germany, France, Italy and the United Kingdom, granting Germany the right to occupy the Sudetenland, in return for agreeing to allow an international commission to oversee future territorial claims, appeared the best possible outcome. It looked as though war had been averted.

So, Chamberlain alighted from the plane. Sixty-nine years old, smart, sprightly and clearly exhilarated. The large crowd gathered to meet him gave him three cheers. He shook hands with his cabinet colleagues, was welcomed by the lord mayor of London and then made a short statement. First of all he thanked the British people for their letters—"letters of support, and approval, and gratitude; I cannot tell you what an encouragement that has been to me." Then he went on:

> Next I want to say that the settlement of the Czechoslovakian problem, which has now been achieved is, in my view, only the prelude to a larger settlement in which all Europe may find peace. This morning I had another talk with the German Chancellor, Herr Hitler, and here is the paper which bears his name upon it as well as mine. Some of you, perhaps, have already heard what it contains but I would just like to read it to you.

He brandished the piece of paper, and read it aloud. There were more cheers. Indeed, crowds cheered him all the way on his journey to Buckingham Palace, in heavy rain, where he met King George VI, before finally returning to Downing Street, where he was persuaded to lean out of a first-floor window and declare to the many gathered well-wishers, "My good friends: this is the second time in our history that there has come back to Downing Street from Germany peace with honour. I believe it is peace for our time." Letters of thanks and telegrams came flooding in from all over the world—tens of thousands of them in just a few days. "Good man," cabled President Franklin D. Roosevelt. There were plans for statues to be erected in his honor. Streets were renamed after him, scholarships endowed in his name: he was a hero. "No conqueror returning from a victory on the battlefield," declared *The Times* on October 1, "has come home adorned with nobler laurels." By 1940 all the laurels had turned to barbs: Chamberlain was regarded by many as a guilty man, an appeaser.

He had been betrayed by a piece of paper; he had trusted in words, and words had run away with him. In the debate on the Munich Agreement on October 6 in the House of Commons he was already seeking to excuse himself, explaining that he had spoken from the Downing Street window "in a moment of some emotion, after a long and exhausting day, after I had driven through miles of excited, enthusiastic cheering people," and that people should "not read into those words more than they were intended to convey." Too late, because Hitler already knew exactly what such words conveyed, and how much they were worth: absolutely nothing.

Chamberlain's piece of paper had been signed after the of-

ficial meetings in Munich in the early hours of the morning on September 30, at Hitler's private flat in Prinzregentenplatz. Chamberlain had foreseen the importance of returning to England with something more tangible than a mere verbal promise about Germany's territorial ambitions, and had taken the precaution of bringing a typewritten statement with him. He later recalled that when he presented the piece of paper to Hitler, the Führer "frequently ejaculated '*ja, ja*', and at the end he said, 'yes, I will certainly sign it; when shall we do it?' I said 'now', and we went at once to the writing-table, and put our signatures to the two copies which I had brought with me." Chamberlain was so delighted to have secured the signature that according to one observer, he patted his breast pocket and exclaimed, "I've got it!" He'd had it. Chamberlain was—in the words of a recent biographer, Robert Self, "the quintessential rationalist." Hitler, alas, was not. Hitler was the *Künstlerpolitiker*, the artist politician, a rhetorician, someone for whom words could mean what he wanted, when he wanted. "For him," writes his biographer Ian Kershaw, "the document was meaningless." Indeed, when the German foreign minister, Joachim von Ribbentrop, complained to Hitler about signing the paper, the Führer told him not to worry about it: "That piece of paper is of no further significance whatever." It is of further significance, but not of the significance that Chamberlain might have hoped. It remains a sign of betrayal, a symbol of the moment at which the covenant is broken, and a piece of paper is revealed as exactly what it is, just a piece of paper. Duff Cooper, First Lord of the Admiralty, and one of Chamberlain's fiercest critics, resigned the day after the Munich Agreement, and later famously referred to Chamberlain's document as "that miser-

able scrap of paper." During the course of the Second World War, paper was to become more miserable still.

There were, of course, all of the various military uses of paper. Paper has been used as a weapon and in war for thousands of years—not least as a means of funding wars. When Queen Anne, for example, wished to raise money for the long-running War of the Spanish Succession in the early eighteenth century, Parliament obligingly introduced a tax on paper, one of the so-called taxes on knowledge, a tax that was steadily increased until being finally abolished in 1861. From taxes to bomber kites to war games to gun cartridge casings to uniforms and armor, paper has been used in every conceivable fashion both to inflict torture and to protect from pain. In China, during the late Tang Dynasty (AD 618–907), governor Xu Shang trained a notorious elite army of a thousand men who were equipped with armor made of thick layers of paper; they were invincible. (In Essex in the 1970s we used to make v-shaped paper pellets from blotting paper, which was heavy, and which stung, and which left a satisfying inky stain. Anyone caught firing paper bullets by one particularly cruel teacher was punished with what he called "the paper shower," which involved the entire class tearing pages from their exercise books, ripping them into tiny shreds and scattering them on the floor for the offenders to pick up, crawling on our hands and knees between and beneath the desks, while the rest of the class was encouraged to kick us. It was, I suppose, a lesson in retributive justice: a life for a life, an eye for an eye, and miserable scraps of paper for miserable scraps of paper. A harsh lesson, and a terrible waste: many of us were put off both education and any kind of white-collar paper-shuffling jobs for life; who needed it?)

During the Second World War, paper was used to make disposable gas tanks and protective window stripes—everybody needed it. It was a precious commodity. In Britain, a National Salvage Campaign was established in 1940; in America, the Salvage for Victory campaign began in 1942. Paper recycling was a patriotic duty. Indeed, so concerned was the British Records Association that important documents and books might be destroyed in the rush to recycle that it published a leaflet encouraging the public to "Look Before You Throw."

Elsewhere, the aim was to throw to get people to look. In early autumn 1939, the Germans dropped paper leaflets on the French troops stationed along the Maginot Line—they already had what one might reasonably call "form" in leaflet bombing, having first taken to the air to scatter pamphlets during World War I. Golden-hued and shaped as maple leaves, the leaflets featured a death's-head image and a message beautifully expressed, almost like a poem: *"Automne: Les feuilles tombent/Nous tomberons comme elles./Les feuilles meurent parce que Dieu le veut/ Mais nous, nous tombons parce que les/Anglais le veulent"* (Autumn: The leaves are falling. We will fall like them. The leaves die because God wills it, but we fall because the English will it). The British were also busy spreading rumors and information of their own: psychological warfare units were equipped with mobile printing presses to provide instant responses and rebuttals to Nazi attacks and propaganda. From the first recorded aerial drop of propaganda leaflets during the siege of Paris in 1870 to the wars and conflicts of today, it is impossible to calculate exactly how much paper has been used as a psyop tool, although Reginald Auckland, the world's leading authority on aerial-dropped leaflets, and the editor for many years of *Fall-*

ing Leaf, the strange-but-true magazine of the Psywar Society, calculated that during the Vietnam War alone, 6,245,200,000 pieces of paper were dropped from bombers and helicopters:

> So lavish were the propagandists with the paper and so enthusiastic were the crews that villages with populations of about one hundred were receiving 100,000 leaflets at one drop. Leaflets were seen everywhere in Vietnam: for wrapping food, in restaurants for wiping chopsticks or spoons, as wallpaper to block holes in poorer homes and, of course, as lavatory paper.

The Japanese, meanwhile, with their long and proud history of paper craft, had no intention of their paper weaponry ending up as toilet tissue. After the American Doolittle air raid

Japanese incendiary balloon

on Tokyo and other Japanese cities of April 1942, the Japanese government under Prime Minister Hideki Tojo made elaborate plans for retribution, including the hot-air balloon bombing of America. The balloons, with a diameter of ten meters, loaded with incendiary bombs, were made of *koso* paper layered into sheets and glued into sections, pasted with calcium chloride and shaped into giant balls. According to Therese Weber, in her book *The Language of Paper: A History of 2000 Years* (2007), during the Second World War a Japanese master papermaker reported that "most papermakers in the country were making paper for military use." But to no great effect. A few of the big paper balloons reached the west coast of California. No real damage was done.

But in Europe, paper caused havoc. In *The Truce* (1963), his book about his return home from Auschwitz—the companion volume to *If This Is a Man* (1947)—Primo Levi describes in detail how a culture of death and destruction was fed and fattened on paperwork. He candidly admits that "printed paper is a vice of mine," but clearly there are vices and there are vices, and during the war Levi, like millions of others, became trapped in the grip of a genocidal machine fueled by paper; this was not a paper vice, it was a paper factory, a smelting works, an industrial pulp plant. The definitive, and utterly shocking, work on Nazi technocracy and bureaucracy is *Die restlose Erfassung* (1984) by two German investigative journalists, Götz Aly and Karl-Heinz Roth—translated into English as *The Nazi Census* (2004)—whose data-dense argument is perhaps best summed up in the words of another historian writing about the period, John Tovey: "Passports, identification cards, population registries, and visible distinguishing marks intended to keep watch on and control the movements of Germany's population came to constitute an

interlocking if not flawless system of registration and tracking. These mechanisms facilitated the task of locating and monitoring Jews, with the ultimate result that they were available for extermination." A more recent tragic example of the casual link between documentation and death can be found in Africa, in Rwanda in 1994, with the mass slaughter of the Tutsi population by Hutu militia. A political scientist, Timothy Longman, sums up the disturbingly simple equation at work there: "Since every Rwandan was required to carry an identity card, people who guarded barricades demanded that everyone show their cards before being allowed to pass. Those with 'Tutsi' marked on their cards were generally killed on the spot."

In the transit camp at Katowice, Primo Levi was employed in checking for lice, and was required to record both the number of lice and the names of the sufferers on endless forms. He admits that he was delighted eventually to be granted his own special form, a *propusk*, "a permit of somewhat homely appearance" that enabled him occasionally to leave the camp, "a sign of social distinction." In all his books about his wartime experiences, Levi describes a world thick with paper and its implications. He watches the Red Army returning home from the Front, for example, arriving on trains, washing in freezing-cold water, and rolling cigarettes using sheets of *Pravda*. When he starts selling goods at a local market with a friend, the first thing they sell—"at the first attempt . . . without bargaining"—is a pen, and when finally he is about to be released from Katowice a Dr. Danchenko ominously arrives with "two sheets of paper":

> We were amazed to learn that the Command expected from us two declarations of thanks for the humanity and correctness

with which we had been treated at Katowice . . . Danchenko in turn took out two testimonials written in a beautiful hand on two sheets of lined paper, evidently torn from an exercise book. My testimonial declared with unconstrained generosity that "Primo Levi, doctor of medicine, of Turin, has given able and assiduous help to the Surgery of this Command for four months, and in this manner has merited the gratitude of all the workers of the world."

With this testimonial Levi is free, though his long journey home presents yet more paper obstacles:

> The local stationmaster, for example, had demanded our travel warrant, which notoriously did not exist; Gottlieb told him that he was going to pick it up, and entered the telegraph office nearby, where he fabricated one in a few moments, written in the most convincing of official jargon, on some scrap of paper which he so plastered with stamps, seals and illegible signatures as to make it as holy and venerable as an authentic emanation from the Top.

In the camps, Levi needed paper to survive—in *If This Is a Man* he describes being involved in the theft of some graph paper, to be used as a form of barter and currency—and after the war he remained dependent upon it. In a celebrated passage in *The Periodic Table* (1975) he describes how the atoms and molecules in his body urge him to make his mark: "It is that which at this instant, issuing out of a labyrinthine tangle of yeses and nos, makes my hand run along a certain path on the paper, mark it with these volutes that are signs: a double snap, up and down, between two levels of energy, guides this hand of mine to impress on the paper this dot, here, this one."

Paper is a tyrant and an oppressor, therefore, but also a savior

and a means of witness. This remains undoubtedly the greatest paper paradox of all. (Like Levi, the Palestinian poet Mahmoud Darwish famously explores these two sides of paper in his work, perhaps most famously in his poem "Identity Card": "Write down/I am an Arab/& my I.D. card number is 50,000.") Paper, our preeminent technology of the self, is both imposed upon us from outside, by others and by the state, constructing our identity for us and through us, but is also the means by which we shape ourselves, and become individuals, interiorized, unique and distinct. Paper makes us legible: it also makes us erasable. Memorable: dispensable. Priceless: worthless. Living: dead. (The poet Eugenio Montale has a poem, "The Decline of Values," which he wrote down, of course, and which is published in a book, and which reads, "Tear up your pages, throw them in a sewer,/take no degree in anything,/and you will be able to say that you were/perhaps alive for a moment or an instant.")

The sociologist Anthony Giddens, in *Modernity and Self-Identity: Self and Society in the Late Modern Age* (1991)—one of those breathtaking books written in the kind of jargon-rich prose that one can only sniff and inhale rather than actually digest and understand, and which seems therefore all the more profound, like the evocative smell of perfume, or cigar smoke at the scene of a crime—suggests that "In the post-traditional order of modernity, and against the backdrop of new forms of mediated experience, self-identity becomes a reflexively organised endeavour. The reflexive project of the self, which consists in the sustaining of coherent, yet continuously revised, biographical narratives, takes place in the context of multiple choice as filtered through abstract systems"—and, one would want to add, rather plainly, waving away the whiff of cigar smoke, on paper.

Paper is our primary method of identification and self-identification. Or in Giddenspeak, it is one of the key mechanisms of our reflexively organized posttraditional endeavor. I am my documents. Passports are an obvious case in point.

My passport—which is, still, a paper passport, though of a highly evolved kind, rich and thick with advanced print technology and special inks and security threads, and even a little radio frequency identification chip embedded in the back cover—reveals certain information about me as an individual, but also about me as a member of a group, or a nation. It also usefully assumes and testifies to the fact that I am what philosophers might call a unitary continuing entity—a person, in other words—and can therefore be held responsible for past actions. (Though it should be admitted that one of the great pleasures of being a person is pretending not to be a unitary continuing entity, and attempting to achieve states of nonunitary, discontinuous nonentity, by going on holiday, say, or to sleep, or having sex, or enjoying role-playing computer games, or getting drunk, or reading novels, using paper to escape from a passport self. Personally, as a young adult I immersed myself not in drugs or sex or foreign travel, but in the worlds of noir fiction and psychological thrillers, where the protagonists were never what they seemed, or who they said they were: Jim Thompson's *The Killer Inside Me* (1952); Georges Simenon's *The Man Who Watched the Trains Go By* (1938), Patricia Highsmith's Ripley novels; and, above all, Frederick Forsyth's *The Day of the Jackal* (1971), a shameless celebration of self-aggrandizing self-creation, in which the nameless assassin creates for himself a new identity by stealing a passport and identification papers and having them altered by a forger he meets in a bar in Brussels, and when this hapless forger tries to

blackmail him—"The papers you have. My silence costs a thousand pounds"—the Jackal simply kills him with his bare hands. That's what it meant to be paper-free! That's what it meant not to be me!)

The origins of the modern passport system are extraordinarily recent, though there have long been various documents that seek to guarantee safe conduct: indeed, the historian Michael Clanchy notes that "by the second half of the thirteenth century it was imprudent for anybody to wander far from his village without some form of identification in writing"; in some villages in Ireland, where I live, it is imprudent still. It wasn't until the nineteenth century that the passport as we know it today—a document issued to a single individual, certifying their identity and securing their right to travel, available on application and not only for diplomatic, trade or military purposes—came into being, and the now familiar pocket-sized, durable passport between cardboard covers was only introduced in the early twentieth century, not just as a guarantee of free travel but as a document of national identity, or, in rare cases, of non-national identity. (Nansen passports, introduced in 1922, were initially used to aid the Russians who had fled from the Bolsheviks, and were so named after the League of Nations' High Commissioner for Refugees, the Norwegian explorer Frijdtof Nansen, who recognized the need for the stateless to be able to cross borders and frontiers.) In his *Devil's Dictionary* (1911) the satirist Ambrose Bierce defined a passport as "A document treacherously inflicted upon a citizen going abroad, exposing him as an alien and pointing him out for special reprobation and outrage." To possess a passport may be to expose oneself to certain forms of reprobation and

outrage, but *not* to have a passport, or to be paperless, can be an altogether more terrifying plight: in France, until this year, 2012, *"sans-papiers,"* illegal immigrants, could be held in police custody for not having the necessary residency papers. Now, instead of custody or imprisonment, they are escorted to the border.

Identity documents, however, have never just been about keeping track of foreigners and constructing paper walls to keep them out. The history of identity documents is in fact related perhaps more profoundly and significantly to the classification and identification of population groups *within* nations, by the use of censuses, registers and statistical records to enable the collecting of taxes and the enforcing of laws, the imposition of military service and the monitoring and managing of state provision of health care and education. Nation states are built from paper, or to borrow Jacques Derrida's terms in *Archive Fever: A Freudian Impression* (1995), "there is no political power without control of the archive, if not of memory," and this memory, this archive, still remains largely on paper.

Given the long history of the state's use of paper to identify, track, manage and control its citizens, it's perhaps no surprise to find that paper archives remain places of controversy and contention. In 1999, for example, thirty-four boxes of documents that had been secured by the Truth and Reconciliation Commission in South Africa disappeared, including the public record of the commission's hearings into the previous apartheid state's chemical and biological warfare program, "Project Coast," and details of hearings about various criminal investigations. The documents were supposed to have been transferred to the South African National Archives, but had actually

been taken into custody by the National Intelligence Agency. It was only after a three-year legal battle waged by the South African History Archive, a freedom-of-information NGO founded by Verne Harris, that the documents were placed in the National Archives, with many of them now in the public domain.

Putting documents into the public domain is not as easy as it sounds: as a source of identity and memory, paper presents some obvious challenges and difficulties. Such as, it decays and can be destroyed. Or shredded. In *Stasiland: Stories from Behind the Berlin Wall* (2003), Anna Funder investigates the legacy of the GDR regime, which required its members "to sign pledges of allegiance that looked like marriage certificates, confiscated children's birthday cards to their grandparents and typed up inane protocols at desks beneath calendars of large-breasted women." Funder calculates that at the height of its power, the Stasi, the East German secret police, had 97,000 employees and 173,000 informers, all of them producing paper documents at an alarming—or, rather, a terrified—rate. After the fall of the Berlin Wall many of these documents were shredded: coming to terms with the past means putting them all back together. Funder describes her visit to the Stasi File Authority offices, in a village near Nuremberg, where women are employed to go through the approximately fifteen thousand sacks of shredded files:

> The window is wide open, a white curtain moves in the breeze and I am panicked, my heart climbing steps up my chest, because on the desk there are masses and masses of tiny pieces of paper—some in small stacks but others spread out all over. There are so many tatters of paper that the desk is not big enough, and the workers have started to lay them

out on top of the filing cabinet as well. The pieces are different sizes, from a fifth of an A4 page to only a couple of centimetres square—and there is nothing, nothing to stop them flying around the room and out the window.

The director of the Stasi File Authority explains the immensity of the task: one worker reconstructs on average ten pages per day; forty workers are employed on the reconstruction; therefore, per year of 250 working days, forty workers reconstruct about 100,000 pages. Each sack contains on average 2,500 pages. Which means that to reconstruct the contents of fifteen thousand sacks will take forty workers . . . approximately 375 years. Of the remaking of many books there is no end.

As individuals, of course, as citizens, or immigrants, refugees, guest workers, travelers or tourists, we don't have that kind of time to play with. So it's perhaps no surprise that many of us keep on frantically building our own miniature memory palaces out of paper—from diaries, photographs, newspaper cuttings, certificates, programs, report cards, menus, and all the other shreddable, scrapbookable ephemera of our lives. If the institutional archive is where data on us is kept, our diaries and scrapbooks and photographs are where we keep data on ourselves, our hopes, our dreams and our failures; our very own *Legitimationspapiere*.

12

FIVE LEAVES
LEFT★

(★The title of Nick Drake's 1969 debut album,
alluding to the phrase "Only Five Leaves Left,"
printed in packs of Rizla cigarette papers,
indicating that only five papers remain.)

Machine-made simulated vellum

The Montgolfier brothers send up their balloon

In 1861 the journalist, playwright and cofounder of the satirical magazine *Punch*, Henry Mayhew, gathered together the three separately published volumes of his bestselling books of interviews into one: *London Labour and the London Poor; Cyclopaedia of the Conditions and Earnings of Those That Will Work, Those That Cannot Work, And Those That Will Not Work.* Mayhew was an oral historian—the Studs Terkel of his day—and his was a modest attempt, in his own words, to "publish the history of a people, from the lips of the people themselves," and in so doing to "give the rich a more intimate knowledge of the sufferings, and the frequent heroism under those sufferings, of the poor," and thus "to bestir themselves to improve the condition of a class of people whose misery, ignorance, and vice, amidst all the immense wealth and great knowledge of 'the first city in the world,' is, to say the very least, a national disgrace to us."

Vigorous, single-minded and determined to cause as much controversy as possible, Mayhew interviewed everyone, from prostitutes to thieves to cigar-end collectors to bone-grubbers, meat dealers, piemen, dog-dung finders, sewer hunters, mud-larks—and every kind of paper seller. He was nothing if not thorough. He interviewed sellers of pamphlets, and he interviewed sellers of tracts. He interviewed sellers of race cards, sellers of playing cards, sellers of almanacs, "conundrums,"

engravings, prints, pictures, and "patterers," those at the very bottom end of the market who were "engaged in vending last dying speeches and confessions . . . accounts of fabulous duels between ladies of fashion—of apocryphal elopements, or fictitious love-letters of sporting noblemen . . . assassinations and sudden deaths of eminent individuals . . . awful tragedies, including mendacious murders, impossible robberies, and delusive suicides." But beyond and below even this lowly class of paper peddlers, he discovered, was another caste of people engaged in a profession "the most curious of any in the hands of the class I now treat of": the wastepaper collectors. "Some may have formed the notion that waste paper is merely that which is soiled or torn, or old numbers of newspapers, or other periodical publications; but this is merely a portion of the trade, as the subsequent account will show."

Mayhew's subsequent account does indeed show the most curious of trades. The wastepaper collectors were canny, ruthless scavengers—Mayhew estimated that there were about sixty men engaged in the trade in London, who would earn between fifteen and thirty-five shillings a week—visiting offices, publishers, coffee shops, printers, publicans, anywhere and everywhere in pursuit of their precious. Interviewed by Mayhew, one collector enumerated the kinds of paper he collected:

I've had Bibles . . . Testaments, Prayer-books, Companions to the Altar, and Sermons and religious works . . . Roman Catholic books . . . Watts' and Wesley's hymns . . . I've dealt in tragedies and comedies, old and new, cut and uncut—they're best uncut, for you can make them into sheets then—and farces, and books of the opera. I've had scientific and medical works of every possible kind, and histories, and travels,

and lives, and memoirs . . . Poetry, ay, many a hundred weight;
Latin and Greek (sometimes), and French, and other foreign
languages . . . Pamphlets I've had by the ton . . . Missionary pa-
pers of all kinds. Parliamentary papers . . . Railway prospectuses
. . . Children's copy-books . . . Old account-books of every
kind . . . Dictionaries of every sort . . . Music books, lots of
them. Manuscripts . . . Letters on every possible subject . . . An
old man dies, you see, and his papers are sold off, letters and
all; that's the way; get rid of the old rubbish, as soon as the
old boy's pointing his toes to the sky. What's old letters worth,
when the writers are dead and buried? Why, perhaps 1½d.
a pound, and it's a rattling big letter that will weigh half-an-
ounce. O, it's a queer trade, but there's many worse.

O, it's a queer trade, but there are many worse. Mayhew's
wastepaper sellers passed their wares on to "cheesemon-
gers, buttermen, butchers, fishmongers, poulterers, pork and
sausage-sellers, sweet-stuff-sellers, tobacconists, chandlers—
and indeed all who sell provisions"—just as I've been offering
my wastepaper to you.

There is much, of course, that I haven't been able to include,
and much that I haven't been able to salvage. On a daily basis
we all still use so much paper to note, to register, to measure,
to account for, to classify, authorize, endorse and generally
to tot up, gee-up and make good our lives that it would be a
Mayhew-like or Joycean undertaking to provide a full history
of all the paper in just one life on just one day, never mind
in the lives of nations and peoples over two thousand years.
Personally, this week alone, I have fingered and handled news-
papers, magazines, books, notebooks, notepads, files, agendas,
programs, dry-cleaning tickets, cinema tickets, parking tickets,

boarding passes, peer review forms, school reports, and bills, invoices and packaging of all kinds, and my pockets as always are stuffed full with train tickets, money and receipts, so much so that sometimes at night I simply shake the contents out onto the floor, creating a paper shower that soon becomes a drift that eventually, if allowed, would overcome first my bedroom, then my house and then finally my life, like the famous American Collyer brothers, Homer and Langley, whose brownstone on Fifth Avenue in New York was filled from floor to ceiling with a lifetime's junk, and who eventually died in squalor and notoriety in 1947, with the police removing over a hundred tons of garbage from their home, Langley having been crushed to death in one of the booby-trapped newspaper tunnels of his own construction, and the blind and paralyzed Homer perishing of starvation some days later.

Much of it must be tossed, then, and of course most of the paper in my life is dross anyway, but there is so much else from the long history of paper that one would want to sort through and to rescue from waste: the odd, adjunct history of paperweights and paper knives, for example, from the first exhibition of paperweights in Vienna in 1845 to the procedures used for the identification of paper knives in criminal history; the cult history of wrestling and boxing posters, which once adorned the barbers and grocers of my youth, and were triumphs of the art of the High Street jobbing printer; the natural history of paper in gardening, horticulture and agriculture, beginning with, say, the "melon paper-House" that Gilbert White made for himself in 1757, "8 feet long & 5 feet wide: to be covered with the best writing paper," oiled with linseed oil, to make it proof against the rain, and ending with the lat-

est graph- and vector-based methods for the construction and
analysis of data in landscape ecology; the true story behind
James Wyld II's Monster Globe, erected in the center of Leices-
ter Square in 1851, which stood for ten years, built ostensibly
as Wyld's contribution to the Great Exhibition, but was in ef-
fect a giant advertisement for his map and globe company; the
magical properties of "soap paper," as described in an article in
The Paper-Maker and British Paper Trade Journal in 1915, which
consisted of little booklets of satin paper coated with a com-
pound of glycerine, spirit and soap, a boon to hikers and pic-
nickers, who "need only extract a basinful of water from a clear
brook and immerse a page or a small piece of soap paper in it,
meantime dabbling it about freely, in order to obtain abun-
dant saponaceous lather suitable for washing hands and face
with," the forerunner of today's wet wipes; the pioneering work
of computer genius David Huffman, developer of so-called
Huffman coding, which forms the basis of various back-end
applications in digital devices, including JPEG and MP3 files,
but who was also a great paper folder, and who in his 1976
paper "Curvature and Creases: A Primer on Paper" explores
the relationship between certain features of paper surfaces and
computer-aided design; the ingenious history of copying paper,
including recipes (such as that for Carbon Duplicating Paper in
Pharmaceutical Formulas: Being the Chemist's Recipe Book, vol. II
(1934, revised edition), requiring 12 lbs. of lard, 2½ lbs. of
Japan wax, 2 lbs. of Ivory Blue, and 2 lbs. of Prussian Blue); rec-
ipes, including one for "Thin Cream Pancakes Call'd a Quire of
Paper," from Mary Kettilby's *A Collection of above three hundred
receipts in cookery, physick, and surgery for the use of all good wives,
tender mothers and careful nurses, by several hands* (1714), a recipe

I have tested, purely in the interests of research, which consists mostly of cream, butter, sugar, eggs, flour and sherry, and which I can confirm is absolutely delicious; the serious art and science of paper forensics, as practiced by the doyen of paper historians, Peter Bower, who is the man to go to if you need to find out exactly how much linen was present in a rag-pulp mix in the mid-nineteenth century, and which soaps were used to wash the rags, and which stampers and beaters and sizing agents were used, and which dyes and colors, and how white is the white, and whether the surface finish was achieved by plate glazing or calendering; tales of the last paper-bag merchants in Spitalfields, east London, Gardners Market Sundriesmen, 149 Commercial Street, est. 1870, as related in what is currently one of the world's hippest blogs, www.spitalfieldslife.com; and the exact meaning of the song "Paper Gangsta" by Lady Gaga (I think she's complaining about her record label). "If all the earth were paper white/And all the sea were ink,/'Twere not enough for me to write/As my poor heart doth think" (John Lyly). "Tis not enough, but let me present you finally with just a few more pages, a few choice cuts and uncuts from the multibale history of paper. Five leaves left: paper and film; paper and fashion; cigarettes; religion; and science.

The history of the relationship between paper and film begins early, earlier even than one might expect, at the very beginning of the history of photography, in 1839, when William Henry Fox Talbot, an inventor and scholar of hieroglyphics, revealed to the Royal Society in London the secrets of his revolutionary photogenic drawing method, just as Louis Daguerre was announcing his own copper-plate process for capturing images to the French Academy of Sciences in Paris. In his book *The Pencil*

Daguerrotype of an eclipse of the sun, July 28, 1851

of Nature (1844), Fox Talbot explains how in 1833 he had been attempting to sketch the scenery of Lake Como, in Italy, using a camera lucida, and that the results were "melancholy to behold." Nonetheless, this failure, he writes, "led me to reflect on the inimitable beauty of the pictures of nature's painting which the glass lens of the Camera throws upon the paper in its focus—fairy pictures, creations of a moment, and destined as rapidly to fade away. It was during these thoughts that the idea occurred to me . . . how charming it would be if it were possible to cause these natural images to imprint themselves durably, and remain fixed upon the paper." Fox Talbot's early image-fixing experiments required soaking paper in a solution of salt, drying it, and then either brushing or floating the paper on a solution of silver nitrate. This prepared paper would then produce magical results when placed under an object, capturing vivid, ghostly images when exposed for long enough to the light. From these exploratory paper-based beginnings—"fairy pictures"—within thirty years photography was being used, in the words of John Berger, for "police filing, war reporting, military reconnaissance, pornography, encyclopedic documentation, family albums,

postcards, anthropological records . . . sentimental moralising, inquisitive probing . . . aesthetic effects, news reporting and formal portraiture." By 1861 over two hundred photographic studios had opened in London alone, with nearly three thousand registered photographers at work in the capital, and throughout the rest of its history, through all of its complex physical and chemical developments and iterations—from heliographs to calotypes to daguerrotypes, niépceotypes, wet plates, dry plates and every other innovation since—photography has continued to rely on paper, either to print out or to print on. Even digital photography, which can do without film and chemical processing, still relies largely on paper to be printed, exhibited, and proudly displayed in frames.

And as with photography, so with cinematography: film has a paper substrate. The history of motion pictures, or at least of moving images, begins with phenakistoscopes and zoetropes, which used static images, usually printed on paper, on spinning disks or cylinders, and one could follow an interesting, flickering paper route the whole way through motion picture history, from the use of cut-paper figures in stop-action animation, say—from the early work of the French cartoonist Émile Eugène Jean Louis Courtet to more recent work by Tim Burton and the Mexican artist Carlos Amorales, reminiscent of the shadow plays of Indonesia (*wayang*), Turkey (*Karagöz-Hacivat* plays), and France (*les ombres noires*)—through the paper print process used to establish copyright of early film negatives, to the famously Benzedrine-driven memo madness of David O. Selznick, and the paperwork nightmares depicted in Terry Gilliam's *Brazil* (1985). But the real paper support behind film—cinema's paper orthotics, as it were, the back brace of

cinema—are storyboards. Initially developed at the Walt Disney studios in the early 1930s, these hand-drawn sketches, arranged in sequence to build up narrative scenes from single frames and shots, were first used to direct a live-action film with *Gone With the Wind*, for which a team of seven artists produced more than 1,500 watercolor sketches—mostly of the burning of Atlanta—that were pasted onto board, and used on location during shooting. *Gone With the Wind* was released in 1939. What's remarkable is that at Pixar Animation Studios they're still using traditional storyboard techniques today, carrying on for all the world like little Poussins—who famously referred to his drawings as *"pensées"*—using drawings on paper as necessary steps toward high-tech movie making. Harley Jessup, a production designer at Pixar, who worked on *Monsters, Inc.* and *Ratatouille*, has described a culture of paper drawing and picture making at the company's headquarters in California that would not seem out of place in an Impressionist's studio in nineteenth-century Paris. There are daily life-drawing and painting classes, open to everyone, and the story department employs between five and fifteen full-time artists solely to work on storyboards. And a storyboard, as Jessup explains, just to be clear, "is literally a 4″ x 8″ (120 cm. x 240 cm.) bulletin board covered with rows of 3.5″ x 8″ (9 cm. x 20 cm.) hand-drawn story panels": no gimmicks, no gizmos, no computer-graphic design. These story panels are scanned and cut together to produce story reels—basic black-and-white cartoon versions of the film—and are only then replaced by computer-graphic sequences, developed using yet further hand-drawn sketches, paintings and sculptures. Jessup adds up the number of storyboard drawings produced for various Pixar films thus:

A Bug's Life (1998)	27,555
Toy Story 2 (1999)	28,244
Monsters, Inc. (2001)	46,024
Finding Nemo (2003)	43,536
The Incredibles (2004)	21,081
Cars (2006)	47,000
Ratatouille (2007)	72,000

So, no signs of a paperless office at Pixar.

Nor in the great fashion houses of the world. It's impossible to imagine a fashion house without its moodboards and port-folios, pieced together using pens, pencils, color photocopies, scissors and paste. The fashion designer John Galliano, for ex-ample, puts together vast research books: "I start with research and from there I build the muse, the idea, tell a story and de-velop a character, a look and then a collection." Matthew Wil-liamson does anime-style sketches. Peter Jensen draws with a black fineliner on white copier paper, creating images that look like cartoons. Vivienne Westwood draws clothes without bod-ies, like funeral garb. (It's perhaps worth noting that the greatest ever television series about fashion—*Ugly Betty*—is set not in a fashion house, but in a fashion magazine, the fictional *Mode*: couture always makes most sense when reflected and refracted in coated glossy paper.) Bespoke tailors create beautiful suits from brown-paper patterns by rock of eye, while my mother and grandmother made our clothes largely by guesswork and Butterick and Simplicity patterns, bought second-hand from market stalls, or collected from magazines, and shared among friends and neighbors, *samizdat*-style, so that everyone we knew ended up wearing odd but identical homemade denim-look leisurewear. The rise of the paper clothes pattern, first devel-

oped in the USA in the 1860s by the indomitable Madame Demorest (*née* Ellen Curtis) and Ebenezer Butterick, who built vast empires on the back of flimsy tissue-paper patterns, arguably led to the democratization of fashion: paper made clothes.

And paper-made clothes. In England in the late nineteenth century an American music hall entertainer, Mr. Howard Paul, used to perform on stage wearing a paper suit, singing a song, "The Age of Paper," by Henry Walker. The song goes like this:

> In ev'ry shop one now espies
> The last new thing is paper ties;
> The coats of best blue wove are made;
> But shirts, of course, are all cream laid.
> A paper hat should you desire,
> Or paper socks, say half a quire,
> Or peg-tops of the last design—
> You'll get them all for three and nine!
> For paper now is all the rage,
> And nothing else will suit the age.

The closest thing to paper clothes actually having been all the rage happened in the late 1960s, when paper dresses had their brief but glorious fashion moment. In 1966 the Scott Paper Company offered a chemise-style dress for just $1, mail order, plus coupon: they sold 500,000 of them. Not to miss out, Hallmark soon began selling paper "hostess dresses," designed to match a range of party napkins and tablecloths; and before you could say underpants there were evening dresses and wedding gowns, slippers, suits, raincoats and bikinis all being made if not entirely from paper, then at least from part paper, part nylon and rayon. One particularly eye- and spill-catching dress was

advertised as the "Party Stopper," a "Shimmering white mini with silver fringe, made of poly-plastic on Scott Dura-Weve paper. Wipe off and press again and again. $5.95 ppd." Irresistible. According to an article in *Time* magazine in March 1967, "Real Live Paper Dolls," paper clothing was so popular that one of America's major manufacturers, Sterling Paper, was developing "paper resort wear," so that holiday makers could leave their luggage at home and simply buy disposable clothes in their hotels. By June 1967 *Mademoiselle* magazine had as one of its cover stories "The Big Paper Craze": "In terms of how much pow you get for your pennies, the paper dress is the ultimate smart-money fashion."

The craze soon passed. But in Japan it never ended, because it had never begun: in the land where paper remains a thing of beauty as well as utility, paper clothes have always been a part of the culture. *Kamiko*, for example, is a robust kind of paper treated with starch that was often worn by priests and samurai during the Edo period (1603–1868), though the most famous wearer of *kamiko* was in fact a poet, or rather *the* poet, Bashō, who immortalized his outfits in his haiku, as Elvis hymned blue suede shoes and T. S. Eliot talked of turned-up trousers:

In my new robe
this morning—
someone else.

Dewy shoulders
of my paper robe—
heat-waves.

Japanese woodcut—paper garments

Shifu—not to be to be confused with *kamiko*, or indeed with Master Shifu, a character in the excellent *Kung Fu Panda* film franchise, voiced by Dustin Hoffman—is a spun paper yarn that can be used to make clothing of all kinds. The very finest kind of *shifu* is combined with silk to make the most exquisite gleaming cloth, and is still made today by the internationally renowned Sadako Sakurai in the small town of Horimachi, north of Tokyo. Unlike its American twentieth-century counterpart, Japanese paper clothing is no novelty wear. It's sturdy stuff. Like the famous oiled and lacquered paper umbrellas, *wagasa*, traditional Japanese paper clothes are often treated to improve resistance to wind and rain. One particular kind of paper, *momigami*, is first treated with starch and then crumpled into balls until it's so flexible and strong that it begins to resemble leather, and so can be made into clothes, bags and wallets, similar to Korean *jumchi*, or *joomchi*, which is made of layers of *hanji* paper laid together, oiled and beaten, and is an integral part of Korean national culture. (In fact, *jumchi* is so versatile it can be used to make both clothes and cupboards.) "It is estimated"—though how is not clear—"that 75 percent or more of the population of China and Japan wear paper clothing," according to *The Paper-Maker and British Paper Trade Journal* in 1914. "The poorer class of Germany likewise indulge in paper apparel, as do a majority of the population of Mexico."

The problem with indulging in paper apparel, wherever you are, and whenever you are, is that it has a tendency to go up in flames. One suspects that one of the main reasons the paper-dress craze died out so suddenly in the late 1960s is that everyone was smoking. It was the wrong material at the wrong time: to borrow the memorable words of Grace Slick,

from Jefferson Airplane's "Greasy Heart," on their magnificent 1968 album *Crown of Creation*, "Paper dresses catch on fire and you lose her in the haze." In 2011, newspapers in England carried reports of a woman whose homemade toilet-paper dress caught fire during a bachelorette party in central London: she wasn't lost in the haze, thank goodness, but she did sustain serious upper-body injuries. A spokesman for the London Fire Brigade said, "There's a serious side to this—candles can be lethal if you don't keep an eye on them. Make sure candles and tea lights are placed well away from flammable items and clothing otherwise the results can be catastrophic." And yet every day, all around the world, people indulge in a seriously dangerous paper ritual: they take a piece of paper, place it in their mouth, and set light to it.

In his book *Cigarettes Are Sublime* (1993), his celebratory "ode to cigarettes," Richard Klein claims that "Extracted from its pack and smoked, the cigarette writes a poem, sings an aria, or choreographs a dance, narrating a story in signs that are written hieroglyphically in space and breath"; the cigarette, in other words, made from paper, works like paper: we write ourselves upon it. Cigarettes, in this Kleinian reading, are another of our paper props, or prosthetics, extending and articulating our very selves. A cigarette can of course be rolled in some kind of leaf rather than in paper, but this is hardly the symbolic smoke we all know and love. According to Ned Rival, another celebrant of the cigarette, in *Tabac, miroir du temps* (1981), *"Tout le chic de la cigarette tient alors dans le papier"* ("The whole chic of the cigarette resides in the paper"). The cylindrical white paper cigarette, one might argue—as many have—is a kind of displaced phallus, and thus a sign of sexual availability. It was certainly

a sign of late-nineteenth-century decadence, with many artists and writers taking up cigarette smoking as an outward and visible sign of their inward and spiritual dissolution and decay. Nothing says I'm a despairing intellectual like sucking on flaming paper. Ned Rival is right: cigarette-chic is paper-chic, and this is nowhere more apparent than in the cult and rituals of rolling papers. As a child, rolling my grandfather's cigarettes for him, using medium-weight green Rizlas, was an act of shared communion, a tacit passing on of knowledge from generation to generation, like the handing-on of the ever-present baton of the *Sun* on the dashboard of his truck (Rizla +, the brand name, comes from the word *"riz,"* being French for "rice," while the "la" and the cross represent the name of the Lacroix family, who established the business in the seventeenth century). I once knew a man who used only French Zig-Zag papers for his roll-ups—which is fine, of course, if you are actually French, and living in actual France. He wasn't. The famous face of the bearded Zouave on Zig-Zag packets remains forever in my mind the ultimate symbol of paper pretension. Decadence turns inevitably to stupid, as paper turns to ash.

If paper-suited cigarettes represent one of the great plea-

sures and evils of this world, it turns out that the next world too is tricked out in paper. Unsurpassed as a spiritual technology, and as a store of spiritual knowledge, paper remains the perfect multifaith, multipurpose platform for almost any religious event and occasion. Whether protecting ourselves with paper amulets, making offerings of votive slips, or nailing it to Wittenberg church doors, paper has the advantage over other popular spiritual technologies, such as, say, blood, animal carcasses, crystals, hair shirts, metal cilices or Scientology E-meters, being light, flexible, flammable, capable of being decorated and inscribed and not requiring batteries.

Perhaps the purest expression of paper's otherworldly aspects are Tibetan *lungta* papers (*"lung"* meaning "wind," and *"ta"* meaning "horse"), those beautiful small pieces of square, thin paper, printed on one side in one of five different colors— white, for water; blue, for sky; yellow, for earth; red, sun; green, air—and in the middle of which is printed a wind horse, which is a flying horse, which is an image of the human soul, obviously, surrounded by sacred text, with other animals depicted in each corner, and which are thrown up into the air to carry prayers, to bless a journey, or just for good luck. No confetti-banning priests in Tibet. When the roll is called up yonder, paper's name will sure be there: as *shide*, the white paper strips hung on the *shimenawa*, the ropes hung at Shinto shrines to mark the division between the sacred and profane, and on the *gohei*, the wooden wands used in purification rituals; as the paper cutouts known as *kata-shiro*, cast into flowing water, as a curse and as a blessing; as *hóngbāo*, or *ang bao*, or *ang pao*, the little red envelopes containing "lucky money," presented as a gift at weddings and at Chinese New Year; as

joss paper, or ghost money, or Bank of Hell notes, burned as offerings in China and elsewhere, that one's ancestors might enjoy peace and prosperity in the afterlife; as the *kongming* sky lanterns that grace numerous religious festivals throughout Asia, and increasingly at Western weddings; and as the piece of paper bearing the *shem* inserted in the mouth of the Golem, which brought it to life to protect the Jewish people; but definitely, definitely not as the text of the *Shema* in a mezuzah, which must be written on parchment by a *sofer*, a scribe; using paper for this purpose is strictly not kosher.

So much then for paper, religion and ritual. Enough already of folklore, God and prayer. One hopes, of course, as John Ashbery has it in his poem "From Old Notebooks," that they are "Worth looking up, these tepid old/things," but what about hot, new, shiny things? What about science and technology, and computers and engineering? We shall take it for granted, as everyone does, that what is now called "technology transfer" has always occurred and even now continues to occur through ideas being transmitted on paper, and that there is no such thing as what the down-to-earth futurist Buckminster Fuller in *Critical Path* (1981) called "telepathically intercommunicated wisdom." This is obvious: scientific wisdom works best when written down, not least for patent purposes. Lab notebooks remain an important part of a research scientist's equipment (Fuller was an obsessive chronicler of his own life and ideas). Obvious. As obvious as the fact that the history of science is first and foremost a history of argument, much of which takes place on paper. But it is perhaps worth reminding ourselves that not just the abstract arguments but also the very practical spaces of science, including the physical and social settings of research,

the experiments, and the scientific visitor attractions, have also been determined by paper. Paper helps turn metaphysics into applied metaphysics. In the nineteenth century, for example, it helped turn natural history into a natural history museum.

Around the middle of the nineteenth century, Richard Owen, superintendent of natural history at the British Museum, decided that natural history deserved its own museum, and he set about making his argument on paper, in letters and in campaigns. In 1858, more than a hundred naturalists signed a letter to the Chancellor of the Exchequer, complaining about the display of natural history in the British Museum. Thomas Huxley and Charles Darwin put together a petition. Owen published a booklet, *On the Extent and Aims of a National Museum of Natural History* (1862). Money was raised. A competition was announced for the building of a new museum. Plans were submitted. Francis Fowke won the competition, on the strength of his perspective drawing. Interiors were sketched and designed. Plans became reality, and the new British Museum (Natural History), which we know now as the Natural History Museum, one of the jewels in the crown of Albertopolis, finally opened to the public on Easter Monday 1881. Paper had helped it happen.

Anecdotal accounts of the propelling power of paper behind developments in science and technology could be gathered *ad infinitum*, stacked like Mary Kettilby's paper-thin cream and sherry pancakes. But to take just one particularly delicious and obvious example: the engineer Henry Petroski, in his memoir *Paperboy: Confessions of a Future Engineer* (2002), focuses on a brief but intense period during his early life, from August 1, 1954, to January 25, 1958, to be calliper-precise, when he worked as a paperboy delivering the *Long Island Press* in his neighborhood in

Queens, New York. Petroski claims that this experience gave him a heightened sense of "distance, time, and number," so much so that it helped influence and determine his future career:

> How many papers a paperboy had to draw was math; how he delivered them was engineering. How many papers could fit in the bag was math; how many more could be fit in was engineering. How the bicycle moved with its load was science; how he managed to pedal it up a hill was engineering. How the papers were supposed to be flipped was science; how the papers were flipped was engineering. How the papers landed where they did was science; how the papers got there was engineering. How the newsprint soiled his hands was science; how he washed it off was engineering.

Or to take a more significant example: in his book on the discovery of the double helical structure of DNA, *The Double Helix* (1968), James Watson describes how the team at the Cavendish Laboratory in Cambridge would build models—actual models, made of metal—in their attempt to understand the working mechanism of DNA. One afternoon, while waiting for some of the models to be constructed, Watson became impatient, "so I spent the rest of the afternoon cutting accurate representations of the bases out of stiff cardboard." The next morning, he writes, he "quickly cleared away the papers from my desk" and set to work with the cardboard, trying to come up with a new shape and pattern to form representational pairs of cardboard bases connected by notional hydrogen bonds. "Suddenly I became aware that an adenine-thymine pair held together by two hydrogen bonds was identical in shape to a guanine-cytosine pair held together by at least two hydrogen bonds. All the hydrogen bonds seemed to form naturally; no fudging was required to make the

two types of base pairs identical in shape." By lunchtime, Watson's lab partner Francis Crick was telling everyone in the pub that "we had found the secret of life."

Crick and Watson's discovery notwithstanding, The Answer to the Ultimate Question of Life, the Universe, and Everything is, of course, 42—at least according to the supercomputer Deep Thought in Douglas Adams's *The Hitchhiker's Guide to the Galaxy*. (And why 42? According to one theory—there are several—the so-called "paperback line theory," Adams picked 42 because it's the average number of lines on the page of a paperback book. More likely, he picked it because it sounds funny.) As every steam- and cyberpunk enthusiast knows, paper played an important role in the development of computing, super-, real, fictional and otherwise, and continues to do so. Charles Babbage's famous Analytical Engine, the first general-purpose programmable computer, relied on cardboard as an essential part of its apparatus. Indeed, Babbage had mocked up his earlier Difference Engine—like the Analytical Engine, a grand project undertaken but never completed, largely due to lack of funds, but partly due to the fact that he was an impossible man to work with—with cardboard cutouts, all worked out in his voluminous "scribbling books."

Babbage's perforated cardboard cards were inspired by and adapted from the cards used by Joseph Marie Jacquard in his programmable weaving loom, an important machine in the history not just of technology but of human evolution, according to Manuel De Landa in *War in the Age of Intelligent Machines* (1991), because it "transferred control (and structure) from the human body to the machine in the form of a primitive program stored as punched holes in paper cards, the earliest form of software": paper helping to inaugurate not just the modern

age of computers, therefore, but also the postmodern age of cybernetics; paper prefiguring the posthuman. In William Gibson and Bruce Sterling's novel *The Difference Engine* (1991), their Babbbage-inspired vision of a technologically advanced Victorian London, governed by Prime Minister Lord Byron, paper proliferates. Everyone carries a "citizen-card," a kind of multipurpose identity-card-cum-credit-card, printers endlessly punch out paper tape, and "clackers" (programmers) are so named because of the sound of paper cards clacking through the big brass steam-driven computers. Fantasy? Reality: in the mid-twentieth century the computer giant IBM's entire business was based on paper, with their famous punch cards ("Do not fold, spindle or mutilate") being used to record units of information in the form of code, before being replaced by magnetic tape during the 1960s. And the sound of clacking can still be distantly heard today in the paper prototyping methods used by Microsoft and others to develop user interfaces. Modern paper prototyping is so low-tech it's almost laughable: a method of sketching on-screen commands and instructions on paper, before spending millions in software development.

No laughing matter is the role—or roll, rather—of paper in the history of medicine and hygiene. We are accustomed now to surgical gowns, masks, caps, tape and bandages all being made from paper. But in the early seventeenth century, in the West, even paper tissues were unheard of. In 1613 Lord Date Masamune, a farsighted, one-eyed Japanese warlord, sent an envoy named Hasekura Rokuemon Tsunenaga to visit Europe, where he and his traveling companions caused a sensation, not least because they carried with them at all times *hanagami*—"flower" or "nose" paper—with which they would blow their noses or

wipe their faces, or clean their hands, and would then discard, with James Brown–like panache. The Marchioness of St. Tropez recalled the impression this made upon the French: "When any one of the Japanese used the paper handkerchief and threw it away on the street they would run up to him and pick it up. They even fought among themselves in order to secure one of these priceless momentoes [*sic*]."

The custom of using paper to wipe and clean the hands and mouth probably goes back to sixth-century China, and by the fourteenth century, according to the scholar Tsien Tsuen-Hsuin and the Sinologist's Sinologist, Joseph Needham, ten million packages of toilet paper a year were being produced in one province alone. The rest of us, however, caught on slowly: in ancient Rome, a stick was used, with a sponge attached to the end; Eskimos reportedly used tundra moss, or snow; and others have used mussel shells, coconut shells, corn cobs, pebbles, broken pottery, and whatever came to hand. Including the hand. The famous chapter of "wipe-bummatory discourse" in Rabelais's *Gargantua* (1534), in the beautifully unrestrained translation by Thomas Urquhart (1653), has Gargantua explaining to his father that he has finally found, "by a long and curious experience," the perfect way to wipe his bottom. He has tried a lady's velvet mask, he says ("very voluptuous and pleasant to my fundament"), earrings ("they fetched away all the skin of my tail with a vengeance"), a March-cat ("her claws were so sharp that they scratched and exulcerated all my perinee"), gloves, sage, fennel, marjoram, roses, lettuce and spinach leaves. He has also tried sheets, curtains, cushions, carpets, a tablecloth, napkins, and a number of hats ("The best of all these is the shaggy hat, for it makes a very neat abstersion of the fecal matter"). Moving on to animals, he admits

that he has tried a hen, a cock, a pullet, a hare and a pigeon, but eventually concludes that of "all torcheculs, arsewisps, bum-fodders, tail-napkins, bunghole cleansers, and wipe-breeches, there is none in the world comparable to the neck of a goose, that is well downed, if you hold her head betwixt your legs." A man named Joseph Gayetty is a great friend to the goose, having been the first person, around 1857, to manufacture toilet paper in the United States, where people now use on average 23.6 rolls per year—which would add up to a lot of geese. And about half a tree. According to current industry figures, approximately eighty-three million rolls of toilet paper are produced worldwide per day, by far the fastest-growing sector in paper production. Greenpeace's recent successful campaign, Kleercut, against Kimberly-Clark's use of wood pulp to make toilet paper from Canada's boreal forest is both evidence of the power of conservation campaigning and a reminder of Gargantua's words, that "Who his foul tail with paper wipes,/Shall at his ballocks leave some chips."

And, finally, from balls to balloons, and the paper we continue to drive on, walk on, ride on and fly in. There was perhaps a certain poetic justice in the use of 2,500,000 remaindered Mills & Boon romantic novels to help make the top layer of asphalt of the M6 in England in 2003. The pulped novels apparently help to absorb sound—the endless silent crushing of romantic hopes and dreams. Paper has also been used to make wheels, on American railway cars in the nineteenth century, from giant disks of paper pasted together under pressure, and has played no small part in the history of manned flight. The Montgolfiers were a family of papermakers, their balloons made of paper and silk; the Wright brothers used paper models in wind tunnels to test their planes; and more recently a team at the University of

Stuttgart has been attempting to develop a large-capacity aircraft with a paper fuselage (as well as its sound- and energy-absorbing capacities, paper as a material is, crucially, much cheaper than steel). Even higher and further, in 2008 Professor Shinichi Suzuki of the University of Tokyo announced plans to launch paper planes from the International Space Station. "We think from this experiment we will be able to create new concepts and in the very near future perhaps new types of airship from this design," he told the BBC. Alas, the Suzuki method never worked out: the Space Age of Paper is yet to come.

The age of the paper boat, meanwhile, has been and gone. From 1989 to 1995 an American eccentric, Ken Cupery, produced an occasional newsletter for paper-boat enthusiasts called *The Paper Boater*, which proclaimed itself "The World's Leading Journal of Cellulose-Based Naval Architecture." The world's only journal of cellulose-based naval architecture. Such an architecture did and does exist. A famous recent example is the eighty-foot-long paper boat built as a memorial to Glasgow's shipbuilding industry by the great Scottish artist George Wylie, who sailed it down the Clyde in 1989, and then up the Hudson in 1990. But the greatest paper boater who ever lived was undoubtedly John Taylor, who started his working life as a waterman on the Thames, went on to serve with Sir Walter Raleigh and the Earl of Essex on the 1596 expedition to Cadiz, and on expeditions to the Azores, and who on eventually returning to England found that he'd developed a taste for adventure, and so embarked on a series of extraordinary escapades and publicity stunts that he hoped would make him rich and famous. Taylor was, in the words of Simon Schama, in *Landscape and Memory* (1995), "not simply some twopenny-ha'penny penny

trickster spawned in the taverns of Bankside. He was in his way truly unique: a self-invented celebrity, a wicked parodist of literary pretensions, the populi of the dockyards and alehouses that lined the south bank of the Thames . . . irate in his opinions, obstinate in his passions, saucy in their expression, selectively highminded, deeply politically incorrect, hugely entertaining . . ."

In 1614 Taylor challenged the poet William Fennor to a "poetic duel" at the Hope Theatre in London. He sold tickets in advance, and published an account of the duel after the event. He was defeated by Fennor, but no matter. He had established a useful model for his future activities, funding adventures using public money up front, and then cashing in with a pamphlet when it was all over. In 1616 he traveled from London to Edinburgh and back again on what he called a "Penniless Pilgrimage." Then he wrote a pub guide. And a directory of carriage services. Ran a pub in Covent Garden. And in 1620 he traveled down the Thames in a brown-paper boat.

Taylor retells his experience in his poem *The Praise of Hemp-Seed with the Voyage of Mr. Roger Bird and the Writer hereof, in a boat of browne-Paper, from London to Quinborough in Kent* (1620):

> I therefore to conclude this much will note
> How I of Paper lately made a Boat,
> And how in forme of Paper I did row
> From *London* unto *Quinborough* Ile show.

The journey started well, but not surprisingly, somewhere off the coast between Kent and Essex, the boat began to leak:

> The water to the Paper being got,
> In one half houre our boat began to rot:
> The Thames (most lib'rall) fild her to the halves,
> Whilst Hodge and I sate liquor'd to the calves.

It was kept afloat by Taylor's determination, by the bullocks' bladders filled with air attached to the flimsy craft, and by the enthusiasm of the cheering crowds:

> Thousands of people all the shores did hide,
> And thousands more did meet us in the tide
> With Scullers, Oares, with ship-boats, & with Barges
> To gaze on us, they put themselves to charges.

The journey lasted three days, from Saturday to Monday, "In rotten paper and boysterous weather," until Taylor and his companion clambered out at Queenborough Castle on the Isle of Sheppey, to be wined and dined by the local mayor. Taylor, in his usual enterprising way, had hoped to be able to exhibit the boat, but as he recounts:

> But whilst we at our dinners thus were merry,
> The Country people tore our tatter'd wherry
> In mammocks peecemeale in a thousand scraps,
> Wearing the reliques in their hats and caps.

What had begun in great hope ended in mammocks peece-meale (a "mammock," explains the *OED*, is "a scrap, shred, broken or torn piece").

We began our journey through the history of paper with Salvador Plascencia's fantastic novel *The People of Paper* (2005). Let us end with Carlos María Domínguez's equally fantastic *The Paper House* (2005), in which the protagonist, Carlos Brauer, becomes first obsessed and then deranged by books, so much so that on his bed there are "twenty or so books carefully laid out in such a way that they reproduced the mass and outline of a human body." To overcome the relationship, to sever the ties,

he commits the brutal act of building a house from his books, cementing them together like bricks, using "a Borges to fit under a windowsill, a Vallejo for the door, with Kafka above it and Kant beside it." For a brief moment all the paper that had nurtured and educated him looks as though it might become a useful shelter and a shade for him and for others, but not for long, "because even in the heady tenacious hope of the printed word, made possible by printers, designers, secretaries, typesetters, commentators, writers, and messengers, craftsmen in inks and bindings, illustrators, prologue writers, cultured critics of memory, paper is an organic product that, like the pine trees on the road, sooner or later falls prey to the jaws of the sea in a silent, devastating collapse."

Mammocks.

A paper boat, sinking

THE HOLLOW IN THE PAPER
Acknowledgments

The hollow in the paper between the front and the back
of a thin sheet of paper . . . To be studied! . . . it is a category
which has occupied me a great deal over the last ten years.
I believe that by means of the intra-slim one can pass from
the second to the third dimension.

MARCEL DUCHAMP, quoted by Denis de Rougement,
"Marcel Duchamp, mine de rien" (1968),
repr. in *Marcel Duchamp, Notes*, ed. Paul Matisse (1980)

For previous acknowledgments see *The Truth About Babies* (Granta
Books, 2002), *Ring Road* (4th Estate, 2004), *The Mobile Library: The Case
of the Missing Books* (Harper Perennial, 2006), *The Mobile Library: Mr.
Dixon Disappears* (Harper Perennial, 2006), *The Mobile Library: The Del-
egates' Choice* (Harper Perennial, 2008), and *The Mobile Library: The Bad
Book Affair* (Harper Perennial, 2010). These stand, with exceptions. In
addition I would like to thank the following. (The previous terms and
conditions apply: some of them are dead; most of them are strangers;
the famous are not friends; none of them bears any responsibility.)

Jonathan Agnew, Foz Allan, Eric Ambler, Kristin Andreassen, Ards Com-
haltas Ceoltóirí Éireann, John Franklin Bardin, Catherine Bates, Maurice
Blanchot, Peter Blegvad, Amy Blythe, Ian Bostridge, Alfred Brendel,
Gerard Brennan, Vera Brice, Carla Bruni, David Burke, Victoria Button,
Paul Caddell, Caine's Arcade, Sophie Calle, Brian Caraher, Michel de
Certeau, Kellie Chambers, Aislinn Clarke, Cheryl Cole, Ruby Colley,
Seamus Collins, Stephanie Conn, Shimon Craimer, Martina Craw-
ford, Martin Cromie, Laura Cunningham, Sean Curran, Guy De-
bord, Linda Drain, Joseph Duffin, David Dwan, Geoff Dyer, Will Eaves,

Lisa Edelstein, Craig Edwards, Hiba El Mansouri, Omar Epps, Frantz Fanon, Patrick Fitzsymons, Maureen Freely, Brid Gallagher, General Fiasco, Craig Gibson, Chris Gingell, Gotye, Andrea Grossman, Moyra Haslett, Caroline Healy, Toni Hegarty, Ivan Herbison, Naftali Herstik, Ben Highmore, Peter Jacobson, Boyd Jamison, Stephen Kelly, Diarmuid Kennedy, Bernadette Kiernan, Nicola Killow, Kimbra, John Knowles, the staff of Krem, Gidon Kremer, Robert Lacey, Martin Lamb, Heather Larmour, Christopher Lasch, Hugh Laurie, Catherine Lavery, Gary Learmonth, Henri Lefebvre, Robert Sean Leonard, Sheila Llewellyn, Johanna Lyle, Shan McAnena, Michael McAteer, Nathaniel McAuley, Darran McCann, Denise McGeown, Michael McGlade, Philip McGowan, Niall McGuckian, Susannah McKenna, Ryan McNeilly, Patrick McOscar, Bernie McQuillan, Karen McQuinn, Sheila McWade, Fiona Mackie, Hugh Magennis, Ben Maier, Alison Marchant, Zeljka Marosevic, Marcel Mauss, Ruben Moi, Helen Molesworth, Martin Mooney, David Morley, Francis Morrison, Jennifer Morrison, Chris Moyles, Kevin Mulhern, Gerry Mulligan, Romano Mullin, Emma Must, Romily Must, Padraigin Ni Ullachain, Michael Nolan, Marcus Patton, Kal Penn, Tommy Potts, Janet Pywell, the staff of Queen's University Library, Katy Radford, Joan Rahilly, Marcelo Rayel, Shaun Regan, Stefano Res, Daniel Roberts, John Roberts, Marco Rodrigues, Gil Scott-Heron, Stephen Sexton, Matthew Shelton, Chris Sherry, Shiftz, Jane Shilling, David Shore, Paul Simpson, Abigail Solomon-Godeau, Jesse Spencer, Roberta Stabilini, Jonathan Stead, Mark Stevenson, Erin Stewart, Martin Strel, Tahan, Orla Travers, Two Door Cinema Club, Malte Urban, Dianne Vinson, Walk off the Earth, David Walliams, Tara West.

TEARING THE BOOK INTO PIECES
A Bibliography

This intensive way of reading, in contact with what's outside the book, as a flow meeting other flows, one machine among others, as a series of experiments for each reader in the midst of events that have nothing to do with books, as tearing the book into pieces, getting it to interact with other things, absolutely anything . . . is reading with love.

GILLES DELEUZE, "Letter to a Harsh Critic,"
in *Negotiations, 1972–1990*, trans. Martin Joughin (1995)

Introduction: RESPECTING PAPER

Brown, John Seely, and Paul Duguid, *The Social Life of Information* (Boston, Mass.: Harvard Business School Press, 2000).

Conan Doyle, Arthur, *The Penguin Complete Sherlock Holmes* (London: Penguin, 2009).

de Saussure, Ferdinand, *Course in General Linguistics* (1916), trans. Wade Baskin (New York: Columbia University Press, 2011).

Derrida, Jacques, *Paper Machine* (2001), trans. Rachel Bowlby (Stanford: Stanford University Press, 2005).

Golding, William, *Free Fall* (London: Faber and Faber, 1959).

Malraux, André, *Museum Without Walls* (1965), trans. Stuart Gilbert and Francis Price (London: Secker & Warburg, 1967).

Mayer-Schönberger, Viktor, *Delete: The Virtue of Forgetting in the Digital Age* (Princeton: Princeton University Press, 2009).

Parry, Ross, ed., *Museums in a Digital Age* (London: Routledge, 2010).

Plascencia, Salvador, *The People of Paper* (San Francisco: McSweeney's Books, 2005).

Sellen, Abigail J., and Richard H.R. Harper, *The Myth of the Paperless Office* (Cambridge, Mass.: MIT Press, 2001).

Smith, Stevie, *Novel on Yellow Paper* (London: Jonathan Cape, 1936).

"The Wonderful Adaptability of Paper," *The Paper World* (June 1880).

"The Wonderful Uses of Paper," *The Paper World* (October 1881).

1: A MIRACLE OF INSCRUTABLE INTRICACY

Baker, Cathleen A., *By His Own Labor: The Biography of Dard Hunter* (Delaware: Oak Knoll, 2000).

Barrett, T., *Japanese Papermaking: Traditions, Tools and Techniques* (New York: Weatherhill, 1983).

Bloom, Jonathan M., *Paper Before Print: The History and Impact of Paper in the Islamic World* (New Haven: Yale University Press, 2001).

Blum, André, *On the Origin of Paper*, trans. Harry Miller Lydenberg (New York: R.R. Bowker, 1934).

Clapperton, Robert Henderson, *The Paper-making Machine: Its Invention, Evolution and Development* (London: Pergamon, 1967).

Clapperton, Robert Henderson, and William Henderson, *Modern Paper-Making* (London: Ernest Benn, 1929).

Coleman, D.C., *The British Paper Industry, 1495–1860* (Oxford: Clarendon Press, 1958).

Hands, Joan, and Roger Hands, *Paper Pioneers* (Berkhamsted: Dacorum Heritage Trust, 2008).

Herring, Richard, *Paper & Paper Making, Ancient and Modern* (London: Longman, 2nd edn., 1856).

Hills, Richard D., *Papermaking in Britain 1488–1988* (London: Athlone Press, 1988).

Hobsbawm, E.J., and George Rudé, *Captain Swing* (London: Lawrence & Wishart, 1969).

Hunter, Dard, *Papermaking: The History and Technique of an Ancient Craft* (London: Cresset Press, 2nd edn., 1957).

Labarre, Emile Joseph, *Dictionary and Encyclopaedia of Paper and Paper-making* (Amsterdam: Swets & Zeitlinger, 2nd edn., 1952).

Lines, Clifford, and Graham Booth, *Paper Matters: Today's Paper & Board Industry Unfolded* (Swindon: Paper Publications Ltd., 1990).

McGaw, Judith A., *Most Wonderful Machine: Mechanization and Social Change in Berkshire Paper Making, 1801–1885* (Princeton: Princeton University Press, 1987).

Maddox, H.A., *Paper: Its History, Sources, and Manufacture* (London: Pitman & Sons, 1916).

Melville, Herman, "The Paradise of Bachelors and the Tartarus of Maids" (1855), in Richard Chase, ed., *Herman Melville: Selected Tales and Poems* (New York: Holt, Rhinehart & Winston, 1966).

Robinson, Laura, and Ian Thorn, *Handbook of Toxicology and Ecotoxicology for the Pulp and Paper Industry* (Oxford: Blackwell Science, 2001).

Stirk, Jean, "The 'Swing Riots' & the Paper Machine Breakers," *The Quarterly: The Journal of the British Association of Paper Historians* 13 (December 1994).

Watson, Barry, "John Evelyn's Visit to a Paper Mill," *The Quarterly: The Journal of the British Association of Paper Historians* 64 (October 2007).

Watt, Alexander, *The Art of Papermaking: A Practical Handbook of the Manufacture of Paper from Rags, Esparto, Straw and Other Fibrous Materials, Including the Manufacture of Pulp from Wood Fibre* (London: Crosby Lockwood and Son, 1890).

2: IN THE WOOD

Bate, Jonathan, *The Song of the Earth* (London: Picador, 2000).

Bloch, Maurice, "Why Trees, Too, Are Good to Think With: Towards an Anthropology of the Meaning of Life," in Laura Rival, ed., *The Social Life of Trees: Anthropological Perspectives on Tree Symbolism* (Oxford: Berg, 1998).

Calvino, Italo, *The Baron in the Trees*, trans. Archibald Colquhoun (New York: Harcourt Brace Jovanovich, 1959).

Carson, Ciaran, *The Inferno of Dante Alighieri: A New Translation* (London: Granta, 2002).

Cox, J. Charles, *The Royal Forests of England* (London: Methuen, 1905).

Dante, *The Divine Comedy of Dante Alighieri: Inferno*, trans. John D. Sinclair (Oxford: Oxford University Press, 1939).

Davies, Keri, "William Blake and the Straw Paper Manufactory at Millbank," in Karen Mulhallen, ed., *Blake in Our Time: Essays in Honour of G.E. Bentley Jr.* (Toronto: University of Toronto Press, 2010).

Deakin, Roger, *Wildwood: A Journey Through Trees* (London: Hamish Hamilton, 2007).

Edlin, Herbert Leeson, *Trees, Woods & Man* (London: Collins, 1956).

Frazer, James, *The Golden Bough: A Study in Magic and Religion* (London: Macmillan, 3rd edn., 12 vols, 1911–15).

Frost, Robert, *Collected Poems, Prose and Plays*, eds. Mark Richardson and Richard Poirier (New York: Library of America, 1995).

Glotfelty, Cheryll, and Harold Fromm, eds., *The Ecocriticism Reader: Landmarks in Literary Ecology* (Athens, Ga.: University of Georgia Press, 1996).

Haggith, Mandy, *Paper Trails: From Trees to Trash—The True Cost of Paper* (London: Virgin Books, 2008).

Harrison, Robert Pogue, *Forests: The Shadow of Civilization* (Chicago: University of Chicago Press, 1992).

Heidegger, Martin, *Off the Beaten Track* (1950), trans. Julian Young and Kenneth Haynes (Cambridge: Cambridge University Press, 2002).

Lowood, Henry, "The Calculating Forester: Quantification, Cameral Science, and the Emergence of Scientific Forestry Management in Germany," in *The Quantifying Spirit of the Eighteenth Century* (Berkeley: University of California Press, 1991).

Mabey, Richard, *Beechcombings: The Narratives of Trees* (London: Chatto & Windus, 2007).

Rackham, Oliver, *Trees and Woodlands in the British Landscape* (London: Dent, 1976).

Rackham, Oliver, *Woodlands* (London: Collins, 2006).

Thomas, Peter, *Trees: Their Natural History* (Cambridge: Cambridge University Press, 2000).

Thoreau, David Henry, *Walden: Or, Life in the Woods* (1854) (London: Dent, 1972).

Tudge, Colin, *The Secret Life of Trees* (London: Penguin, 2006).

Zipes, Jack, *The Brothers Grimm: From Enchanted Forests to the Modern World* (New York: Routledge, 1988).

3: WALKING PAPERS

Andrews, J.H., *Maps in Those Days: Cartographic Methods Before 1850* (Dublin: Four Courts, 2009).

Borges, Jorge Luis, "On Exactitude in Science" (1946), in *Labyrinths*, trans. Donald A. Yates and James E. Irby (Harmondsworth: Penguin, 1970).

Brown, Lloyd A., *The Story of Maps* (Boston: Little, Brown, 1950).

Clarke, Keith C., *Getting Started with Geographic Information Systems* (Upper Saddle River, N.J.: Prentice Hall, 5th edn., 2011).

Harmon, Katharine, *You Are Here: Personal Geographies and Other Maps of the Imagination* (New York: Princeton Architectural Press, 2004).

Harvey, Miles, *The Island of Lost Maps: A True Story of Cartographic Crime* (New York: Random House, 2000).

Hyde, Ralph, *Printed Maps of Victorian London 1851–1900* (Folkestone: Dawson, 1975).

Ishikawa, T., K. Murasawa and A. Okabe, "Wayfinding and Art Viewing by Users of a Mobile System and a Guidebook," *Journal of Location Based Services* 3 (2009).

Ishikawa, T., and H. Fujiwara, O. Imai and A. Okabe, "Wayfinding with a GPS-

Based Mobile Navigation System: A Comparison with Maps and Direct Experience," *Journal of Environmental Psychology*, 28 (2008).

Jacobs, Frank, *Strange Maps: An Atlas of Cartographic Curiosities* (New York: Viking Studio, 2009).

King, Geoff, *Mapping Reality: An Exploration of Cultural Cartographies* (Basingstoke: Macmillan, 1996).

Koeman, C., *The History of Abraham Ortelius and His Theatrum Orbis Terrarum* (Lausanne: Sequoia S.A., 1964).

Kraak, Menno-Jan, and Allan Brown, eds., *Web Cartography: Developments and Prospects* (London: Taylor and Francis, 2001).

Martí-Henneberg, Jordi, "Geographical Information Systems and the Study of History," *Journal of Interdisciplinary History*, 42:1 (Summer 2011).

Meier, Patrick, and Rob Munro, "The Unprecedented Role of SMS in Disaster Response: Learning from Haiti," *SAIS Review*, 30:2 (Summer-Fall 2010).

Monkhouse, F.J., and H.R. Wilkinson, *Maps and Diagrams: Their Compilation and Construction* (London: Methuen, 3rd edn., 1971).

Monmonier, Mark, *How to Lie with Maps* (Chicago: University of Chicago Press, 1991).

www.openstreetmap.org.

www.osmfoundation.org.

Radford, P.J., *Antique Maps* (London: Garnstone Press, 1971).

Rosenberg, Daniel, and Anthony Grafton, *Cartographies of Time* (New York: Princeton Architectural Press, 2010).

Tyacke, Sarah, ed., *English Map-Making 1500–1650* (London: The British Library, 1983).

Wood, Denis, *The Power of Maps* (New York: Guildford Press, 1992).

Woodward, David, ed., *Five Centuries of Map Printing* (Chicago: University of Chicago Press, 1975).

Wright, J.K., "Map Makers Are Human" (1942), repr. in Wright, ed., *Human Nature in Geography* (Cambridge, Mass.: Harvard University Press, 1966).

4: VICTIMS TO THE BIBLIOMANIA!

Anderson, Benedict, *Imagined Communities: Reflections on the Origin and Spread of Nationalism* (London: Verso, rev. edn., 1991).

Baker, Nicholson, *Double Fold: Libraries and the Assault on Paper* (New York: Random House, 2001).

Basbanes, Nicholas A., *A Gentle Madness: Bibliophiles, Bibliomania, and the Eternal Passion for Books* (New York: HarperCollins, 1995).

Birkerts, Sven, *The Gutenberg Elegies: The Fate of Reading in an Electronic Age* (London: Faber and Faber, 1994).

Black, Alastair, Simon Pepper and Kaye Bagshaw, *Books, Buildings and Social Engineering: Early Public Libraries in Britain from Past to Present* (Aldershot: Ashgate, 2009).

Bolter, Jay David, *Writing Space: Computers, Hypertext, and the Remediation of Print* (Mahwah, N.J.: Lawrence Erlbaum, 2001).

Bradbury, Ray, *Fahrenheit 451* (1953) (London: Rupert Hart-Davis, 1954).

Burroughs, William S., *The Naked Lunch* (1959) (London: John Calder, 1982).

Carey, James, "The Paradox of the Book," *Library Trends* 33:2 (Fall 1984).

Darnton, Robert, *The Case for Books: Past, Present, and Future* (New York: PublicAffairs, 2009).

Darnton, Robert, *The Great Cat Massacre* (London: Allen Lane, 1984).

Dibdin, Thomas Frognall, *Bibliomania, or Book-madness; containing some account of the history, symptoms, and cure of this fatal disease* (1809) (Boston: Bibliophile Society, 1903).

Eisenstein, Elizabeth, *The Printing Revolution in Early Modern Europe* (Cambridge: Cambridge University Press, 1983).

Eliot, Simon, and Jonathan Rose, eds., *A Companion to the History of the Book* (Oxford: Blackwell, 2007).

Farrer, James Anson, *Books Condemned to be Burnt* (London: Elliot Stock, 1892).

Finkelstein, David, and Alistair McCleery, eds., *The Book History Reader* (London: Routledge, 2002).

Gillett, Charles Ripley, *Burned Books: Neglected Chapters in British History and Literature* (New York: Columbia University Press, 1932).

Greenhalgh, Liz, and Ken Worpole, *Libraries in a World of Cultural Change* (London: UCL Press, 1995).

Howard, Nicole, *The Book: The Life Story of a Technology* (Baltimore: Johns Hopkins University Press, 2009).

Jianzhong, Wu, *New Library Buildings of the World* (Shanghai: IFLA, 2003).

Johns, Adrian, *The Nature of the Book: Print and Knowledge in the Making* (Chicago: University of Chicago Press, 1998).

MacCarthy, Fiona, *William Morris: A Life for Our Time* (London: Faber and Faber, 1994).

Nunberg, Geoffrey, ed., *The Future of the Book* (Berkeley: University of California Press, 1996).

O'Brien, Flann, *The Best of Myles: A Selection from "Cruiskeen Lawn"* (London: Macgibbon & Kee, 1968).

Petroski, Henry, *The Book on the Bookshelf* (New York: Alfred A. Knopf, 1999).

Rothenberg, Jerome, and Steven Clay, eds., *A Book of the Book: Some Works and Projections About the Book and Writing* (New York: Granary Books, 2000).

Sartre, Jean-Paul, *The Words* (1963), trans. Bernard Frechtman (New York: George Braziller, 1964).

Striphas, Ted, *The Late Age of Print: Everyday Book Culture from Consumerism to Control* (New York: Columbia University Press, 2009).

Towheed, Shafquat, Rosalind Crone and Katie Halsey, eds., *The History of Reading: A Reader* (London: Routledge, 2011).

Von Merveldt, Nikola, "Books Cannot Be Killed by Fire: The German Freedom Library and the American Library of Nazi-Banned Books as Agents of Cultural Memory," *Library Trends*, 55:3 (Winter 2007).

Watson, Barry, "William Morris and Paper," *The Quarterly: The Journal of the British Association of Paper Historians*, 43 (July 2002).

Whitfield, Stephen J., "Where They Burn Books . . ." *Modern Judaism*, 22:3 (October 2002).

Zaid, Gabriel, *So Many Books*, trans. Natasha Wimmer (London: Sort of Books, 2004).

5: ORNAMENTING THE FAÇADE OF HELL

Benjamin, Walter, "One-Way Street" (1928), in *One-Way Street and Other Writings*, trans. Edmund Jephcott and Kingsley Shorter (London: Verso, 1979).

Brook, Chris, ed., *K Foundation Burn a Million Quid* (London: Ellipsis, 1997).

Brown, Dan, *Angels and Demons* (2000) (London: Bantam, 2005).

Burke, Bryan, *Nazi Counterfeiting of British Currency During World War II: Operation Andrew and Bernhard* (San Bernadino, Cal.: Book Shop, 1987).

Cantor, Paul A., "The Poet as Economist: Shelley's Critique of Paper Money and the British National Debt," *Journal of Libertarian Studies*, 13:1 (Summer 1997).

Coggan, Philip, *Paper Promises: Money, Debt and the New World* (London: Allen Lane, 2011).

Dickens, Charles, *Dombey and Son* (1848), ed. Alan Horsman (Oxford: Oxford University Press, 2nd edn., 2008).

Doty, Richard, *America's Money—America's Story* (Iola, Wis.: Krause Publications, 1998).

Douglas, Mary, *Purity and Danger: An Analysis of Concepts of Pollution and Taboo* (London: Routledge, 1966).

Dye, Ian, "The Great Bank Note Paper Robbery, 1861–1862," *The Quarterly: The Journal of the British Association of Paper Historians*, 58 (April 2006).

Gold, Andrew, "Balancing the Books on Paper," *The Quarterly: The Journal of the British Association of Paper Historians*, 61 (January 2007).

Heinzelman, Kurt, *The Economics of the Imagination* (Amherst: University of Massachusetts Press, 1980).

Hill, Geoffrey, *Mercian Hymns* (London: Deutsch, 1971).

Hume, David, *Writings on Economics*, ed. Eugene Rotwein (London: Nelson, 1955).

Ingrassia, Catherine, *Authorship, Commerce, and Gender in Early Eighteenth-Century England: A Culture of Paper Credit* (Cambridge: Cambridge University Press, 1998).

Jefferson, Thomas, "Notes on Coinage" (1784), in *The Papers of Thomas Jefferson*, Julian P. Boyd et al., eds., vol. 7 (Princeton: Princeton University Press, 1953).

Komroff, Manuel, ed., *The Travels of Marco Polo*, trans. William Marsden (Rochester, N.Y.: Leo Hart, 1933).

McLuhan, Marshall, *Understanding Media: The Extensions of Man* (London: Routledge, 1964).

Marx, Karl, "Economic and Philosophical Manuscripts," trans. T.B. Bottomore, in Bottomore, ed., *Karl Marx: Early Writings* (London: Watts, 1963).

Michaels, Walter Benn, *The Gold Standard and the Logic of Naturalism: American Literature at the Turn of the Century* (Berkeley: University of California Press, 1987).

Rendell, Kenneth W., *Forging History: The Detection of Fake Letters and Documents* (Norman, Okla.: University of Oklahoma Press, 1994).

Robertson, Frances, "The Aesthetics of Authenticity: Printed Banknotes as Industrial Currency," *Technology and Culture*, 46:1 (January 2005).

Schlichter, Detlev S., *Paper Money Collapse: The Fall of Elastic Money and the Coming Monetary Breakdown* (Hoboken: John Wiley & Sons, 2011).

Schumpeter, Joseph A., *History of Economic Analysis*, ed. Elisabeth Boody Schumpeter (London: George Allen & Unwin, 1954).

Shell, Marc, *The Economy of Literature* (Baltimore: Johns Hopkins University Press, 1978).

Shell, Marc, *Money, Language, and Thought: Literary and Philosophical Economies from the Medieval to the Modern Era* (Berkeley: University of California Press, 1982).

Sinclair, David, *The Pound: A Biography* (London: Century, 2000).

Stock, Noel, *The Life of Ezra Pound* (London: Routledge, 1970).

Swanson, Donald F., " 'Bank Notes Will Be But as Oak Leaves': Thomas Jefferson on Paper Money," *The Virginia Magazine of History and Biography*, 101:1 (January 1993).

Tschachler, Heinz, *The Greenback: Paper Money and American Culture* (Jefferson, N.C.: McFarland, 2010).

6: THE SOUL OF ADVERTISEMENT

Ackroyd, Peter, *Dickens* (London: Sinclair-Stevenson, 1990).

Baker, Laura E., "Public Sites Versus Public Sights: The Progressive Response to Outdoor Advertising and the Commercialization of Public Space," *American Quarterly*, 59:4 (December 2007).

Barnicoat, John, *A Concise History of Posters* (London: Thames and Hudson, 1972).

Benjamin, Walter, *One-Way Street and Other Writings*, trans. Edmund Jephcott and Kingsley Shorter (London: Verso, 1979).

Berger, Alfred Paul, "James Joyce, Adman," *James Joyce Quarterly*, 3:1 (Fall 1965).

Brantlinger, Patrick, *The Reading Lesson: The Threat of Mass Literacy in Nineteenth-Century British Fiction* (Bloomington, Ind.: Indiana University Press, 1998).

Brewster, E.H., "Poster Politics in Ancient Rome and in Later Italy," *The Classical Journal*, 39:8 (May 1944).

Brodersen, Momme, *Walter Benjamin: A Biography* (1990), trans. Malcom R. Green and Ingrida Ligers, ed. Martina Dervis (London: Verso, 1996).

Dagnall, H., *The Taxation of Paper in Great Britain 1643–1861* (Edgware: The British Association of Paper Historians, 1998).

Darwin, Bernard, *The Dickensian Advertiser: A Collection of the Advertisements in the Original Parts of Novels by Charles Dickens* (New York: Macmillan, 1930).

Dickens, Charles, "Bill-Sticking," repr. in *Dickens' Journalism, Volume 2: "The Amusements of the People" and Other Papers 1834–35*, ed. Michael Slater (Columbus: Ohio University Press, 1996).

Dickens, Charles, *Our Mutual Friend* (1865), ed. Michael Cotsell (Oxford: Oxford University Press, 1998).

Dickens, Charles, *Sketches by "Boz," Illustrative of Every-day Life and Every-day People* (1836) (London: Penguin, 1995).

Dobraszczyk, Paul, "Useful Reading? Designing Information for London's Victorian Cab Passengers," *Journal of Design History*, 21:2 (2008).

Douglas-Fairhurst, Robert, *Becoming Dickens: The Invention of a Novelist* (Cambridge, Mass.: Belknap Press, 2011).

Eisenstein, Elizabeth, *The Printing Revolution in Early Modern Europe* (Cambridge: Cambridge University Press, 1983).

Forbes, Derek, *Illustrated Playbills* (London: Society for Theatre Research, 2002).

Forster, John, *The Life of Charles Dickens* (London: Chapman & Hall, 1879).

Hewitt, John, " 'The Poster' and the Poster in England in the 1890s," *Victorian Periodicals Review*, 35:1 (Spring 2002).

Hodges, Jack, *The Maker of the Omnibus: The Lives of English Writers Compared* (London: Sinclair-Stevenson, 1992).

Hollingshead, John, "The City of Unlimited Paper," *Household Words*, 404 (19 December 1857).

Hunter, Dard, *Papermaking: The History and Technique of an Ancient Craft* (London: Cresset Press, 2nd edn., 1957).

Joyce, James, *Ulysses* (1922) (London: Penguin, 2000).

Kiberd, Declan, *Ulysses and Us: The Art of Everyday Living* (London: Faber and Faber, 2010).

Levinson, Marc, *The Box: How the Shipping Container Made the World Smaller and the World Economy Bigger* (Princeton: Princeton University Press, 2006).

McLaughlin, Kevin, *Paperwork: Fiction and Mass Mediacy in the Paper Age* (Philadelphia: University of Pennsylvania Press, 2005).

Matlack, Charles, *Posters: A Critical Study of the Development of Poster Design in Continental Europe, England and America* (New York: G.W. Bricka, 1913).

Nead, Lynda, *Victorian Babylon: People, Streets, and Images in Nineteenth-Century London* (New Haven: Yale University Press, 2000).

Opie, Robert, *The Art of the Label: Designs of the Times* (London: Simon & Schuster, 1987).

Orwell, George, "Charles Dickens," in *Inside the Whale and Other Essays* (London: Gollancz, 1940).

Rickards, Maurice, *The Rise and Fall of the Poster* (Newton Abbott: David and Charles, 1971).

Spicer, A. Dykes, *The Paper Trade: A Descriptive and Historical Survey of the Paper Trade from the Commencement of the Nineteenth Century* (London: Methuen, 1907).

Tomalin, Claire, *Charles Dickens: A Life* (London: Viking, 2011).

Trotter, David, *Circulation: Defoe, Dickens and the Economies of the Novel* (New York: St. Martin's Press, 1988).

Wicke, Jennifer, *Advertising Fictions: Literature, Advertisement, & Social Reading* (New York: Columbia University Press, 1988).

Williams, Raymond, "Advertising: The Magic System," in *Problems in Materialism and Culture: Selected Essays* (London: Verso, 1980).

7: CONSTRUCTIVE THINKING

Alberti, Leon Battisti, *On the Art of Building in Ten Books* (1452), trans. Joseph Rykwert, Neil Leach and Robert Tavernor (Cambridge, Mass.: MIT Press, 1991).

Ban, Shigeru, *Paper in Architecture*, eds. Ian Luna and Lauren A. Gould (New York: Rizzoli, 2009).

Bayer, Herbert, Walter Gropius and Ise Gropius, eds., *Bauhaus Weimar 1919–1925* (London: Secker and Warburg, 1975).

Corbusier, Le, *The Modulor: A Harmonious Measure to the Human Scale Universally Applicable to Architecture and Mechanics*, trans. Peter de Francia and Anna Bostock (London: Faber and Faber, 1954).

Corbusier, Le, *Toward an Architecture* (1923), trans. John Goodman (London: Frances Lincoln, 2008).

Downes, Kerry, *Christopher Wren* (London: Allen Lane, 1971).

Droste, Magdalena, *Bauhaus 1919–1933* (Köln: Taschen, 1998).

Eaton, Ruth, *Ideal Cities: Utopianism and the (Un)Built Environment* (London: Thames and Hudson, 2002).

Ellmann, Richard, *Oscar Wilde* (London: Hamish Hamilton, 1987).

Entwhistle, E.A., *A Literary History of Wallpaper* (London: Batsford, 1960).

Greysmith, Brenda, *Wallpaper* (London: Studio Vista, 1976).

Herbert, Gilbert, *Pioneers of Prefabrication: The British Contribution in the Nineteenth Century* (Baltimore: Johns Hopkins University Press, 1978).

Hughes, Sukey, *Washi: The World of Japanese Paper* (Tokyo: Kodansha International, 1978).

Klotz, Heinrich, ed., *Paper Architecture: New Projects from the Soviet Union* (New York: Rizzoli, 1990).

Krasny, Elke, *The Force Is in the Mind: The Making of Architecture* (Basel: Birkhäuser, 2008).

Lynn, Greg, *Animate Form* (New York: Princeton Architectural Press, rev. edn., 2011).

Neuman, Eckhard, ed., *Bauhaus and Bauhaus People: Personal Opinions and Recollections of Former Bauhaus Members and Their Contemporaries*, trans. Eva Richter and Alba Norman (New York: Van Nostrand Reinhold, 1970).

Robbins, Edward, *Why Architects Draw* (Cambridge, Mass.: MIT Press, 1994).

Steegmuller, Francis, *Flaubert and Madame Bovary: A Double Portrait* (London: Robert Hale, 1939).

Sugden, A.V., and J.L. Edmondson, *A History of English Wallpaper 1509–1914* (London: Batsford, 1925).

Tanizaki, Junichirō, *In Praise of Shadows* (1933–34), trans. Thomas J. Harper and Edward G. Seidensticker (London: Jonathan Cape, 1991).

Toller, Jane, *Papier-mâché in Great Britain and America* (London: G. Bell & Sons, 1962).

Vitruvius, *Ten Books on Architecture*, trans. Morris Hicky Morgan (Cambridge, Mass.: Harvard University Press, 1914).

Whorton, James C., *The Arsenic Century: How Victorian Britain Was Poisoned at Home, Work, and Play* (Oxford: Oxford University Press, 2010).

Wick, Rainer K., *Teaching at the Bauhaus* (Ostfildern-Ruit: Hatje Cantz, 2000).

Wolfe, Tom, *From Bahaus to Our House* (New York: Farrar, Straus & Giroux, 1981).

8: THE SECRET IS THE PAPER

Baldassari, Anne, *Picasso Working on Paper*, trans. George Collins (London: Merrell, 2000).

Barr, Alfred H., *Matisse: His Art and His Public* (New York: Museum of Modern Art, 1951).

Bashō, *On Love and Barley—Haiku of Bashō*, trans. Lucien Stryk (Harmondsworth: Penguin, 1985).

Berger, John, *The Success and Failure of Picasso* (New York: Pantheon Books, rev. edn., 1989).

Bermingham, Ann, *Learning to Draw: Studies in the Cultural History of a Polite and Useful Art* (New Haven: Yale University Press, 2000).

Beuys, Joseph, *The Multiples*, ed. Jörg Schellmann (New York: Edition Schellmann, 1997).

Blunt, Anthony, *The Drawings of Poussin* (New Haven: Yale University Press, 1979).

Collings, Matthew, *Blimey!: From Bohemia to Britpop: The London Artworld from Francis Bacon to Damien Hirst* (London: 21 Publishing, 1997).

Cowling, Elizabeth, et al., *Matisse Picasso* (London: Tate Publishing, 2002).

Da Vinci, Leonardo, *Notebooks*, ed. Thereza Wells (Oxford: Oxford University Press, 2008).

Dietrich, Dorothea, *The Collages of Kurt Schwitters: Tradition and Innovation* (Cambridge: Cambridge University Press, 1993).

Dupin, Jacques, *Miró* (Paris: Flammarion, 2004).

Elderfield, John, *Matisse in the Collection of the Museum of Modern Art* (New York: Museum of Modern Art, 1978).

Elsen, Albert, J. Kirk and T. Varnedoe, *The Drawings of Rodin* (London: Elek, 1972).

Gilot, Françoise, *Life with Picasso* (New York: Anchor, 1964).

Glaubinger, Jane, *Paper Now: Bent, Molded and Manipulated* (Cleveland: Cleveland Museum of Art, 1986).

Gombrich, E.H., *Norm and Form* (London: Phaidon, 1966).

Gowing, Lawrence, *Matisse* (London: Thames and Hudson, 1979).

Greenberg, Clement, *The Collected Essays and Criticism, Volume 4: Modernism with a Vengeance, 1957–1969*, ed. John O'Brian (Chicago: University of Chicago Press, 1993).

Greer, Germaine, "Making Pictures from Strips of Cloth Isn't Art at All—but It Mocks Art's Pretensions to the Core," *The Guardian*, August 13, 2007.

Hilton, Timothy, *Picasso* (London: Thames and Hudson, 1975).

Hockney, David, *Secret Knowledge: Rediscovering the Lost Techniques of the Old Masters* (London: Thames and Hudson, 2001).

Hughes, Robert, *Nothing if Not Critical: Selected Essays on Art and Artists* (London: Harvill, 1990).

Hughes, Robert, *The Shock of the New: Art and the Century of Change* (London: BBC Books, 1980).

Kemp, Martin, *The Science of Art: Optical Themes in Western Art from Brunelleschi to Seurat* (New Haven: Yale University Press, 1990).

Krill, John, *English Artists' Paper: Renaissance to Regency* (Delaware: Oak Knoll Press, 2nd edn., 2001).

McFadden, David Revere, ed., *Slash: Paper Under the Knife* (Milan: Museum of Arts and Design/5 Continents, 2009).

MacPhee, Josh, *Paper Politics: Socially Engaged Printmaking Today* (Oakland, Cal.: PM Press, 2009).

Peacock, Molly, *The Paper Garden: Mrs Delany (Begins Her Life's Work) at 72* (London: Bloomsbury, 2011).

Poggi, Christine, *In Defiance of Painting: Cubism, Futurism, and the Invention of Collage* (New Haven: Yale University Press, 1992).

Spurling, Hilary, *Matisse the Master: A Life of Henri Matisse, Volume 2: The Conquest of Colour, 1909–1954* (London: Hamish Hamilton, 2005).

Spurling, Hilary, *The Unknown Matisse: A Life of Henri Matisse, Volume 1: 1869–1908* (London: Hamish Hamilton, 1998).

Thomas, Jane, and Paul Jackson, *On Paper: New Paper Art* (London: Merrell, 2001).

Willetts, William, *Foundations of Chinese Art: from Neolithic Pottery to Modern Architecture* (London: Thames and Hudson, 1965).

Williams, Nancy, *More Paperwork: Exploring the Potential of Paper in Design* (London: Phaidon, 2005).

Williams, Nancy, *Paperwork: The Potential of Paper in Graphic Design* (London: Phaidon, 1993).

Zwijnenberg, Robert, *The Writing and Drawings of Leonardo da Vinci: Order and Chaos in Early Modern Thought* (Cambridge: Cambridge University Press, 1999).

9: THE SQUIGGLE GAME

Benjamin, Walter, "The Cultural History of Toys," "Old Toys: The Toy Exhibition at the Märkisches Museum," "Toys and Play: Marginal Notes on a

Monumental Work," in *Walter Benjamin: Selected Writings, Volume 2, Part 1: 1927–1930*, ed. Michael Jennings et al. (Cambridge: Belknap Press, 2005).

Bowen, Elizabeth, "Children's Play," in *Collected Impressions* (New York: Alfred A. Knopf, 1950).

Chesteron, G.K., "The Toy Theatre," in *Tremendous Trifles* (London: Methuen, 8th edn., 1925).

Croall, Jonathan, *Gielgud: A Theatrical Life* (London: Methuen, 2001).

Culin, Stewart, *Korean Games* (Philadelphia: Pennsylvania University Press, 1895).

Dickens, Charles, *A Christmas Carol and Other Christmas Stories*, ed. Robert Douglas Fairhurst (Oxford: Oxford University Press, 2006).

Dostoevsky, Fyodor, *The Gambler* (1867), trans. Richard Pevear and Larissa Volokonsky (New York: Everyman's, 2005).

Ferguson, Andy, *Tracking Bodhidharma: A Journey to the Heart of Chinese Culture* (Berkeley: Counterpoint, 2012).

Foulkes, Richard, *Lewis Carroll and the Victorian Stage: Theatricals in a Quiet Life* (Aldershot: Ashgate, 2005).

Freud, Sigmund, "Dostoevsky and Parricide" (1928), in *The Standard Edition of the Complete Psychological Works of Sigmund Freud, vol. XXI* (1927–31), trans. James Strachey (London: Hogarth Press, 1961).

Hannas, Linda, *The English Jigsaw Puzzle 1760–1890* (London: Wayland, 1972).

Hargrave, Catherine Perry, *A History of Playing Cards and a Bibliography of Cards and Gaming* (New York: Houghton Mifflin, 1930).

Hofer, Margaret K., *The Games We Played: The Golden Age of Board and Table Games* (New York: Princeton Architectural Press, 2003).

Hoffmann, Detlef, trans. C.S.V. Salt, *The Playing Card: An Illustrated History* (Greenwich, Conn.: New York Graphic Society, 1973).

Houdini, Harry, *Paper Magic: The Whole Art of Performing with Paper, Including Paper Tearing, Paper Folding and Paper Puzzles* (New York: E.P. Dutton, 1922).

Houseman, Lorna, *The House That Thomas Built: The Story of De La Rue* (London: Chatto & Windus, 1968).

Ishigaki, Komaku, *Japanese Paper Dolls*, trans. John Clark (Osaka: Hoikusha Books, 1976).

Marx, Ursula, and Gudrun Schwartz, Michael Schwartz and Erdmut Wizisla, *Walter Benjamin's Archive: Images, Texts, Signs*, trans. Esther Leslie (London: Verso, 2007).

Moncrief-Scott, Ian, *De la Rue: Straw Hats to Global Securities* (York: Imagination, 1999).

Murray, H.J.R., *A History of Board-Games Other Than Chess* (Oxford: Oxford University Press, 1952).

Nesbit, E., *The Railway Children* (London: Wells Gardner, Darton & Co., 1906).

Norcia, Megan A., "Puzzling Empire: Early Puzzles and Dissected Maps as Imperial Heuristics," *Children's Literature*, 37 (June 2009).

Parlett, David, *The Oxford History of Board Games* (Oxford: Oxford University Press, 1999).

Parlett, David, *The Oxford Guide to Card Games* (Oxford: Oxford University Press, 1990).

Speaight, George, *Juvenile Drama: The History of the English Toy Theatre* (London: Macdonald & Co., Ltd., 1946).

Stevenson, Robert Louis, "A Penny Plain and Twopence Coloured," in *Memories and Portraits* (London: T. Nelson & Sons, 1887).

Tilley, Roger, *A History of Playing Cards* (London: Studio Vista, 1973).

Whitehouse, F.R.B., *Table Games of Georgian and Victorian Days* (London: Peter Garnett, 1951).

Williams, Anne D., *The Jigsaw Puzzle: Piecing Together a History* (New York: Berkeley Publishing, 2004).

Winnicott, D.W., "The Squiggle Game" (1968), in *Psychoanalytic Explorations*, ed. Clare Winnicott, Ray Shepherd and Madeleine Davis (London: Karnac Books, 1989).

Wowk, Kathleen, *Playing Cards of the World: A Collector's Guide* (Guildford: Lutterworth, 1983).

10: A WONDERFUL MENTAL AND PHYSICAL THERAPY

Boehn, M. von, *Miniatures and Silhouettes* (London: J.M. Dent, 1928).

Brottman, Mikita, *Funny Peculiar: Gershon Legman and the Psychopathology of Humor* (Hillsdale, N.J.: Analytic Press, 2004).

Brust, Beth Wagner, *The Amazing Paper Cuttings of Hans Christian Andersen* (Boston: Houghton Mifflin, 1994).

Coke, Desmond, *The Art of Silhouette* (London: Martin Secker, 1913).

Feng, Diane, *Chinese Paper Cutting* (Kenthurst, NSW: Kangaroo Press, 1996).

Harbin, Robert, *Origami: The Art of Paper-Folding* (London: Teach Yourself Books, 1968).

Harbin, Robert, *Origami 3: The Art of Paper-Folding* (London: Coronet, 1972).

Harbin, Robert, *Paper Magic* (London: Oldbourne Book Company, 1956).

Harbin, Robert, *Secrets of Origami* (London: Oldbourne Book Company, 1963).

Hickman, Peggy, *Silhouettes: A Living Art* (Newton Abbot: David and Charles, 1975).

Holmes, John Clellan, *Nothing More to Declare* (New York: E.P. Dutton, 1967).

Jackson, E.N., *Silhouettes: Notes and Dictionary* (New York: Charles Scribner's, 1938).

Kenneway, Eric, *Complete Origami: An A-Z of Facts and Folds* (New York: St. Martin's Press, 1987).

Lang, Robert, *The Complete Book of Origami* (New York: Dover Publications, 1989).

Leslie, H., *Silhouettes and Scissor-Cutting* (London: John Lane, 1939).

Lister, David, "The Lister List," accessed at www.britishorigami.info.

Piper, David, *Shades: An Essay on English Portrait Silhouettes* (Cambridge: Rampant Lions Press, 1970).

Randlett, Samuel, *The Art of Origami* (New York: E.P. Dutton, 1966).

Rutherford, Emma, *Silhouette* (New York: Rizzoli, 2009).

Swannell, M., *Paper Silhouettes* (London: George Philip and Son, 1929).

Warner, John, *Chinese Papercuts* (Hong Kong: John Warner Publications, 1978).

Zipes, Jack, *Hans Christian Andersen: The Misunderstood Storyteller* (New York: Routledge, 2005).

11: LEGITIMATIONSPAPIERE

Allan, Kate, ed., *Paper Wars: Access to Information in South Africa* (Johannesburg: Wits University Press, 2009).

Aly, Götz, and Karl-Heinz Roth, *The Nazi Census: Identification and Control in the Third Reich*, trans. Edwin Black (Philadelphia: Temple University Press, 2004).

Anderson, Martin, "Tourism and the Development of the Modern British Passport, 1814–1858," *Journal of British Studies* 49 (April 2010).

Berger, John, *About Looking* (New York: Pantheon, 1980).

Bullock, Alan, *Hitler: A Study in Tyranny* (London: Odhams, 1952).

Caplan, Jane, and John Torpey, *Documenting Individual Identity: The Development of State Practices in the Modern World* (Princeton: Princeton University Press, 2000).

Clanchy, Michael, *From Memory to Written Record: England 1066–1307* (Oxford: Blackwell, 1993).

Darwish, Mahmoud, *Selected Poems*, trans. Ian Wedde and Fawwaz Tuqan (Cheadle Hulme: Carcanet, 1973).

Derrida, Jacques, *Archive Fever: A Freudian Impression*, trans. Eric Prenowitz (Chicago: University of Chicago Press, 1995).

Dudley, Leonard M., *The Word and the Sword: How Techniques of Information and Violence Have Shaped Our World* (Cambridge, Mass.: Basil Blackwell, 1991).

Dutton, David, *Neville Chamberlain* (London: Arnold, 2001).

Falling Leaf (Quarterly Magazine of the Psywar Society), ed. R.G. Auckland, (1958–).

The Falling Leaf: Aerial Dropped Propaganda 1914–1968, catalogue to accompany exhibition at The Museum of Modern Art, Oxford, 1978 (Oxford: Holywell Press, 1978).

Feiling, Keith, *The Life of Neville Chamberlain* (London: Macmillan, 1946).

Fothergill, Robert A., *Private Chronicles: A Study of English Diaries* (London: Oxford University Press, 1974).

Funder, Anna, *Stasiland: Stories from Behind the Berlin Wall* (London: Granta, 2003).

Fussell, Paul, *Abroad: British Literary Traveling Between the Wars* (New York: Oxford University Press, 1980).

Giddens, Anthony, *Modernity and Self-Identity: Self and Society in the Late Modern Age* (Cambridge: Polity Press, 1991).

Giddens, Anthony, *The Nation-State and Violence* (Berkeley: University of California Press, 1987).

Kershaw, Ian, *Hitler 1936–45: Nemesis* (New York: W.W. Norton & Co., 2000).

Lau, Estelle T., *Paper Families: Identity, Immigration Administration, and Chinese Exclusion* (Durham, N.C.: Duke University Press, 2006).

Levi, Primo, *If This Is a Man* (1947), trans. Stuart Woolf (New York: Orion Press, 1959).

Levi, Primo, *The Periodic Table* (1975), trans. Raymond Rosenthal (New York: Schocken Books, 1984).

Levi, Primo, *The Truce* (1963), trans. Stuart Woolf (London: Bodley Head, 1965).

Longman, Timothy, "Identity Cards, Ethnic Self-Perception, and Genocide in Rwanda," in Jane Caplan and John Torpey, eds., *Documenting Individual Identity: The Development of State Practices in the Modern World* (Princeton: Princeton University Press, 2000).

Lyon, David, *The Electronic Eye: The Rise of Surveillance Society* (Minneapolis: University of Minnesota Press, 1994).

Marrus, Michael, *The Unwanted: European Refugees in the Twentieth Century* (New York: Oxford University Press, 1985).

Montale, Eugenio, *New Poems*, trans. G. Singh (London: Chatto & Windus, 1976).

Parker, R.A.C., *Chamberlain and Appeasement: British Policy and the Coming of the Second World War* (Basingstoke: Macmillan, 1993).

Reale, Egidio, *Le régime des passeports et la société des nations* (Paris: Librairie A. Rousseau, 1930).

Ripka, Hubert, *Munich: Before and After*, trans. Ida Šindelková and Edgar P. Young (London: Gollancz, 1939).

Self, Robert, *Neville Chamberlain: A Biography* (Aldershot: Ashgate, 2006).

Sen, Amartya, *Identity and Violence: The Illusion of Destiny* (London: Allen Lane, 2006).

Smart, Nick, *Neville Chamberlain* (London: Routledge, 2010).

Spotts, Frederic, *Hitler and the Power of Aesthetics* (Woodstock: The Overlook Press, 2003).

Torpey, John, *The Invention of the Passport: Surveillance, Citizenship and the State* (Cambridge: Cambridge University Press, 2000).

Walker Bynum, Caroline, *Metamorphosis and Identity* (New York: Zone Books, 2001).

Weber, Therese, *The Language of Paper: A History of 2000 Years* (Bangkok: Orchid Press, 2007).

12: FIVE LEAVES LEFT

Adburgham, Alison, *Shops and Shopping, 1800–1914: Where and in What Manner the Well-Dressed Englishwoman Bought Her Clothes* (London: Allen & Unwin, 1981).

Ashbery, John, *Wakefulness* (Manchester: Carcanet, 1998).

Batchen, Geoffrey, *William Henry Fox Talbot* (London: Phaidon, 2008).

Behlmer, Rudy, ed., *Memo from David Selznick* (New York: Viking Press, 1972).

Berger, John, *About Looking* (New York: Pantheon Books, 1980).

Berman, Patricia G., "Edvard Munch's *Self-Portrait with Cigarette:* Smoking and the Bohemian Persona," *The Art Bulletin*, 75:4 (December 1993).

Bower, Peter, "The White Art: The Importance of Interpretation in the Analysis of Paper," in John Slavin, et al., eds., *Looking at Paper: Evidence & Interpretation* (Toronto: Symposium Proceedings, Royal Ontario Museum and Art Gallery of Ontario, May 13–16, 1999).

Canemaker, John, *Paper Dreams: The Art and Artists of Disney Storyboards* (New York: Hyperion, 1999).

Cave, Roderick, *Chinese Paper Offerings* (Hong Kong: Oxford University Press, 1998).

Daves, Jessica, *Ready-Made Miracle: The Story of Fashion for the Millions* (London: Putnam, 1967).

Davies, Hywel, *Fashion Designers' Sketchbooks* (London: Laurence King, 2010).

De Landa, Manuel, *War in the Age of Intelligent Machines* (New York: Swerve, 1991).

Doctorow, E.L., *Homer & Langley* (New York: Random House, 2009).

Domínguez, Carlos María, *The Paper House*, trans. Nick Caistor (London: Harvill Secker, 2005).

Fuller, Buckminster, with Kiyoshi Kuromiya, *Critical Path* (New York: St. Martin's Press, 1981).

Holmes, Frederic Lawrence, *Investigative Pathways: Patterns and Stages in the Careers of Experimental Scientists* (New Haven: Yale University Press, 2004).

Holmes, Frederic Lawrence, et al., eds., *Reworking the Bench: Research Notebooks in the History of Science* (Dordrecht: Kluwer Academic, 2003).

Jessup, Harley, "Graphite and Pixels: Drawing at Pixar," in Marc Treib, ed., *Drawing/Thinking: Confronting an Electronic Age* (Taylor & Francis, 2008).

Livingstone, David N., *Putting Science in its Place: Geographies of Scientific Knowledge* (Chicago: University of Chicago Press, 2003).

Livingstone, David N., *Science, Space and Hermeneutics, Hettner Lectures 5* (Heidelberg: University of Heidelberg, 2002).

Mayhew, Henry, *London Labour and the London Poor* (1861), ed. Robert Douglas-Fairhurst (Oxford: Oxford University Press, 2012).

Petroski, Henry, *Paperboy: Confessions of a Future Engineer* (New York: Alfred A. Knopf, 2002).

Porter, Glenn, and Harold C. Livesay, *Merchants and Manufacturers: Studies in the Changing Structure of Nineteenth-Century Marketing* (Baltimore: Johns Hopkins University Press, 1971).

Purtell, David J., "The Identification of Paper Cutting Knives and Paper Cutters," *The Journal of Criminal Law, Criminology, and Police Science*, 44:2 (July–August 1953).

Rhodes, Barbara, and William Wells Streeter, *Before Photocopying: The Art & History of Mechanical Copying 1780–1938* (Delaware: Oak Knoll, 1999).

Rival, Ned, *Tabac, miroir du temps* (Paris: Librairie Académique Perrin, 1981).

Rudolph, Richard C., ed. and trans., *A Chinese Printing Manual* (Los Angeles: Ward Ritchie Press, 1954).

Schama, Simon, *Landscape and Memory* (London: HarperCollins, 1995).

Snyder, Carolyn, *Paper Prototyping: The Fast and Easy Way to Design and Refine User Interfaces* (San Francisco: Morgan Kaufmann, 2003).

Swade, Doron, " 'It Will Not Slice a Pineapple': Babbage, Miracles and Machines," in Jennifer S. Uglow and Francis Spufford, eds., *Cultural Babbage: Technology, Time and Invention* (London: Faber and Faber, 1996).

Thackray, John C., and Bob Press, *The Natural History Museum: Nature's Treasurehouse* (London: Natural History Museum, 2001).

Tsuen-Hsuin, Tsien, *Science and Civilization in China, Volume 5: Chemistry and Chemical Technology, Part 1, Paper and Printing* (Cambridge: Cambridge University Press, 1985).

Watson, James D., *The Double Helix: A Personal Account of the Discovery of the Structure of DNA* (London: Weidenfeld and Nicolson, 1968).

TEXT PERMISSIONS

PICTURE CREDITS

A NOTE ON THE TYPEFACES

The main typeface is ITC Giovanni book, designed by Robert Slimbach and released by the International Typeface Corporation in 1989. Based on the classic old-style humanist faces, especially that of Nicolas Jenson who was one of the first to break away from Gutenberg's "black face." Characterized by Jenson's diagonal bar to the lower case "e" but is a rounder, more refined letter than his, with proportionally larger x height, and more balanced weight of stroke for present-day lithographic and digital printing.

Headings and captions are set in Bembo, a twentieth-century reworking of the classic humanist face cut by Francesco Griffo and first printed by the Venetian, Aldus Manutius, in 1496. Classic proportions and good legibility have made this the mainstay of book printing and the benchmark for classic typeface design for five hundred years. Reworked by the Monotype Corporation for Monotype hot-metal printing in the early twentieth century and then again for lithographic and digital printing for the present.

If you enjoyed *Paper: An Elegy*, why not visit
the Paper Museum?
www.thepapermuseum.com